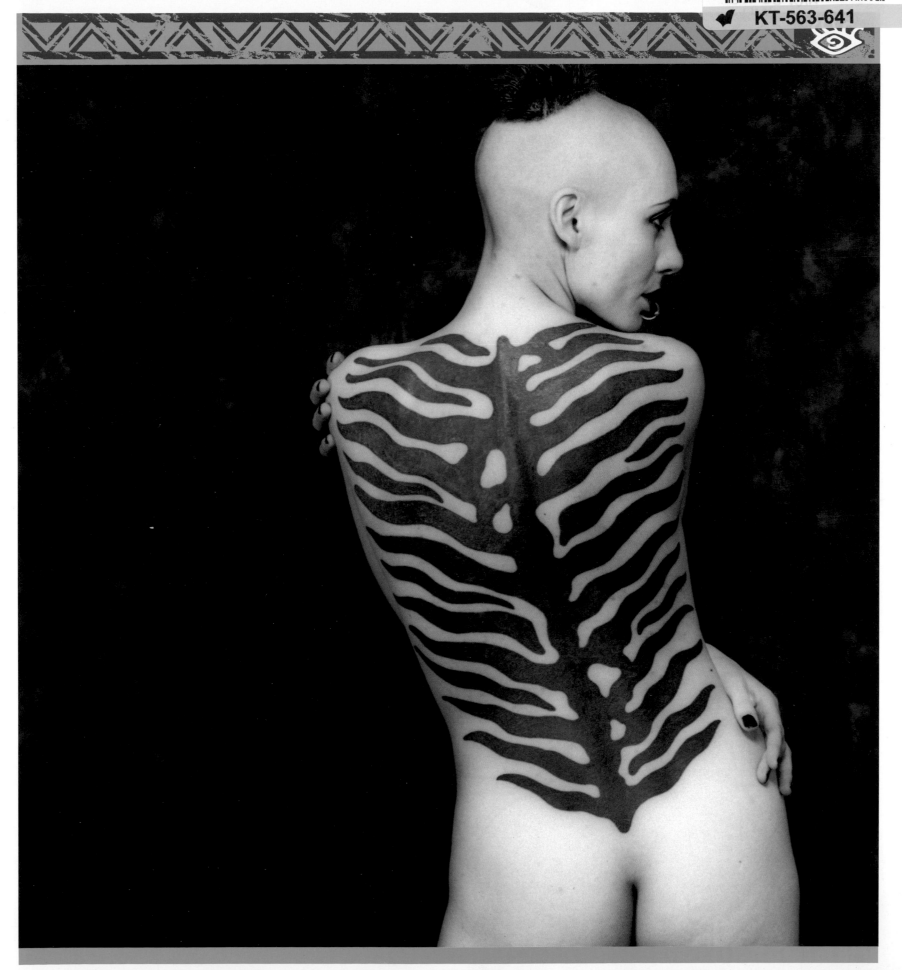

FOR THE TRADITIONAL PEOPLES OF THE WORLD
FROM WHOM WE STILL HAVE SO MUCH TO LEARN.

The Customized Body

Text
TED POLHEMUS

Photos & Interviews
HOUSK RANDALL

London and New York

CONTENTS

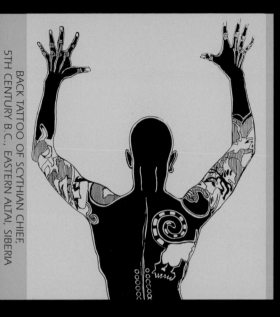

BACK TATTOO OF SCYTHIAN CHIEF, 5TH CENTURY B.C., EASTERN ALTAI, SIBERIA

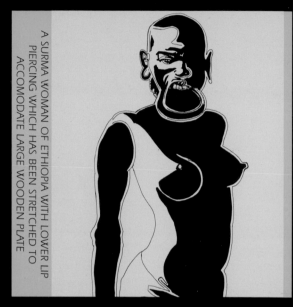

A SURMA WOMAN OF ETHIOPIA WITH LOWER LIP PIERCING WHICH HAS BEEN STRETCHED TO ACCOMODATE LARGE WOODEN PLATE

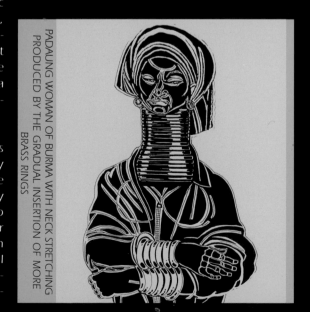

PADAUNG WOMAN OF BURMA WITH NECK STRETCHING PRODUCED BY THE GRADUAL INSERTION OF MORE BRASS RINGS

ent society will acquire an entirely different standard of what a 'normal' human being should look like. And there have always been and will always be those - like so many of the people who kindly agreed to be photographed for this book - who bravely stretch and push forward the definition of acceptable appearance.

It has often been argued that it is language or tool use which sets us apart from other animals. But these apparently firm lines of separation have been blurred by recent discoveries - the chimpanzees' adroit modification of twigs for extracting termites from their mounds, the previously unappreciated sophistication of other primates' non-verbal communication. What is beyond dispute is the uniqueness of humankind's determination to escape its physical inheritance. The chameleon may change its coloration but unlike us it has no control over this transformation - it doesn't get up in the morning and ask itself 'What colour shall I be today?'

We are the only creature on this planet which chooses and manipulates its own appearance. This isn't something new. Human beings have been altering their appearance for as long as there have been human beings. Nor is customizing the body freakish or even exceptional. No society has ever been found where appearance is dictated only by genetic inheritance. Everywhere, to be normal, acceptable and attractive is to do certain things to your body - rubbing bright red mud into the hair, cutting intricate patterns of scars in your skin, wearing a suit and tie, etc. - which defy and subvert what nature intended.

Or, to put it the other way around, it is human nature - indeed, at the very heart of human nature - to customize the body. From the most technically 'primitive' societies to the most (so called) 'advanced', from half a million or so years ago to the present day, human appearance has always been a cultural as well as a biological creation. An individual born in another era or in a differ-

This fact of human nature has often been seen as trivial and insignificant - prompting only a 'So what?' shrug of the shoulders. Yet the persistence and universality of the customized body - not to mention the sheer expenditure of effort and the acceptance of pain and discomfort for the sake of appearance - surely points towards some reasons for such behaviour which cannot be so easily dismissed.

Why do human beings persistently alter their natural appearance? From the perspective of the (so called) 'Developed World' the most likely and obvious reason is that such alteration of the body provides an invaluable means of self-expression. We want to stand out from the crowd - to be different and unique - and hair-styling, make-up, jewellery and other adornments, our choice of clothing, etc. offer a straight-forward means of accomplishing this. Furthermore, our particular choice of appearance style serves to tell others about our personal values, beliefs and approach to life. That is, our 'presentation of self' (to use the sociologist

Erving Goffman's phrase) exploits a complex communication code which, arguably, says more about us than words ever can - or at least, unlike words, offers the means to broadcast 'where we're coming from' to people we've not even yet met. In this way our chosen appearance style functions as an advertisement of ourselves - the first crucial step in our interactions with others.

But even today, in the modern world, that which appears to be done in the pursuit of individuality may actually serve to accomplish its opposite - demonstrating our membership in some social group or tribe'. For example, within the arena of streetstyle a keen sense of communality and group membership is often visually focused upon various dress and appearance styles which (while demonstrating a non-conformity in relationship to the mainstream) proclaim a compliance with the shared values and beliefs of a chosen subculture or styletribe. Such customizing of the body is in one sense a uniquely modern phenomenon - with international

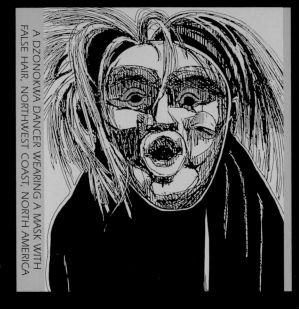

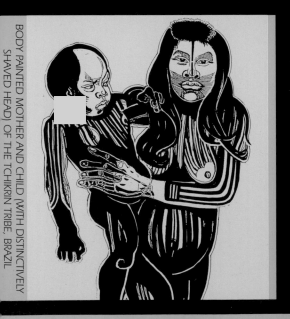

BODY PAINTED MOTHER AND CHILD (WITH DISTINCTIVELY SHAVED HEAD) OF THE TCHIKRIN TRIBE, BRAZIL

A DZONOKWA DANCER WEARING A MASK WITH FALSE HAIR. NORTHWEST COAST, NORTH AMERICA

groups like Hippies, Punks or Goths only possible within the context of the 'global village'. Yet at the same time, here is a contemporary revival of the most ancient function of body modification - the visible realization of tribal identity, appearance as a marker of group membership.

The tribe is humankind's most important invention. An inter-generational system, it allowed our most distant ancestors to pass on and build upon the discoveries made within one lifetime. The tribe also imposes rules and regulations which make communal life efficient, productive and powerful. But 'our tribe' is only a vague mental construct until it is literally embodied in the form of our tribe's distinctive appearance style. If tribe A decrees that the body should be painted with red stripes while the neighbouring tribe B decrees that the body should be painted with blue dots then immediately a clear line has been drawn between 'us' and 'them'. In this way the customized body - far from being frivolous - played and continues to play a crucial role in human development.

But this isn't all. Because colour, pattern, adornments and so on all tap into and express deeper meanings - that is, because red/blue, stripes/dots, etc. are a kind of language - a tribe can use the customized body as a means of expressing complex values, beliefs and ideals. In this the customized body is the medium within which tribal customs are most succinctly and powerfully expressed. This is as true of our contemporary styletribes as it is of the ancient tribes of the Third World. For example, the different appearance styles of Hippies and Punks in the late 1970s or Travellers and Technos today each serve to express and realize the respective values, beliefs and ideals of each of these different subcultures. A Punk dressed as a Hippy, or vice versa, would be 'saying' all the wrong things - his or her look in complete contradiction to his or her subculture's worldview.

Where our contemporary world differs from that of the traditional tribes and peasant communities of the Third World is

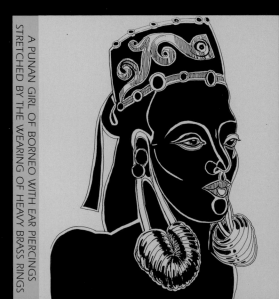

A PUNAN GIRL OF BORNEO WITH EAR PIERCINGS STRETCHED BY THE WEARING OF HEAVY BRASS RINGS

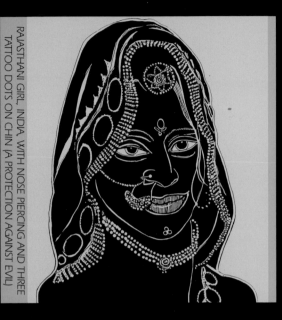

RAJASTHANI GIRL, INDIA, WITH NOSE PIERCING AND THREE TATTOO DOTS ON CHIN (A PROTECTION AGAINST EVIL)

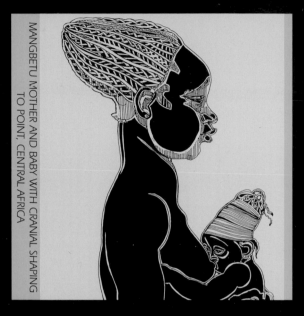

MANGBETU MOTHER AND BABY WITH CRANIAL SHAPING TO POINT, CENTRAL AFRICA

leather jacket, a pair of Levi 501's which look right whatever year it is and whatever **Vogue** may say is 'in' or 'out'. More radically, permanent alterations of the body first seen amongst traditional peoples - tattooing or piercing, for example - are employed to render the customized body a truly timeless creation. Responding to a world where everything is in flux the permanently customized body offers stability, continuity and (when desired) an enduring demonstration of tribal commitment.

Complexity, confusion, diversity, fragmentation and alienation increasingly characterise our post-modern world. When 'there is no such thing as society' (Margaret Thatcher) neither is there such a thing as one appearance style which defines normality and which is accepted as beautiful or desirable by one and all. Radically different, often extreme, apparently bizarre versions of the body compete for our attention. Reflecting on a half million years of our ancestors' experience in customizing the human form,

fine-tuning our extraordinary abilities in using the body as a medium of expression, these experiments in the possibilities of appearance propose alternative visions of life in the next millennium.

Having left behind the dictatorship of fashion, able to choose between dozens of different styletribes - or, increasingly, to simply go it alone as unique, extraordinary individuals - we stand at an unprecedented point in human history. Never before have we had such choice and possibility in how to look/be. Never before has the customized body been so unfettered in its potential metamorphosis. This book attempts to trace the history of how we got to this point and to offer an index of possibilities for the future. For however extensive, various and innovative today's techniques and styles, the history of the customized body is far from complete. All that we can be certain of for the future is that - as in the past - human beings will go on finding ever more ingenious ways of transforming their flesh into art.

in the fact that we have choice - in selecting which look (and therefore which tribe) we want to opt for. As well as choice and complexity our world is also characterised by rapid change and this too has a profound effect upon the customized body. New fashions come and go with each season and particular styletribes gain or lose popularity. The result is a perpetual motion machine of different, constantly changing ways of altering the appearance of the human form. All of which is in marked contrast with the situation in any traditional society where an appearance style may remain constant and unchanging through dozens of generations.

Yet it is also true that a growing number of people in contemporary society are shifting away from fashion's capricious imperative of constant change - choosing instead to stick to a chosen appearance style year in and year out. In its most typical, mainstream form this is seen in a new appreciation of 'timeless classics' - an Armani suit, a 'Perfecto' style black

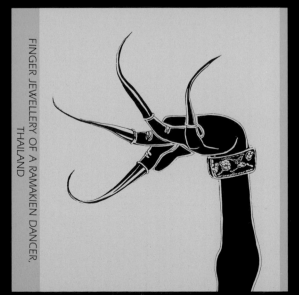

FINGER JEWELLERY OF A RAMAKIEN DANCER, THAILAND

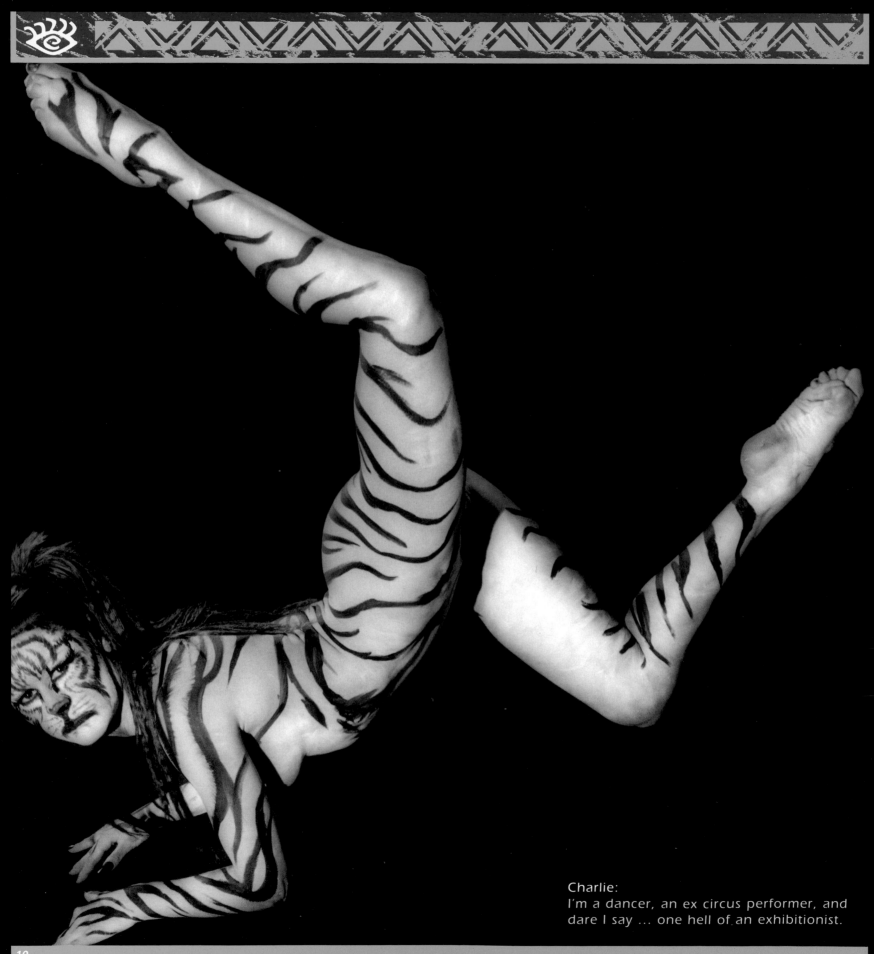

Charlie:
I'm a dancer, an ex circus performer, and dare I say ... one hell of an exhibitionist.

BODY PAINTING & MAKE-UP

Imagine the confusion of a group of Martians on a visit to earth. Touching down in the Mt. Hagen area of New Guinea they see a long line of women all with identical red, blue and white faces. Stopping off in the Amazon, they observe members of the Tchikrin tribe with red limbs and black torsos. In the Sudan, amongst the Nuba peoples they see men with bodies which are white on one side, black on the other and women with either red or yellow bodies. Setting down in New York's East Village they encounter a group of vibrantly multicoloured Punks and in London, a gathering of deathly white, vampiric Goths with huge, black, skull-like eyes and jet black lips.

So what colour are human beings?

Innately very dull creatures, human beings have always striven to and often succeeded at making themselves one of the most colourful and decorated of all species. In tribal and peasant societies this is particularly true of the males. Young Nuba men, for example, traditionally spent many hours a day - every day - applying their make-up in innovative, unique designs from head to toe - while Nuba women simply slapped on the appropriate colour of their kinship group leaving them more time for their chores. This specific pattern is repeated throughout most traditional societies: as in the animal world, it is more often than not the males who are the exalted, elaborately decorated peacocks.

Body painting (the world's first art form?) turns human skin into a three-dimensional canvas. The transitory nature of such decorations allowed our ancestors to become the first animal which could, unlike the leopard, change its spots. Aside from the aesthetic potential of such decorations, they also soon acquired a communicative

function - their depiction of animals or seemingly abstract patterns, the choice of particular colours and so forth a sort of 'storyboard' of ancient myths and a schematic representation of tribal values, beliefs and organisation. By means of body painting (and, in time, the other body arts) humankind was set apart from the rest of the animal world, neighbouring tribes became visually distinct and individual personal differences within each tribe were 'colour coded' for instant identification.

While the permanent body arts like tattooing, scarification and piercing have a special role to play in marking life's irreversible changes (like the moment a young man or woman becomes a fully fledged member of society) here-today-and-gone-tomorrow body painting also has its unique role to play. For example, the action of applying elaborate, time-consuming designs can serve to underline the significance of special ritual events or festivals - driving home the point that such occasions are set apart from the everyday and the mundane.

Also, the transitory nature of body painting makes it ideally suited to mark out the stages of personal development. Thus, amongst the already mentioned Nuba of the Sudan, particular age grades (groupings of those of a similar age) of males are immediately identifiable by the colours with which they paint their bodies (only the members of the older age grades, for example, being allowed the use of deep yellow or jet black). Finally, because such colours and patterns can be easily removed, they can be employed as 'warpaint' - deliberately transforming the warrior temporarily into a terrifying and horrible being in order to strike fear in the heart of an enemy.

Clothing - whether for protection from the elements or for modesty - is the natural

enemy of body painting for obvious reasons. At the same time, however, clothing tends to focus attention on whatever parts of the body remain uncovered and these - typically the face, hands and feet - are often decorated with special care.

This is certainly the case in our own society where eye make-up, powder and lipstick celebrate the feminine face while bright nail varnish may draw attention to the hands and feet. But only for women. While we share with many clothing-wearing societies in rendering huge parts of the body invisible, only our own society has so fully reversed the peacock principle to the extent that we define make-up as an exclusively feminine body decoration. (Interestingly, perhaps because of the pain involved, the permanent painting of the body - that is, tattooing - has tended to escape this woman only ban; in fact reversing the proportion of male and female involvement.)

The assumption that only women can paint themselves wasn't, of course, always held in the West. Right up to the time of the French Revolution, the upper-class men of Europe, Britain and America delighted in painting and preening. It has been argued by J.C. Flugel in **The Psychology of Clothes** that the subsequent 'Great Masculine Renunciation' of make-up and other adornments occurred as a response to the French Revolution - a means by which the sober, respectable middle-class could distance itself from the frivolity and excess of the now suspect aristocracy. Whatever the reason, this extraordinary shift away from what must be considered a natural, universal human drive to decorate the body, has left the Western male in a uniquely dull, aesthetically frustrated, almost invisible position. And one

which, as Western habits become the norm throughout the world, threatens the male peacock with extinction.

Even women's make-up in the West has rarely achieved the level of creativity so often found amongst tribal peoples (or, for that matter, of the ancient Egyptians many thousands of years ago). This is because make-up in the West - at least that of mainstream fashion - has typically served a cosmetic rather than an artistic purpose. That is, as with our cosmetic surgery, (see Chapter 8) the ideal sought is often one of invisible enhancement; an improvement of a person's actual face so that it more perfectly emulates a current fashionable ideal of physical beauty.

Thus lips and cheeks may be given a rosier glow, small eyes made to appear larger, a large nose made to appear smaller, the overall contours of the face invisibly sculpted and skin blemishes concealed. While it is true that the make-up and body paint of tribal peoples (with the exception of 'warpaint') are seen as aesthetically enhancing, the objective of invisibility is rarely if ever sought. Perhaps, the tribal person, by lifestyle inherently close to the environment, finds pleasure in a distancing from nature by means of deliberate artifice while we, living estranged from nature, seek the opposite effect.

But there are exciting exceptions to this Western preoccupation with make-up as invisible enhancement. Particularly interesting in this regard are several youth-oriented subcultures which have emerged in recent decades. The psychedelic patterns and flowery designs of the Hippies' make-up (and, in some instances, body painting) were clearly intended to be seen as a form of art which used the body as a canvas. Glam Rockers like David Bowie or Marc

Bolan (and a great many of their fans) further challenged traditional Western visual style - in the case of Bowie's famous **Aladdin Sane** album cover, slashing his face with vibrant red and blue. The same can be said of the adventurous make-up of the Punks which was 'primitive' not only in its graphic aesthetics but also in its intent - a celebration of body adornment as a creative art and a medium of visual experimentation. If only for a few brief moments in our history, these subcultures revived that ancient tradition of using paint to transform the human body into fantasy.

The Hippies, the Glam Rockers and the Punks were also important in that they strove to over-turn 'The Great Masculine Renunciation' of body adornment, deliberately ignoring that peculiar Western assumption that only women can indulge in flamboyant decoration, male Hippies, Glams and Punks re-discovered their potential as peacocks.

While these particular subcultural experiments in masculine adornment may have come and gone, new possibilities present themselves from what one would have thought was an unexpected quarter - the football terraces. It is now commonplace to see football fans at particularly important matches with their faces brightly coloured in bold styles

which are reminiscent of tribal male body artists like the Nuba of the Sudan. Significantly, these modern tribalists, aside from re-asserting their right to decoration, have also re-discovered body painting's ancient function as a marker of special occasions and a badge of group identity.

Cherie:
My boyfriend and I had an evening at home alone last night and ... this is what happened. He was supposed to do my hand but he decided to practise on himself first so I got tired of waiting and did my own. What's that saying? Oh yes, you know the one about idle hands and the Devil. This stuff takes weeks to wash off.

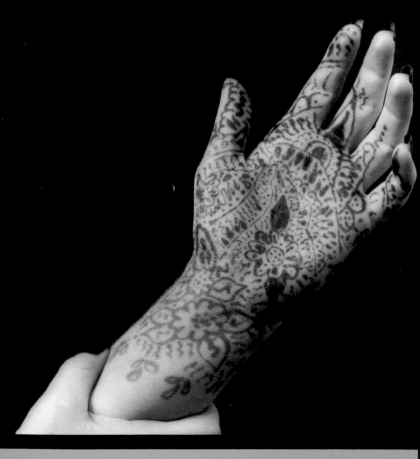

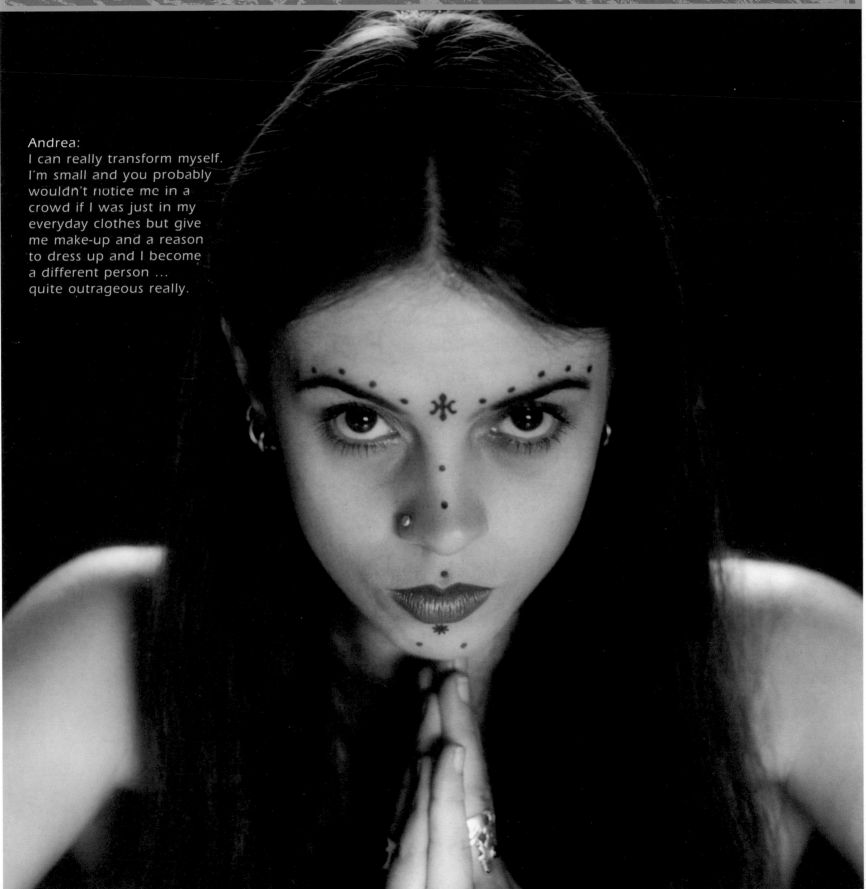

Andrea:
I can really transform myself.
I'm small and you probably
wouldn't notice me in a
crowd if I was just in my
everyday clothes but give
me make-up and a reason
to dress up and I become
a different person ...
quite outrageous really.

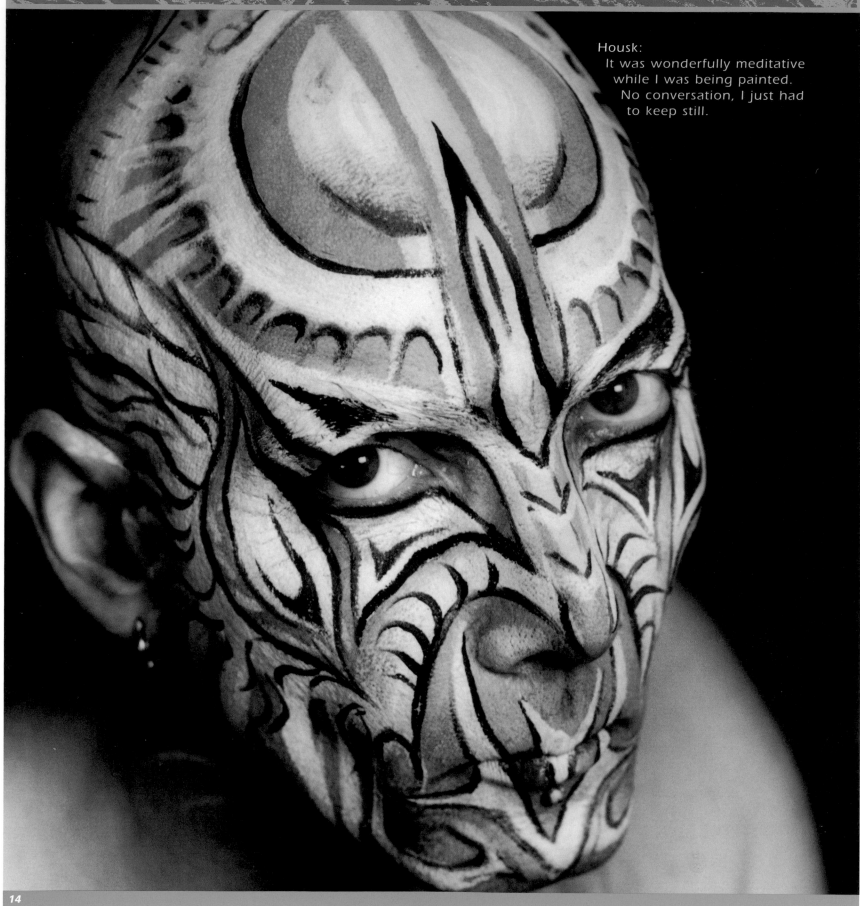

Housk:
It was wonderfully meditative while I was being painted. No conversation, I just had to keep still.

Isa:

My God, this is taking forever! Please excuse me, I have so little patience … is it finished? Let me see. Oh, but this is really me! There is a serpent inside that can show itself when it needs to, this is very good!

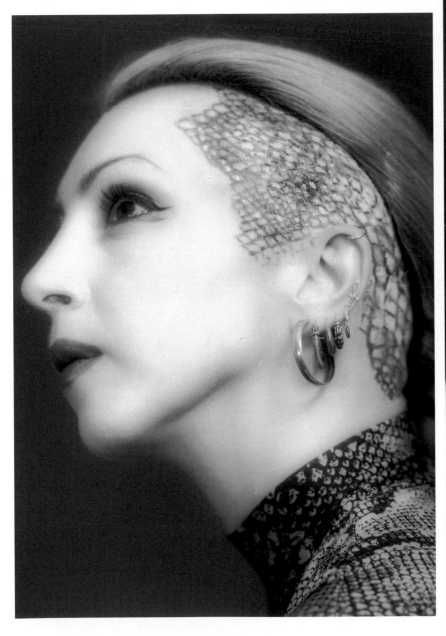

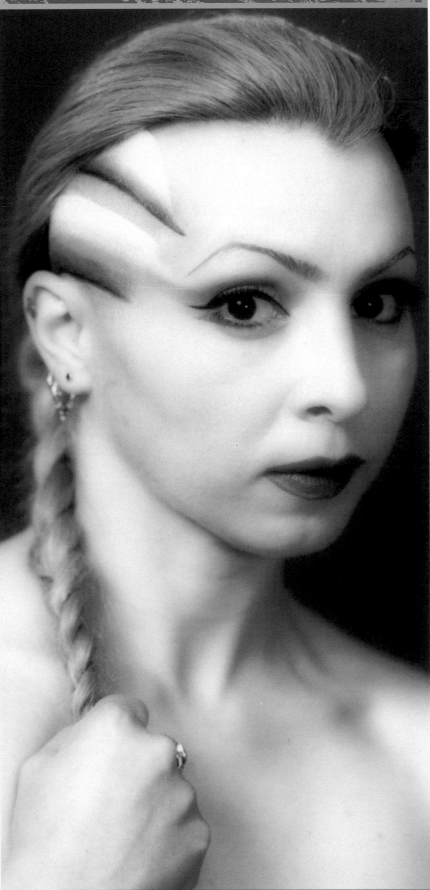

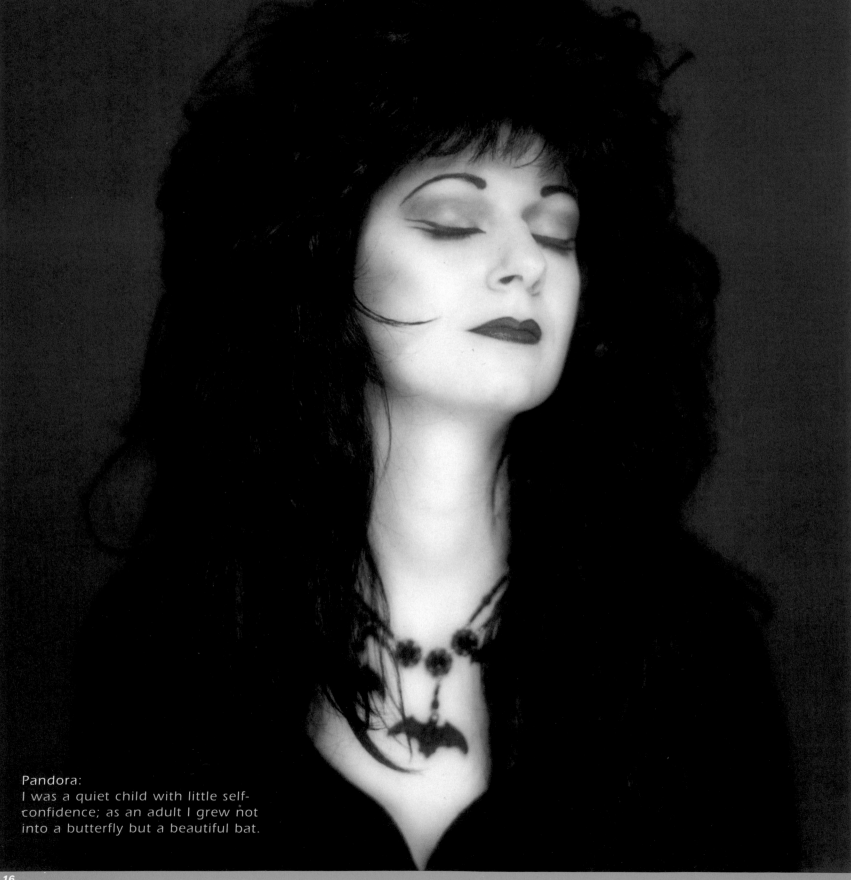

Pandora:
I was a quiet child with little self-confidence; as an adult I grew not into a butterfly but a beautiful bat.

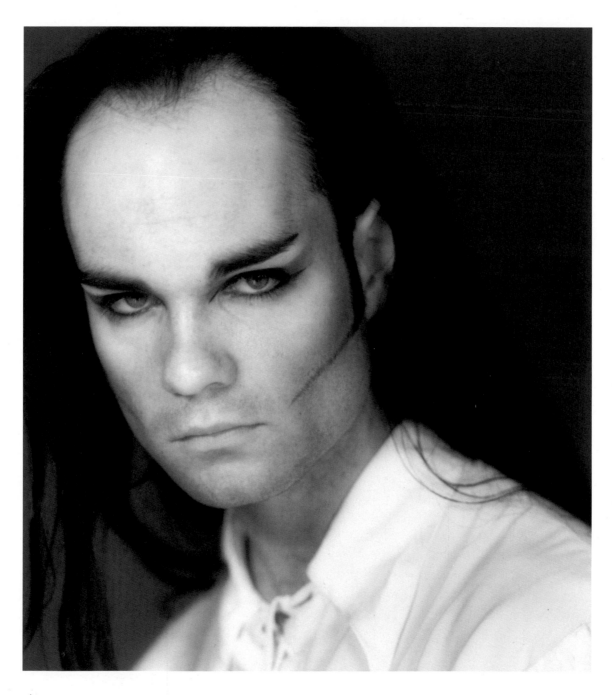

Joe:

As strange as this sounds I'm ashamed to be human sometimes and my look is a form of disassociation. I'd rather be a vampire creature than a person. I look like this all the time to remind myself not to slip into the uncaring, abusive ways of most people.

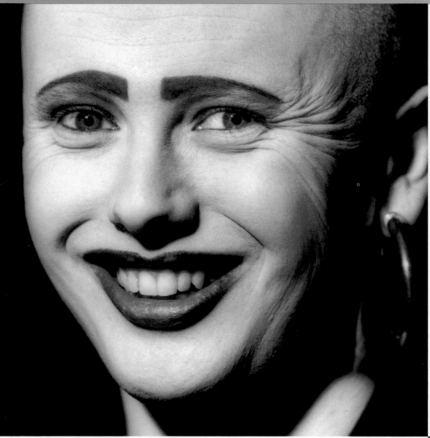

Richard:
This is my homage to the tough girls and SM dykes I love so much. It's great fun, though I don't know how long I'll do it for. When I went down to the clubs all the girls fell about, they almost didn't recognize me.

Sam:
Whew! I feel like I'm in drag. I don't normally wear glam make-up but this was fun ... weird, but fun. I don't recognize myself, who is that person?

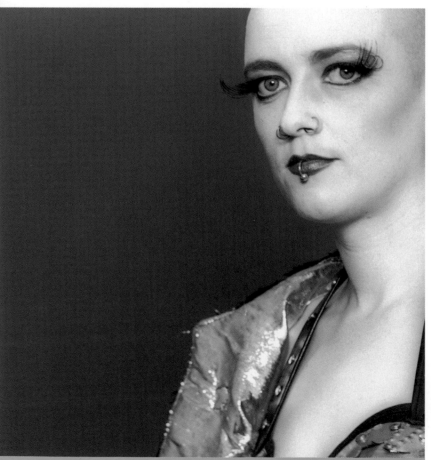

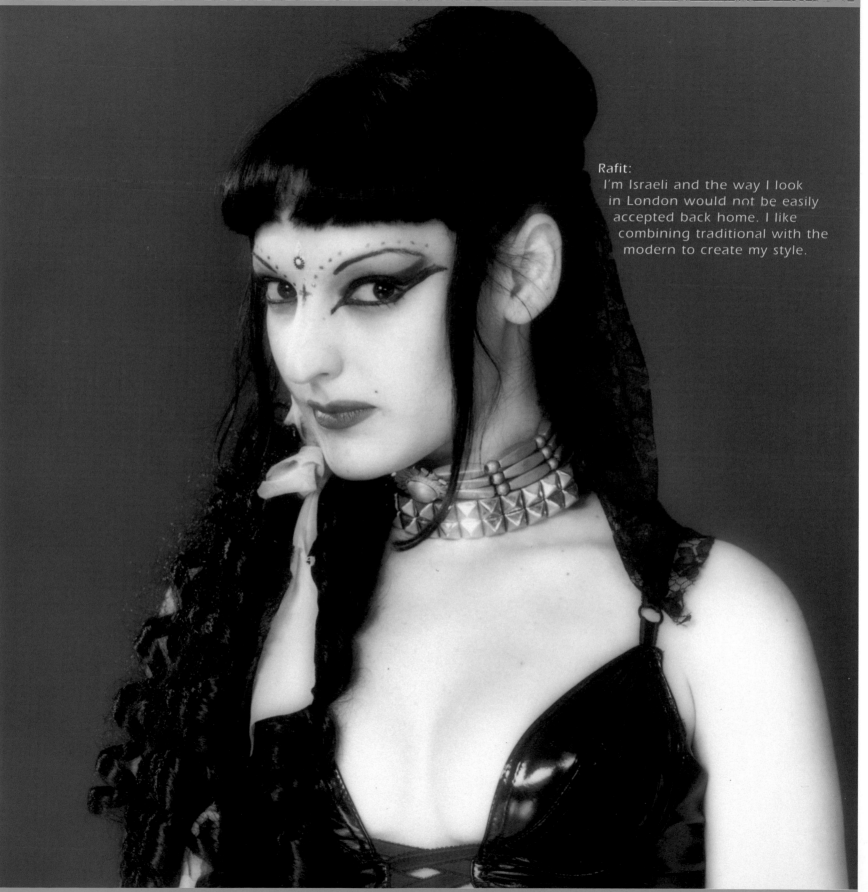

Rafit:
I'm Israeli and the way I look in London would not be easily accepted back home. I like combining traditional with the modern to create my style.

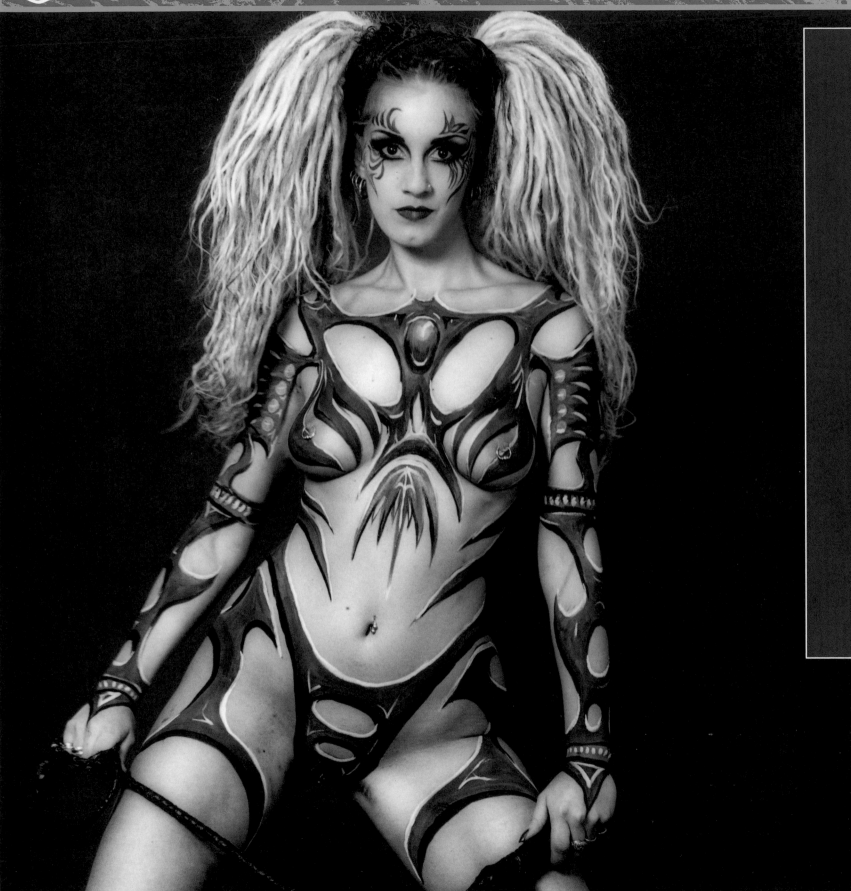

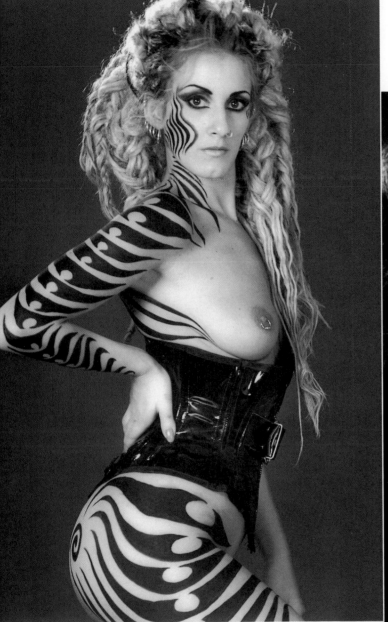

Simon:
What I like most of all about body painting is … other people's bodies! Skin is wonderful and it might as well be different colours if it can be. Give me flesh … it's so much fun.

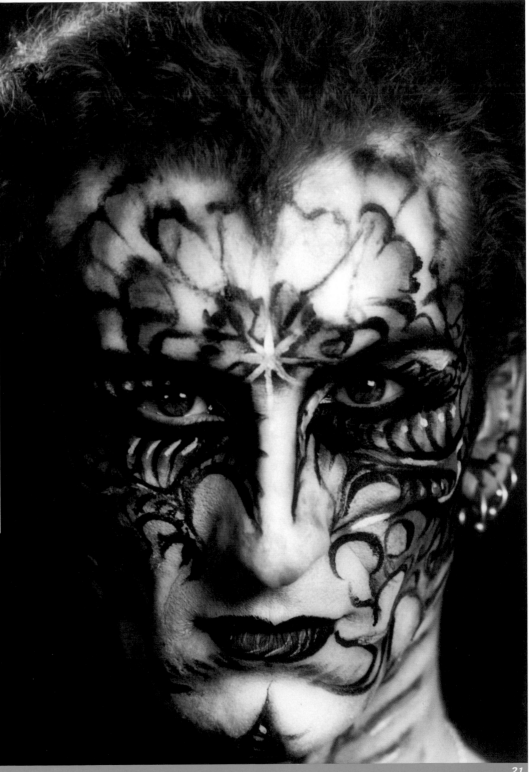

Sarah:
I was at a club a while ago and I had been painted earlier, I was only wearing a jacket. Things got hot, as they do, and I removed the jacket. No-one realized I was nude … at first. Then, as the men became very chatty, I noticed that all the women were blanking me - interesting experience. I never felt vulnerable because the designs painted on me kept me from feeling truly nude. I did feel very powerful and attractive.

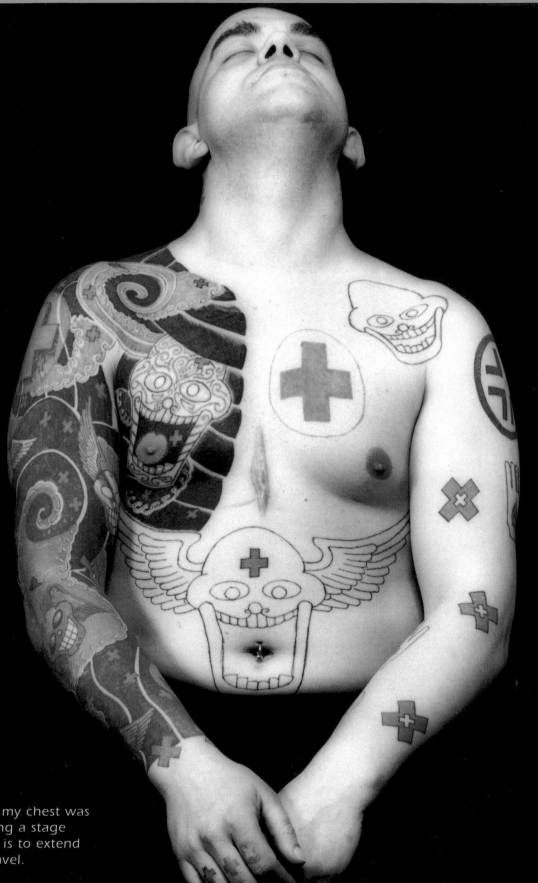

Franko B:
The scar in the centre of my chest was deliberately created during a stage performance; my fantasy is to extend it from my neck to my navel.

TATTOOING & SCARIFICATION

A permanent body art, a tattoo is created whenever pigment is injected into (rather than on top of) the skin. No doubt the first such markings were made accidentally when, for example, soot got rubbed into a cut. Our early ancestors could have then deliberately reproduced the effect using a sharp splinter of antler or bone dipped in a vegetable or fruit dye. Accuracy and efficiency could be enhanced by attaching such a needle (or cluster of needles) to a pole which could be pushed or tapped with another stick into flesh. Alternatively, as amongst the Eskimos, a sooty thread could be 'sewn' through the skin using a needle.

The only significant modification of these ancient techniques came in 1891 when 'Professor' Samuel O'Reilly patented the 'tattaugraph': the precursor of today's electric tattooing machines which insert needle and ink into skin at between 500 and 600 strokes per minute. (Prisoners have been known to make crude but effective copies of this device using a BIC pen, piece of wire and a motor from a portable cassette player.) It was, however, the more ancient 'tat-tat' of two sticks which apparently inspired the Polynesian word **ta** (meaning, to strike or hit) which (via Captain Cook) eventually became **tattoo** in English (**tatouage** in French, **tatowirung** in German and **tatuaggio** in Italian).

Because it is usually only the bones and not the skin of our more distant ancestors which have survived the full antiquity of tattooing is impossible to ascertain. The oldest surviving complete human body is that of the 'Iceman' discovered only a few years ago frozen in a glacier in the Alps. Some 5000 years old, this Neolithic hunter's body has 15 tattoos including rows of short lines to the right and left of the spine, parallel stripes around the left wrist and a large cruciform mark on the inside of the right knee. Two female Egyptian mummies from the XI Dynasty (2160-1994 BC) - Amunet, a priestess of the goddess Hathor and an anonymous dancer - have abstract patterns of dots and dashes tattooed on their bodies (the former with an elliptical pattern running across her abdomen beneath the navel). The 2500-year-old body of a Scythian chief found in Pazyryk, Siberia in 1948 (preserved by the constant cold of his burial place) has extraordinary animal tattoos on his arms, chest, back and lower legs. The breathtaking, colourful graphic clarity of this chief's designs - and in particular the skill with which their placement fits with the natural contours of the body - would be the envy of any tattoo enthusiast today.

Such accidental or deliberate mummification cannot, however, tell the whole story. Any human activity which is as geographically widespread as tattooing - virtually covering the globe and appearing in places unlikely to have been historically linked - must be very old indeed.

To appreciate the true antiquity of this body art it is necessary to appreciate its logic. Our ancestors were traditional peoples - wary of change, determined to preserve the status quo - and the permanent alteration of appearance made possible by the discovery of tattooing was (and is) perfectly suited to such a lifestyle. For example, the permanence of a tattoo could reflect the permanence of a rite of passage which marked (literally) a young man or woman's coming of age and lifelong membership in a tribe. While our modern world may celebrate change and impermanence with the ephemeral, here-today-gone-tomorrow cycles of fashion, traditional societies are naturally drawn to those body arts like tattooing which resist the transitory and underline enduring stability.

It should come as no surprise, therefore, that so many traditional societies perfected tattooing into an elaborate, often exquisite, art form. Perhaps most famous of these aesthetic traditions is the delicate, facial swirls of the New Zealand Maori whose designs were actually chiselled into the face. But just as extraordinary are the distinctive tattooing styles found throughout the Pacific (in particular, Samoa, the Philippines, the Marquesas, Hawaii, Borneo and Melanesia) and the body adornment of the Arapaho, Mohave, Cree and Eskimo peoples of North America. Ceramic figurines from Neolithic Japan have mouth tattoos similar to those worn by Ainu women until recent times and the detailed, whole body style of Japanese tattooing which flourished in the Edo Period (1600-1868) and which survives to this day is considered by many to be the epitome of the tattooist's art. In Central America the Incas, Mayas and Aztecs all developed sophisticated tattooing styles while the same was true in Europe of the Iberians, Gauls, Goths, Teutons, Picts, Scots and the Britons who, like the Picts, derive their name from their stunning body adornment. (**Pict** probably coming from a Celtic word meaning 'etched' and **Briton** from the Breton word **Breizard** meaning 'painted in various colours'.)

Indeed, with the exception of the ancient Greeks and Romans, most Europeans - like the 'Iceman' before them - used tattooing to customize their bodies. This was true of the early Christians as well and even many of the Crusaders returned home with tattooed trophies of their conquests. This attitude persisted until 325 A.D. when Constantine, declaring Christianity the official religion of the Holy Roman Empire, forbade tattooing of the face because it disfigured 'that fashioned in God's image'. In 787 AD Pope Hadrian banned tattooing anywhere on the body on the same grounds. Then, when the spirit of modernism flowered in the Renaissance - celebrating change and progress - it promoted interest in ephemeral fashion and, for the first time in human history, undermined the desirability of permanent body adornments like tattooing.

Nevertheless, those Westerners directly exposed to the tattooing arts of traditional peoples - for example, sailors - found the allure of such decorations irresistible. So did many

aristocrats including Queen Victoria's grandsons ▮ George and Prince Albert and also the future Nicolas II of Russia who all travelled to Japan in order to have themselves tattooed. The ever-growing ranks of the Western middle classe ▮ however, continued to show disdain for tattoo ▮ vehemently labelling it as 'barbaric' and, worst of all, 'common'.

Ghettoized and stigmatized in this way, tattooing in the West became associated with the disreputable, the criminal and the freakish. Certainly in such conditions the odds were stacked against it developing as an art form. Yet despite this the 1960s saw the beginnings of a 'Tattoo Renaissance' which reflecting a new awareness of and respect for non-Western cultures in general) has forced a new appreciation in the West of the aesthetic possibilities of this form of body decoration. Pioneering American tattooists like Cliff Raven and Ed Hardy had seen at first hand what could be achieved in Japan, Hawaii, Samoa and other traditional centres of tattooing excellence and they brought back to the West a new, enlightened perspective.

While Western tattooing had degenerated into a kind of haphazard graffiti with hackneyed hearts, sailing ships and bluebirds placed willy-nilly all over the body, the Japanese and other masters of the art showed how the three-dimensional nature of the body could be utilized rather than ignored - carefully sculpting their designs around the contours of the body. And because many of this new generation of tattooists had trained as artists they were in a position to get away from simply re-using pre-existing 'flash' designs - working together with their clients to create the unique and innovative. When famous pop stars like Janis Joplin proudly displayed such tattoos even their middle-class and university-educated fans followed in their footsteps. Suddenly it was cool to have a tattoo.

Two other changes in the West - ironically con-

tradictory - have underlined this trend. On the one hand the growing conformity of our consumer society has generated a need for individual expression - a need which can be satisfied by a unique, personal tattoo. On the other hand, our new 'tribalism' (from Hells Angels to Hippies, Punks to Modern Primitives) has brought us full circle back to that world of our most distant ancestors where a tattoo perfectly expresses group commitment and belonging.

However, while the West has been re-discovering the art of the Tattoo, it has been disappearing in those traditional societies where it originally flourished. Generations of Western missionaries have unfortunately done their job only too well - succeeding in most instances in getting native peoples to 'modestly' cover themselves with clothes and to reject ancient forms of body decoration which 'mutilate' that which was created in God's image. Ironically, therefore, it is increasingly in the West, within the context of the 'Tattoo Renaissance', that Samoan, Hawaiian, Maori, Filipino, Iban, Dyak and other traditional tattoo styles are being preserved and developed.

The one part of the world where tattooing has never thrived is Africa. This is of course because heavily pigmented skin doesn't show up traditional tattoo dyes effectively. Instead, Africa has seen the development of the art of scarification - that is, the creation of patterns on the skin by means of cutting. These may be 'hollow' or 'raised'; the latter achieved by means of rubbing an irritant such as ashes, charcoal or indigo into the wound in order to create a more prominent scar (keloid) or, occasionally, by inserting pebbles or other objects within the wound.

Such body decoration may consist of anything from small designs on the face to amazingly complex patterns all over the body. Very often, as with tattooing, such scars are acquired at key, transitional moments of life - thereby marking out personal development

and identity. For example, amongst the Nuba of the Sudan a young girl receives her first set of scars (covering the area between navel and breasts) when her breasts first begin to develop. The rest of the torso is covered when she has her first menstruation and the final set (on the back, the back of the legs, arms and neck is created when her first child is weaned. (The patterns of hundreds of round scars are achieved by using a hooked thorn to raise the skin and a blade to cut off the raised flesh beneath the thorn.)

While few Westerners seem to find such decorations attractive, in the eyes of those Africans (or dark-skinned Australian aborigines) raised in traditional cultures where scarification is the norm they are an essential component of beauty - an attractiveness and erotic enhancement experienced by means of touch as well as sight. Additionally, as amongst the Baule tribe of the Ivory Coast such scars may be seen as the very mark of civilization - that which distinguishes between those who do and do not live their lives with dignity and correctness.

Unfortunately the art of scarification is fast disappearing, with some African countries actually passing laws to ban it. Even where things have not gone this far most young people - eager to move to the cities and leave tribal ways behind - have shunned scarification. And while, as we have seen, traditional tattoo styles have been given a new lease of life within the West, there has, at least to date, been no equivalent 'Scarification Renaissance'. A few adventurous 'Modern Primitives' have experimented with scarification, but many of the resulting designs have been 'primitive' in more ways then one. And so, while traditional tattooing seems set to survive and even thrive, traditional scarification looks set to disappear. In the process the customized body will become a more purely visual phenomenon, its tactile possibilities lost forever.

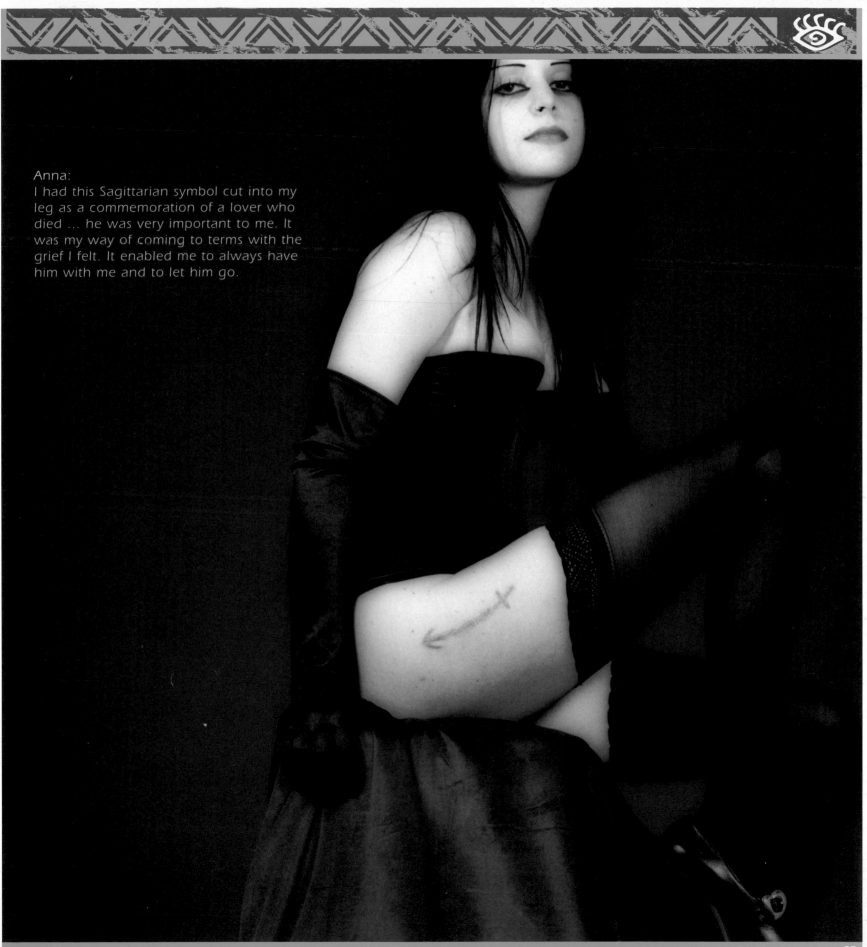

Anna:
I had this Sagittarian symbol cut into my leg as a commemoration of a lover who died ... he was very important to me. It was my way of coming to terms with the grief I felt. It enabled me to always have him with me and to let him go.

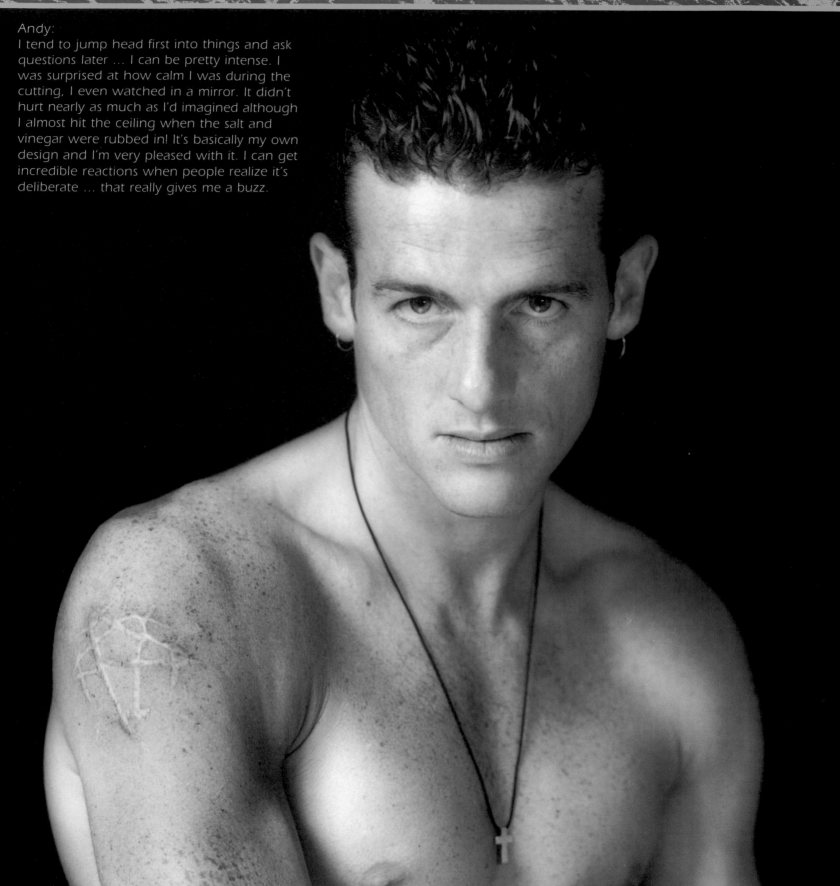

Andy:
I tend to jump head first into things and ask questions later … I can be pretty intense. I was surprised at how calm I was during the cutting, I even watched in a mirror. It didn't hurt nearly as much as I'd imagined although I almost hit the ceiling when the salt and vinegar were rubbed in! It's basically my own design and I'm very pleased with it. I can get incredible reactions when people realize it's deliberate … that really gives me a buzz.

Blue:

My first tattoo was a little dagger and heart on my ankle. I was 18 and feeling dark, gothic and depressed, as you do. I was out of touch with myself and quite insecure but the tattoos have given me strength … they've been a rite of passage for me. To be a woman and highly tattooed takes considerable courage and for me to be able to deal with people's reactions has required that I discover that in myself. Another important aspect is my need to keep the design un-unified, so to speak. I'm not completely sure why but part of the reason is the very fact of so many people telling me not to go on until I have an overall vision for my body … I can be really stubborn.

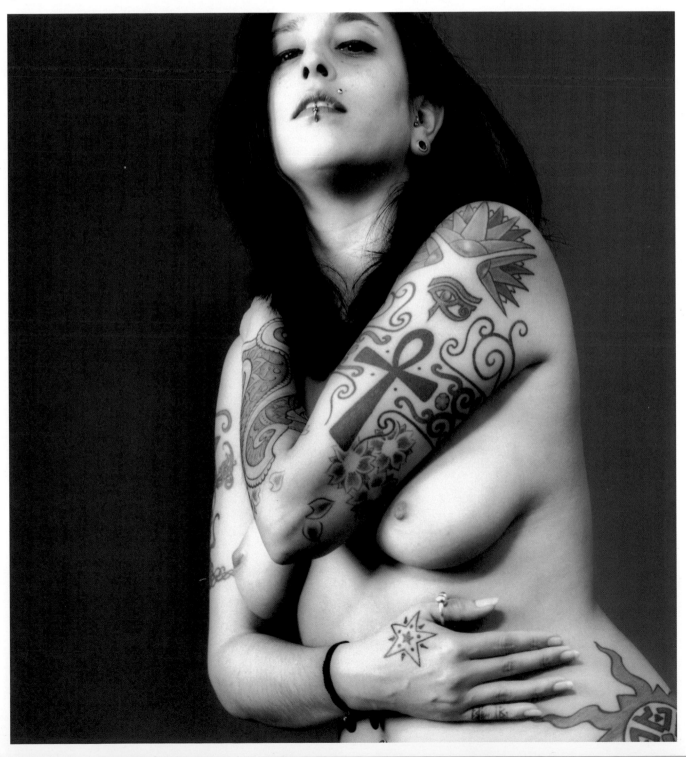

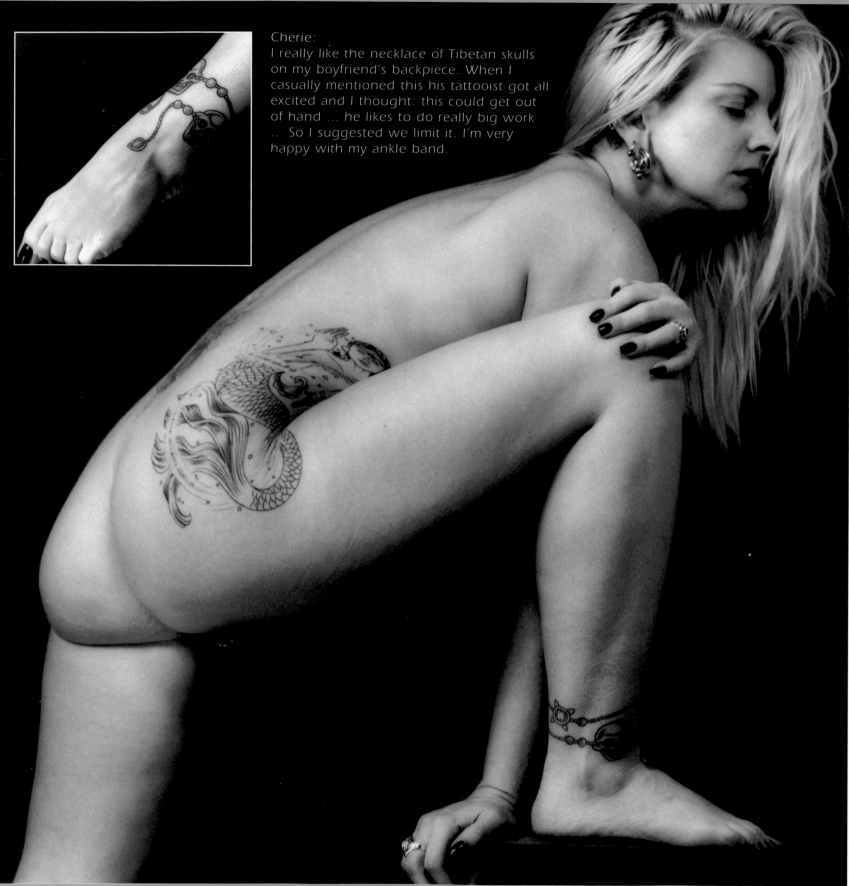

Cherie:
I really like the necklace of Tibetan skulls on my boyfriend's backpiece. When I casually mentioned this his tattooist got all excited and I thought: this could get out of hand … he likes to do really big work … So I suggested we limit it. I'm very happy with my ankle band.

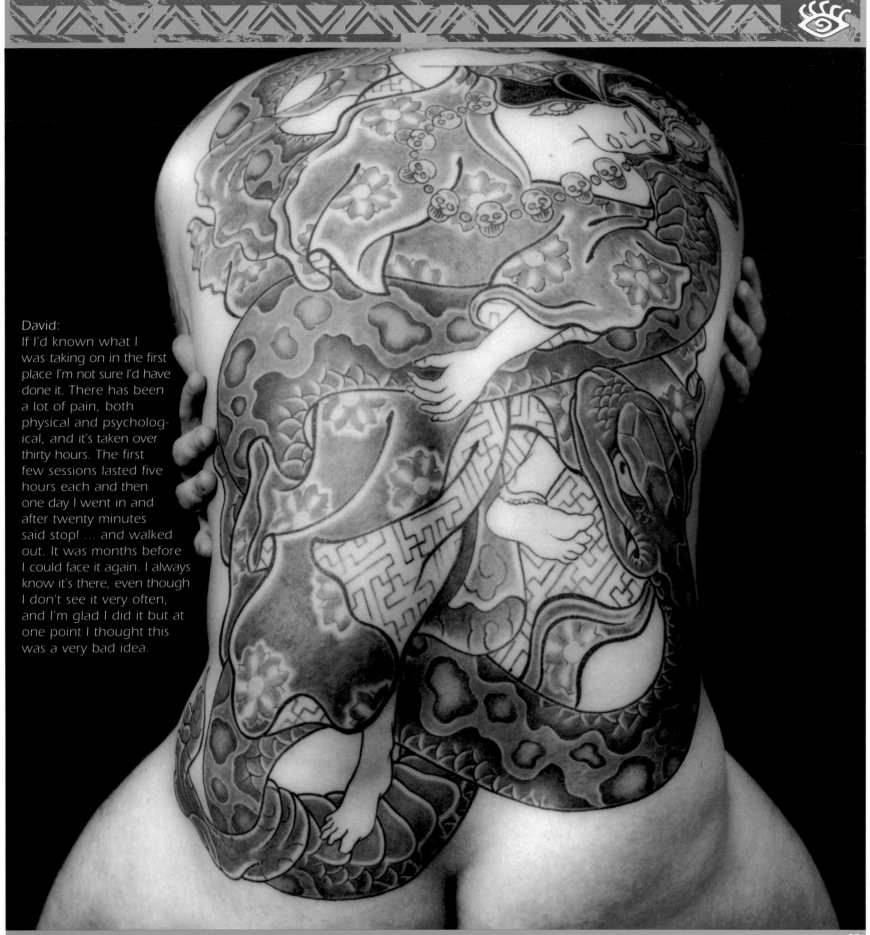

David:
If I'd known what I was taking on in the first place I'm not sure I'd have done it. There has been a lot of pain, both physical and psychological, and it's taken over thirty hours. The first few sessions lasted five hours each and then one day I went in and after twenty minutes said stop! ... and walked out. It was months before I could face it again. I always know it's there, even though I don't see it very often, and I'm glad I did it but at one point I thought this was a very bad idea.

Dave:
My scarification was done on stage. I was mummified and upside down. Once the cutting began I lost all sense of time ... it was the most painful thing I've ever done ... but I felt great afterwards, filled with a sense of strength and completion. Although I do these things more often than some, make no mistake, it never stops being frightening. For me, these rituals demonstrate how, as people, we only know differences ... happiness because we've felt sadness, comfort because we've known pain.

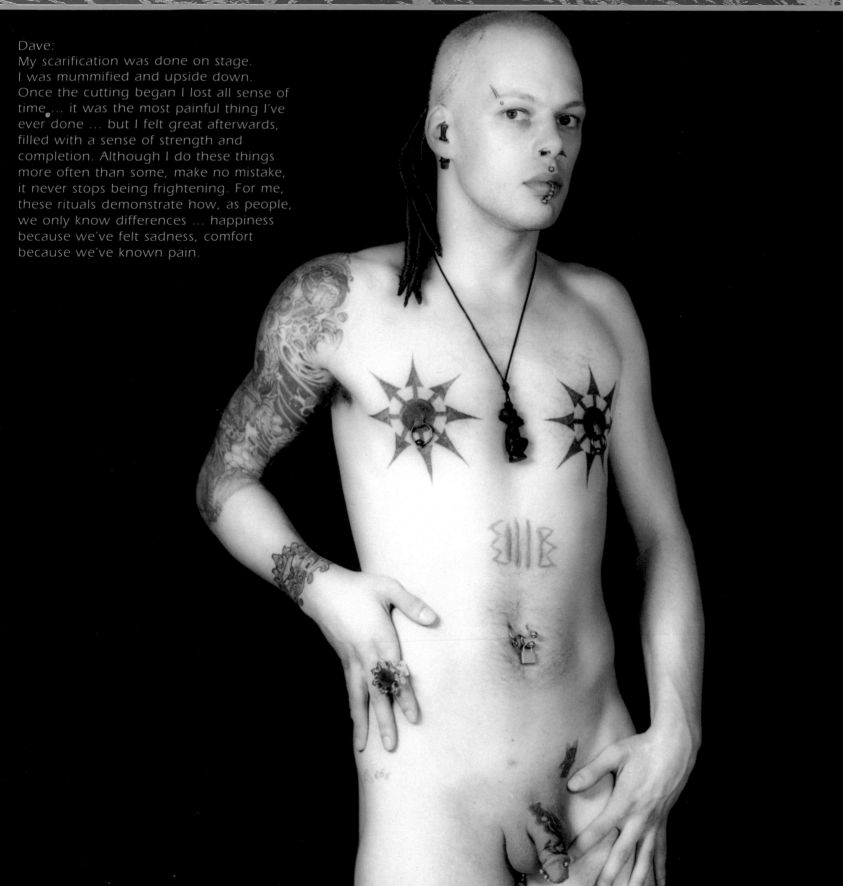

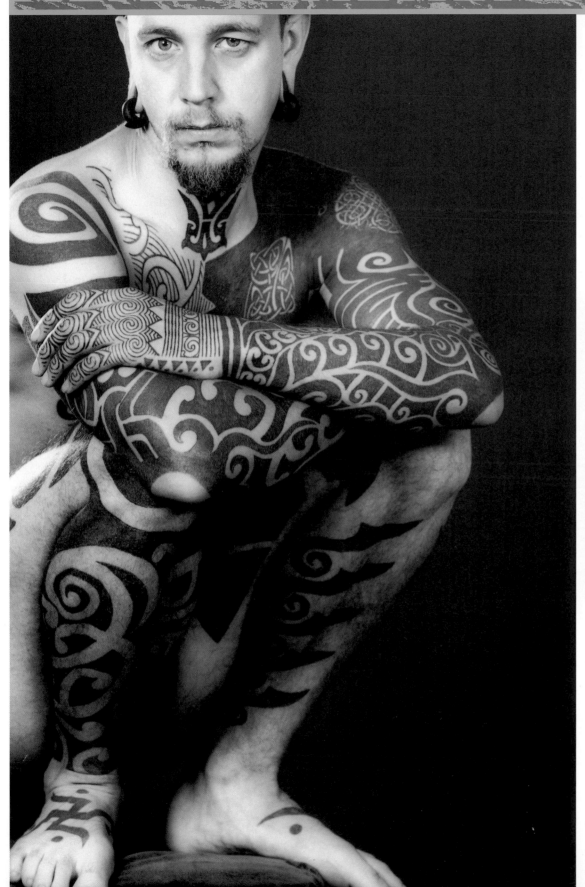

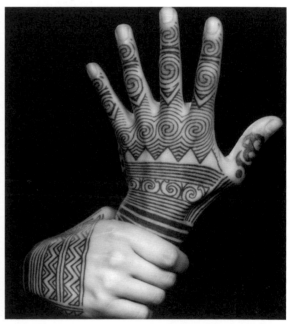

Curly:

It took a fair old while to get rolling but when I did ...! It can be hard to explain why one goes through this sort of behaviour but a part of it is my need to be separate. I know that sounds silly when there are so many other tattooed and pierced people but that's the main truth of it. I began by drawing tattoo designs for other people and then decided to cut out the middle man. Things really got going once I started to tattoo myself. I've done my legs, arm, left hand, ribs, stomach and nipples ... it's not the highest quality but the designs are good enough to carry it.

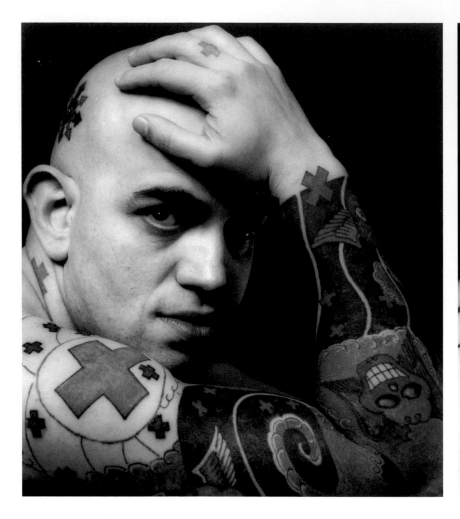

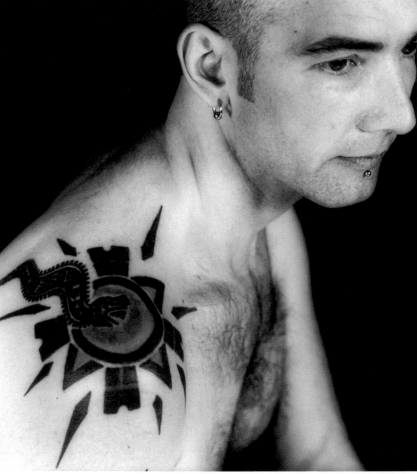

Franko B:
I was raised at The Red Cross Institute for
Battered Children and consider myself
one Life's refugees.

Housk:
This tattoo is a visual representation of
my life's' path. The snake and sun are
Aztec designs - I'm half Mexican - symbol-
izing rebirth and wisdom through the
undergoing of suffering and near-death
experience. It can be read not only as a
passage from darkness to light but also
as a symbol of sexuality and life ... the
sperm into the ovum.

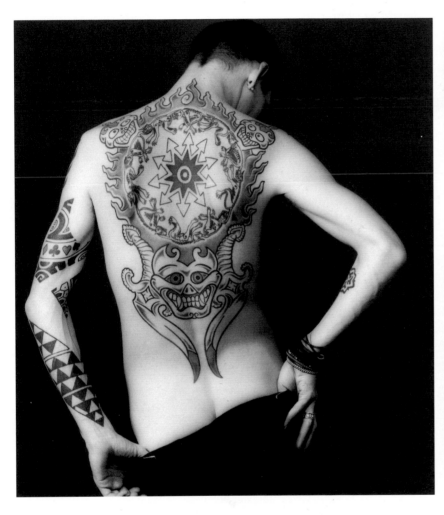

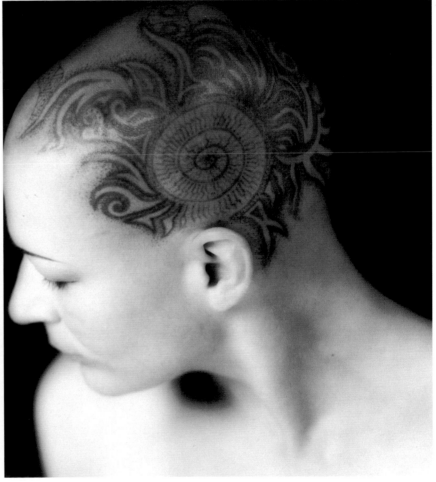

Mark:
People say that certain parts of the body are more painful to get tattooed than others. Well, guess what? ... it all hurts! I like the grinning Tibetan skulls on my back the most. I guess you could say they represent my view on things, sort of smiling in the face of death ... a sense of humour as the saving grace.

King:
I'm not interested in being a "tattooed lady" but I wanted something special and I trusted the skill of my tattooist, he's a former lover. He did this by hand, not machine, and it evolved over the period of a year. I'd leave town, he'd leave town, and when we were in the same place we'd continue. It's a beautiful soft henna colour and if I get bored I can always grow my hair.

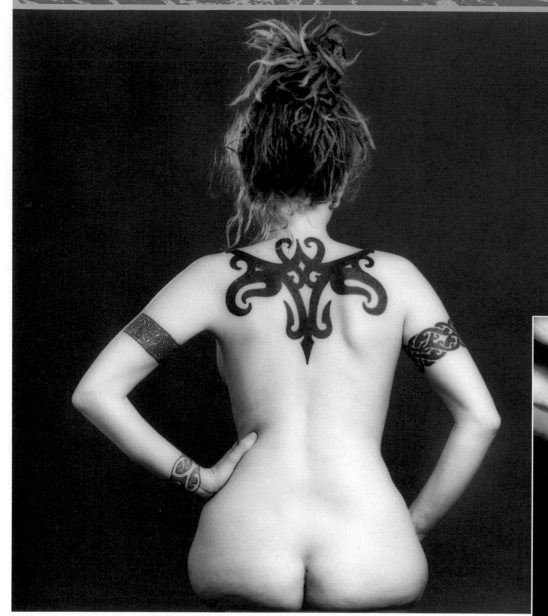

Michelle:
My mother's tattooed and pretty outrageous ... I used to be terribly embarrassed by her when I was young. Obviously, I've changed my mind and I seem to be following a similar path. Off the top of my head I don't think I have any deep inner reasons for my tattoos other than aesthetics but, having just said that, I'm about to contradict myself - I feel a real kinship with tribal societies and the way they used body arts to help knit them together as a community ... that really appeals to me. I miss that sense of closeness and bonding in our modern Western world.

Sally:
I went round to my tattooist to get one of my armbands finished and he'd mixed me up with someone else. Instead of a relatively petite design he had this huge backpiece ready to go. I was hell-bent on getting something so I had him shrink it down and put it on my neck. A lot of people have said that I'm spoiling myself, "You'd be such a pretty girl ... if you didn't have these!" But chances are if I looked like everyone else they wouldn't have even noticed me.

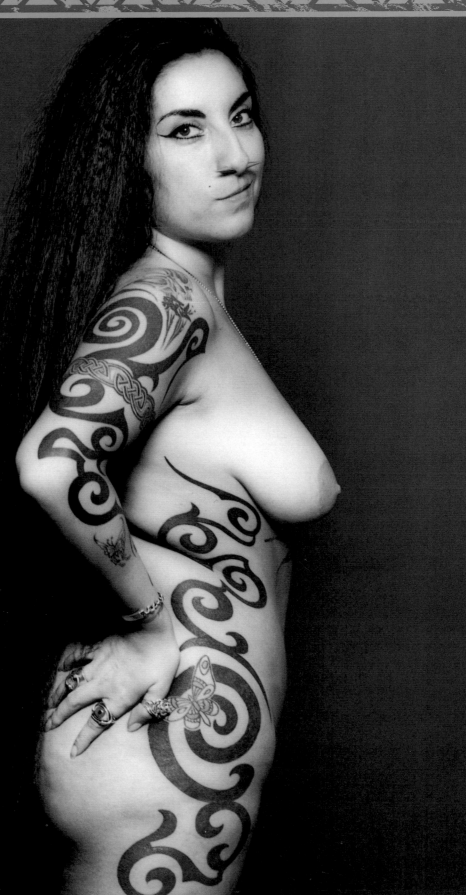

Tota:
I come from quite an aristocratic family but I'm a rebel and very independent. I earn my own living and do what I want ... sort of. My mother doesn't know I'm tattooed, she'd be too upset if she found out. I also live with a boyfriend who can't stand my tattoos or my piercings. What am I doing?

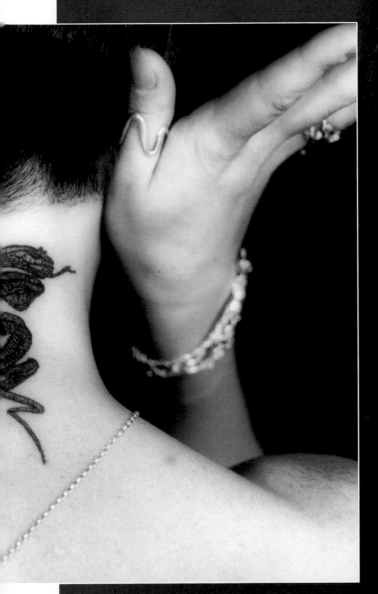

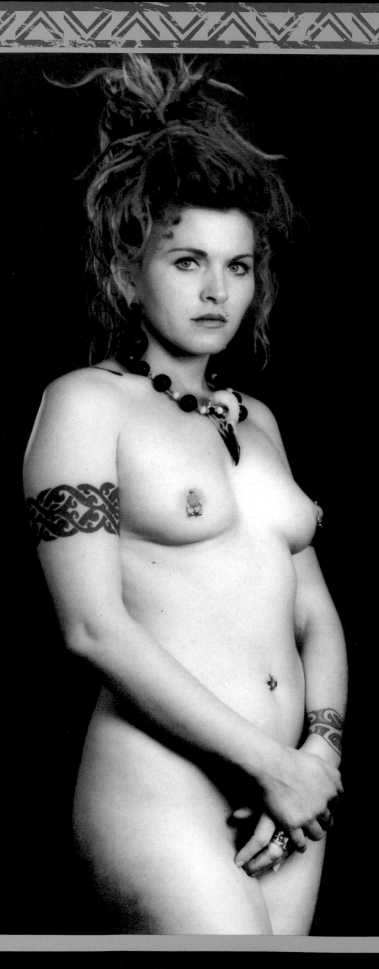

Michelle:
I look tribal, I feel tribal, I am tribal.

JEWELLERY & PIERCING

Not The Naked Ape, we are and always have been The Adorned Ape. It is part of human nature to take beautiful objects from our surroundings - flowers, leaves, feathers, stones, metals - and attach them to our bodies.

We do this either to make ourselves more attractive or because the ornament itself is seen as magically powerful (a talisman). Just as importantly, such objects can serve to convey information about us - our wealth (a diamond necklace, the precious shells worn by a native of New Guinea) or our status or role (a wedding ring, the huge feather headdress of a native American chief). Especially where clothing is not worn (our Western assumptions about modesty being a comparatively recent invention) adornment serves to identify and summarize an individual - to signal to others where he or she is 'coming from'.

Luckily the human body is an excellent medium for attaching things. The neck, the wrist, the waist, the ankle and the fingers all have a natural disposition to keep such attachments in place. So useful are these points of attachment and so strong the human drive for adornment that necklaces, bracelets, belts or rings are found in all human societies. Occasionally such adornments cannot be removed, as was the case with the enormous, very heavy bronze anklets which long served as a status symbol in the forested regions of equatorial Africa and which in some societies were traditionally forged around a women's ankles (a practice outlawed by the Liberian government in the mid-20th century).

Jewellery need not, of course, be made of metal. Long before our ancestors learned to hammer or cast malleable metals like gold or silver into desired shapes they were fashioning pebbles, shells, feathers, flowers and leather thongs into beautiful objects which they attached to their bodies. Typically, such decorations crafted by our most distant ancestors have disappeared without trace but such non-metal decorations are a valued part of life in all tribal and peasant societies and it is inconceivable that the same was not true throughout human history. (The 'Iceman' discovered recently preserved in a glacier in the Alps wore at his waist an ornamental leather tassel and a brilliantly white, polished marble bead with a hole cut through it to facilitate its attachment.)

In their eagerness to adorn their bodies with valued, precious and powerful objects our ancestors devised and perfected yet another technique for altering the appearance of the human body. Piercing - puncturing small holes in flesh for decorative purposes - is arguably the most widespread of all the permanent body arts. (Actually, technically, simple piercings are only a semi-permanent body art because they will usually heal over and disappear in time if their jewellery is removed.)

While the earlobe (seemingly existing for no other reason than that of piercing and the wearing of earrings) is no doubt the most popular site, the nose (either nostrils or septum) and the lips are also popular piercing sites throughout the world. And once such artificially made places for attachment were created the full scope of the human imagination was unleashed on finding and fashioning objects with which to adorn them.

Nor is this the end of the story as regards the possibilities of the piercing art. Once a small piercing has been made it can be stretched by inserting ever larger plugs or heavier adornments. In some instances (as with the huge, elongated earlobes visible on the mysterious statutes of Easter Island) the desired result is in stretching flesh into new, fantastic shapes. Alternatively, the aim is simply to make it possible to wear ever larger adornments. In either case the results can be truly extraordinary and must rate as one of humankind's foremost achievements in the customizing of the body.

Both in the Amazon and in West Africa - for example, amongst the Suya and the Sara peoples - examples can be found of lips which have been stretched to accommodate wooden plugs the size of saucers. What is astounding about these decorations is both the extent to which normal, everyday activities like eating or drinking have been (one would have thought) made extremely difficult and, secondly, the fact that such similar extreme decorations are to be found in two such geographically disparate locations. The most likely explanation is that the Amazonian and the African lip adornments represent parallel independent discoveries and developments. (And the same can presumably be said of the large labret plugs which many Eskimo peoples wore above or below their lips and the visually similar labret adornments found amongst the Lobi and Kirdi tribes of West Africa.)

The choice of which part of the body or face to decorate with piercing and jewellery often reflects a special regard for that feature or body part: a regard which, more than simply an aesthetic fascination, underlines a people's mythic, moral or spiritual views about human achievement and existence. For example, the enormous lip plugs of the Amazon tend to be found amongst those tribes where the art of oratory is highly developed and respected while the most startling examples of nose piercing found in New Guinea tend to occur in societies where smell is accorded great significance and where breath is equated with the life-force.

As with tattooing and other forms of permanent (or semi-permanent) body decoration, piercing has not traditionally been popular in the West. Only 30 or 40 years ago it was extremely rare to see any such decoration except for the occa-

sional woman with pierced ears. Everything else (and even ear piercing on men) was seen as suspect, 'barbaric' and 'primitive'.

Perhaps we still associate this technique of body modification with the so-called 'primitive' but what seems to have changed is that now a growing number of people in the West see the 'primitive' in a positive rather than a negative light. Arguably such a revaluation began way back with Rousseau, but in terms of people actually altering their lifestyle, attitudes and appearance it was only with the Hippies' emulation of native Americans or Asian peasants and the Punks' wholesale adoption of 'primitive' adornments and attitudes that this became more than simply a whimsical yearning after a long lost way of life.

Piercing is now without doubt the fastest growing form of body decoration in the modern world. Ultimately, the reason for this is a shift in attitude and a fundamental reappraisal of the deficiencies of our modern way of life (why, for example, do we as a culture no longer see the obvious values of a rite of passage ritual to mark a young person's coming of age?) but a few key individuals greatly assisted this process on its way. In America, Doug Malloy, Fakir Musafar and Jim Ward played a key, pioneering part (the latter as the founder of Gauntlet which made safe piercing jewellery readily available and the creator of the first regular piercing magazine, **Piercing Fans International Quarterly**). In the UK, Alan Oversby (Mr Sebastian) carried on Doug Malloy's original experiments - recently being charged with 'grievous bodily harm' by the British authorities for his efforts. Although not an original pioneer, Pauline Clarke in the UK deserves mention as the author of the most comprehensive book on the subject of piercing - **The Eye of the Needle** - which offers sound and valuable advice for anyone contemplating acquiring this form of adornment. By both reviving ancient practices and pio-

neering new ones, today's 'Modern Primitives' have created a huge repertoire of contemporary piercing possibilities. As well as multiple ear piercings, nostril, septum, labret (under the lip), eyebrow and navel piercings have all become a common sight on American, British and European streets. In the private sphere, genital and nipple piercings have become **de rigueur** in certain - ever growing - circles. Here, perhaps more than in any other area of body customizing, we see the extent of the 'Modern Primitive' revolution - the rediscovery

of ritual, of body arts previously condemned as 'barbaric' and, most importantly of all, of the fact that it is our bodies and what we do to them which define us as human beings. In an age which increasingly shows signs of being out of control, the most fundamental sphere of control is re-employed: mastery over one's own body.

Sarah:
I feel sexual and powerful with all of my many and varied piercings.

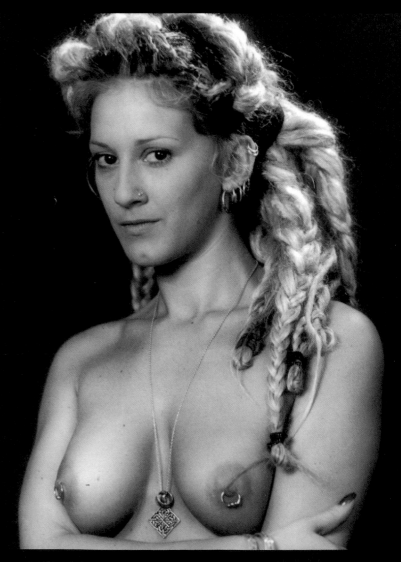

Alex:
My persona is based on transgression ... sort of Wake Up! This is reality, not the fairy tales you've been fed. I'll cut myself, pierce myself ... anything to get a reaction or provoke thought, dispel hypocrisy. You see, when I was young I based my decisions on facts given to me by the adults I knew ... They lied.

Ruth:
I've always identified with the monster, normality is so cruel. Western society provides strict guidelines governing how you're supposed to look and since inside I've always felt like an outsider I decided to visually look the part, too.

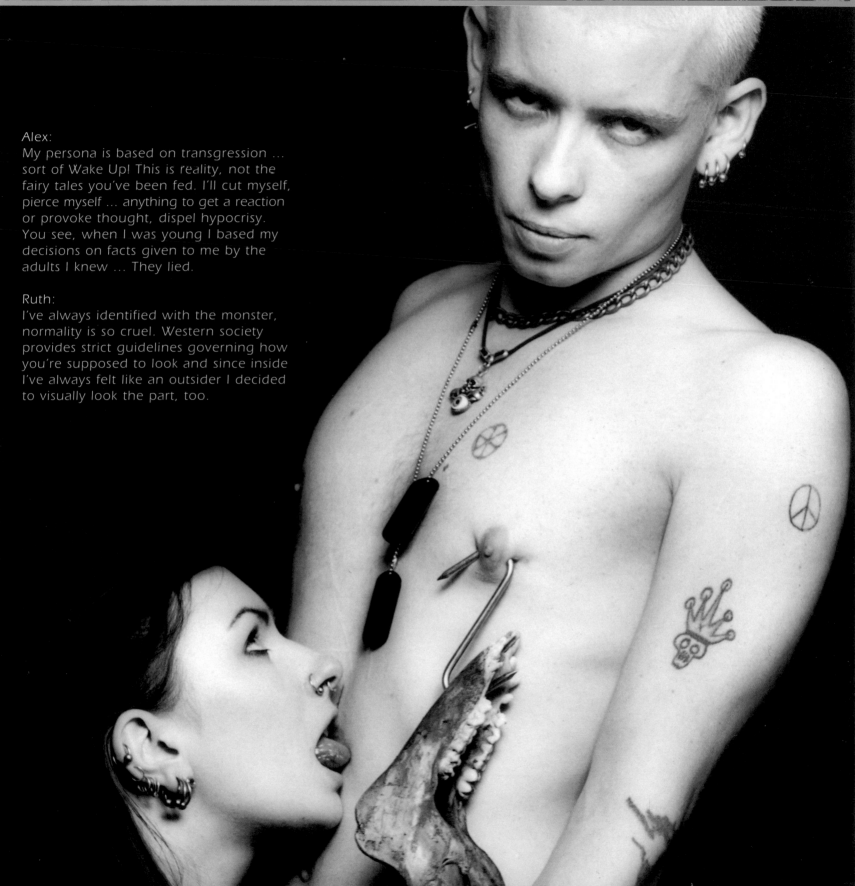

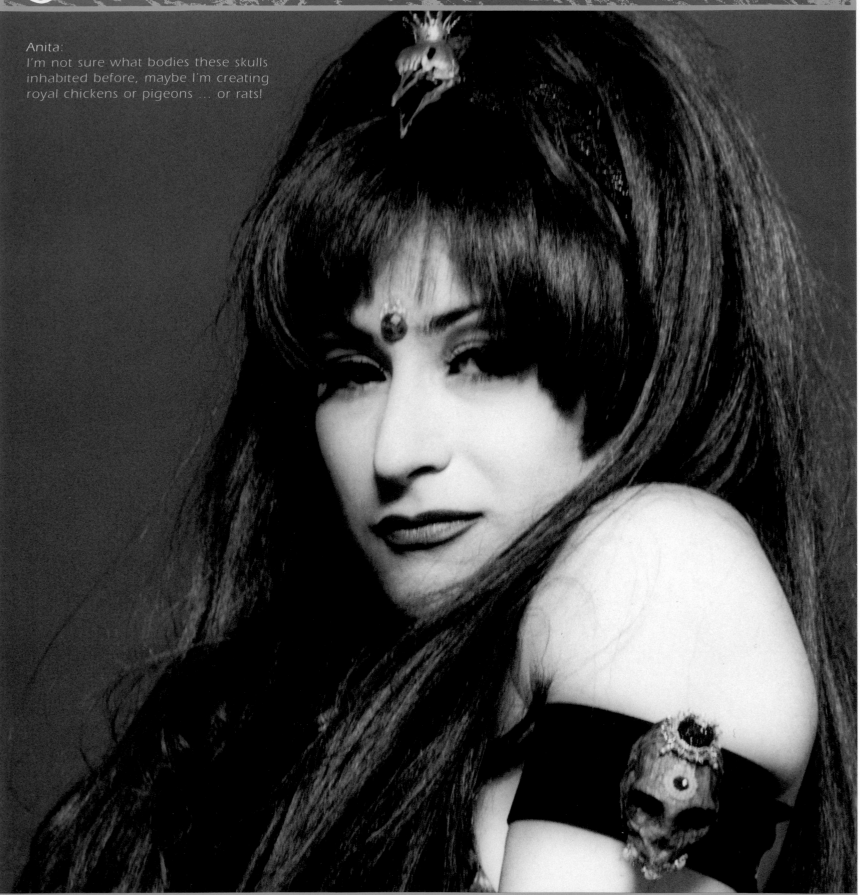

Anita:
I'm not sure what bodies these skulls inhabited before, maybe I'm creating royal chickens or pigeons … or rats!

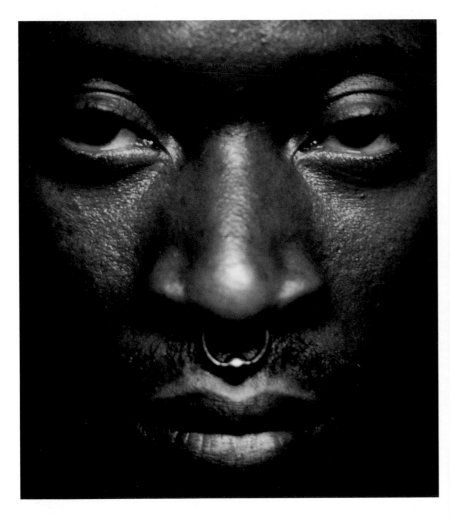

Cordelia:
My body wasn't mine until I claimed it through piercing, I didn't do it for fashion. I make all my own jewellery and use it to create balance within me, that is very important. I like modifying and recreating my body in many ways, this is exciting … I want to be somewhere between a man and a woman.

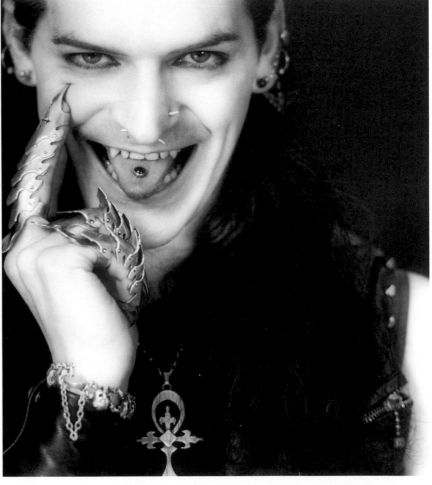

Arthur:
I look so much like my mother in this photograph it's scary! Even though I love my septum ring I can get fed up with it sometimes … it can be damned uncomfortable … but I think I'll keep it in, it's so distinguished.

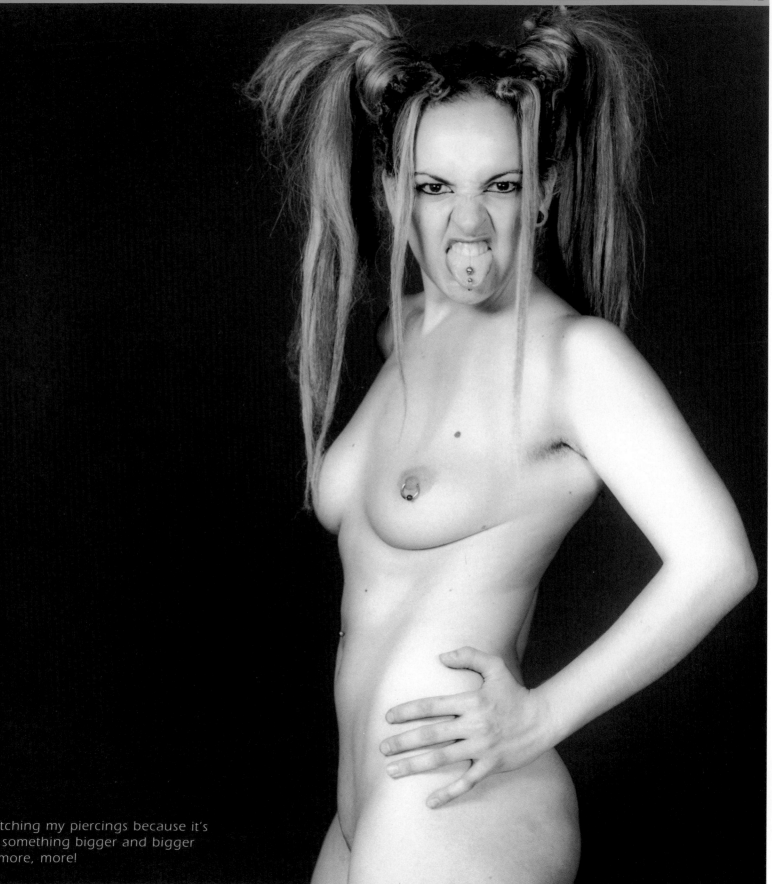

Eva:
I love stretching my piercings because it's
going for something bigger and bigger
... more, more, more!

Fabian:

I've always liked looking fabulous, like a genie or some mad creature out of a fairy tale. Life can be drab and dreary and if you're theatrical, that's not enough, you want more! When I started piercing myself ... I'd seen pictures in National Geographic and loved the look ... it was a sexual as well as a visual thing. Now I get them done professionally, too. I sometimes lose a piercing ... too much stretching or whatever ... and I feel a real sense of grief when it happens.

Nigel:

I'm an attention-seeker, too... just want to be noticed. I got my first piercing when I was 15 and just never stopped ... I wanted more and more. Although Punk started me off, since meeting Fabian I've really gone for it, he's my guide ... my perfect companion.

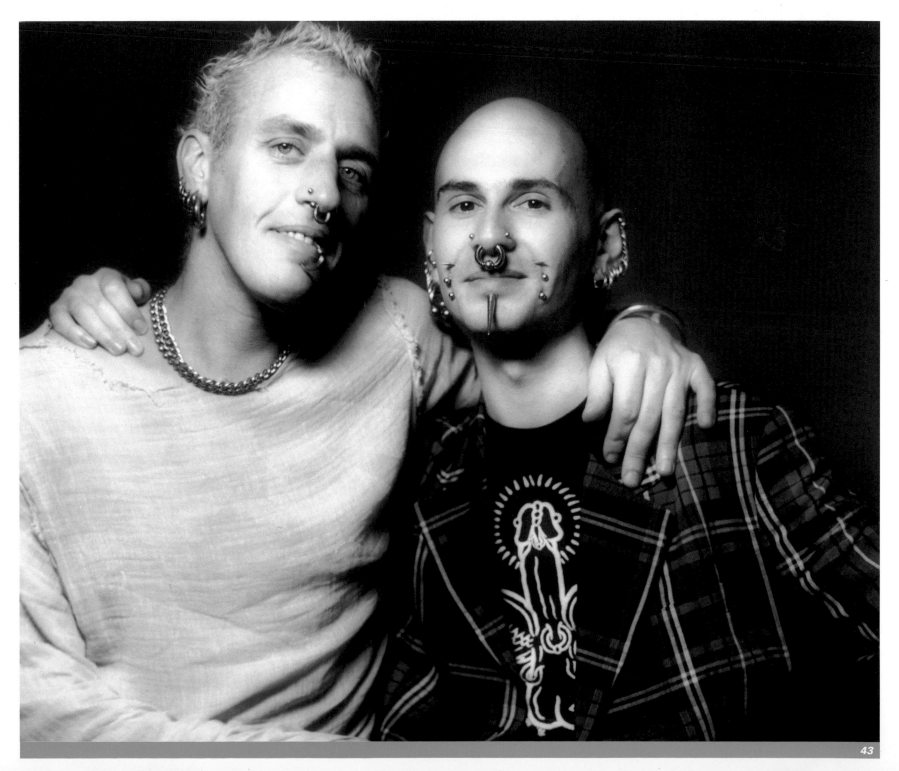

Xed:

I was a great believer that tattoos and piercings don't mix. Then, to my complete and utter horror, I woke up one morning and knew I had to pierce my nipples ... it was like I had no choice in the matter. Afterwards, things calmed down and got back to normal until suddenly ... the urge happened again ... it was really distressing. Now I look back and smile at myself because I really love them, but for a while it was pretty touch and go.

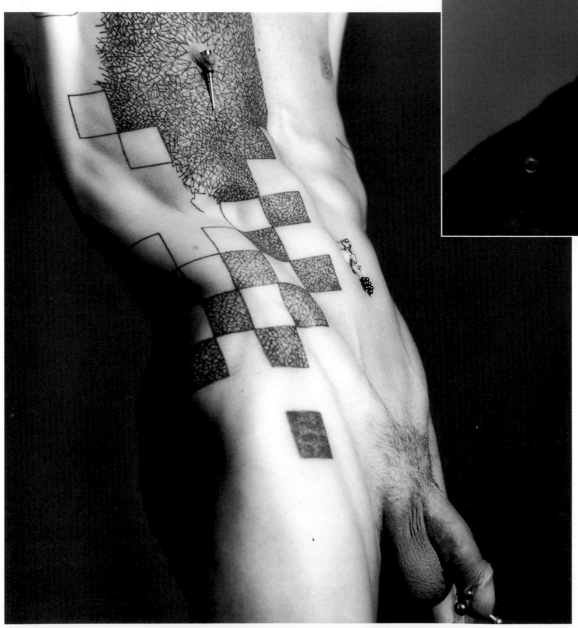

Fran:

I like looking tough. When you're a female who looks butch you can get a lot of hassle on the street so it helps to look as if you can take care of trouble ... and I can ... but I'd rather not have to fight every time I go shopping, so I use my appearance to back people off.

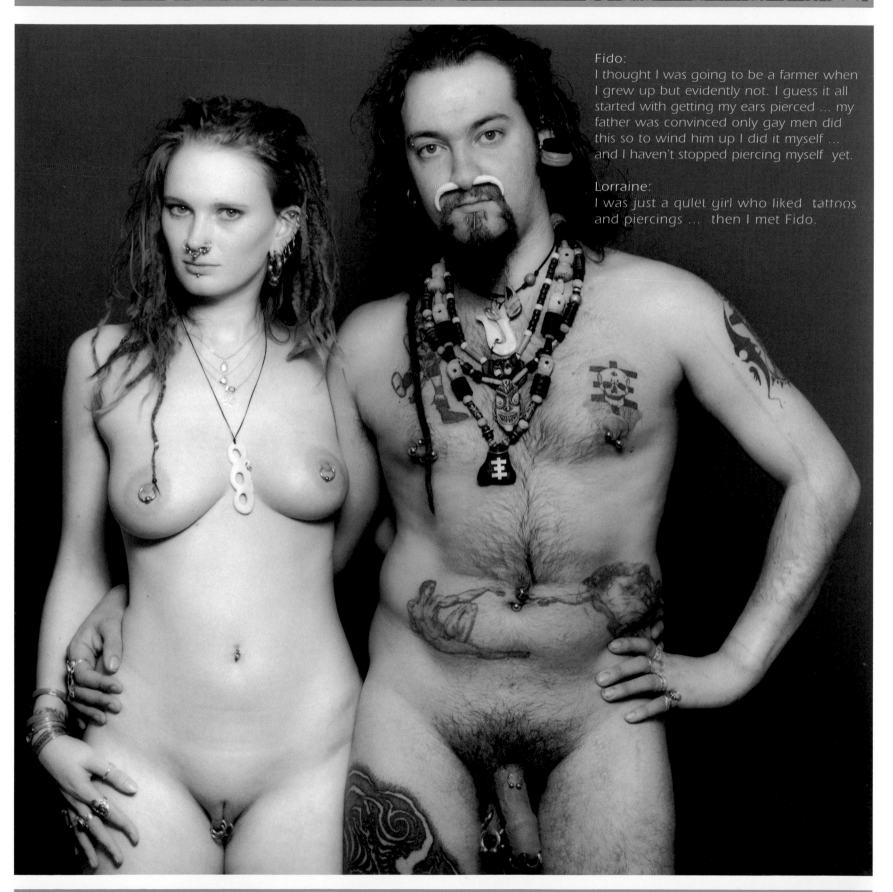

Fido:
I thought I was going to be a farmer when I grew up but evidently not. I guess it all started with getting my ears pierced ... my father was convinced only gay men did this so to wind him up I did it myself ... and I haven't stopped piercing myself yet.

Lorraine:
I was just a quiet girl who liked tattoos and piercings ... then I met Fido.

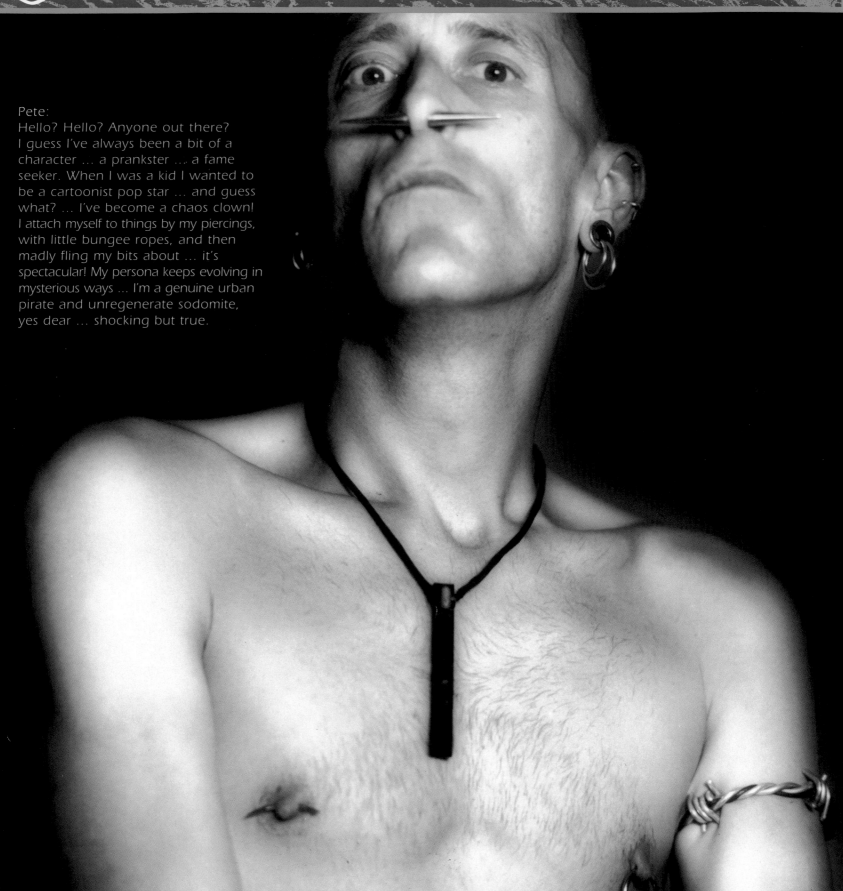

Pete:
Hello? Hello? Anyone out there?
I guess I've always been a bit of a
character ... a prankster ... a fame
seeker. When I was a kid I wanted to
be a cartoonist pop star ... and guess
what? ... I've become a chaos clown!
I attach myself to things by my piercings,
with little bungee ropes, and then
madly fling my bits about ... it's
spectacular! My persona keeps evolving in
mysterious ways ... I'm a genuine urban
pirate and unregenerate sodomite,
yes dear ... shocking but true.

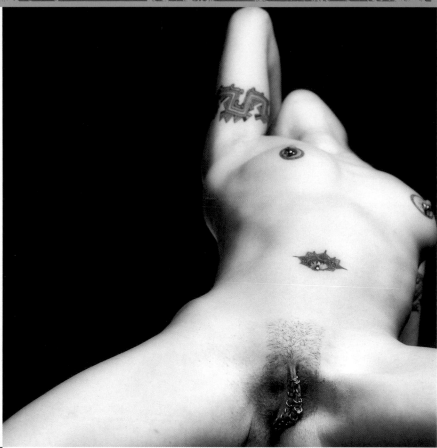

Sally:

I used to get piercings whenever I was stressed out. There was a time in my life when I allowed myself to be manipulated by men, and some were quite violent. I acquired an addiction to pain. I'd need a painfix now and then, and piercing became a safe way to achieve this. I figured I could either have a fight and possibly end up scarred or with a broken nose or ... have a piercing and end up with some new jewellery, which seemed more productive. I no longer get pierced for this reason but it helped wean me off my self-destructive habits.

Tracey:

People say it hurts but I like that. Also, the more you have the less they hurt ... you get over the fear. I think they're appealing, other people find them fascinating and they do add to sexual sensations as well. Actually, I sometimes get pierced just to feel the pain. It can be good.

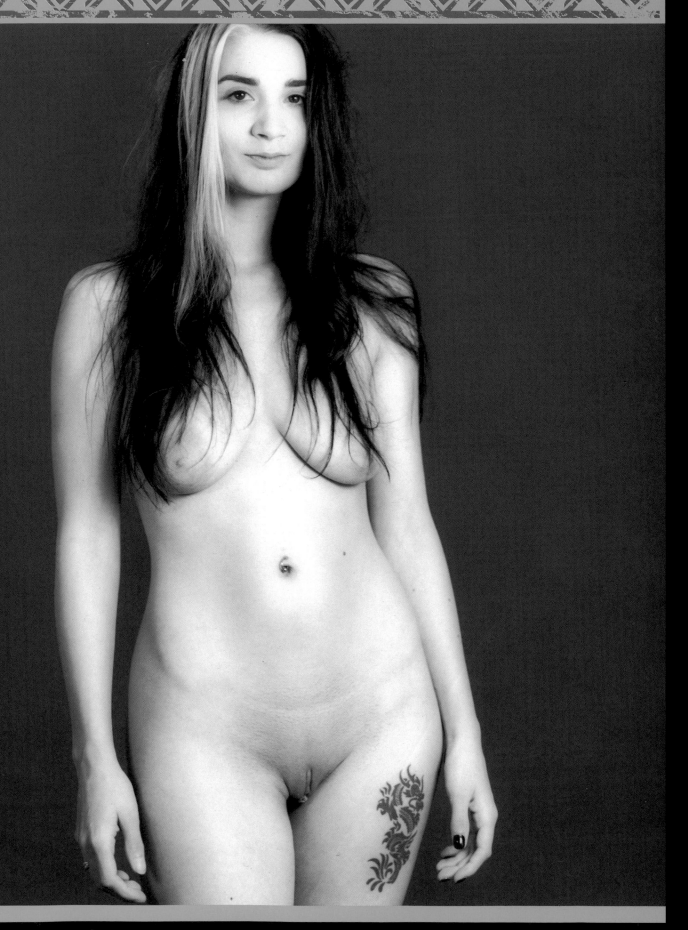

Shelly:
I love my hair …
but only where I want it.

HAIR & NAILS

Why do human beings have hair? Why, in other words, are we not truly 'naked apes'?

As Desmond Morris's famous phrase reminds us, unlike all other primates, our species lost its thick covering of fur. Yet in certain key areas - the crotch, the underarms, the top of the head and, for men, the chest and lower part of the face - rather than disappearing, our original fur was gradually transformed into hair. Male hairiness can be explained as a simple marker of gender. The positioning of hairy patches at the crotch and underarms is probably linked to the fact that these are also the sites of myriad scent-producing glands - the thatch of hair serving to retain scents which, while increasingly perceived as undesirable, were at least originally highly sexually arousing.

Head hair, however, eludes simple explanation. Arguably, in cold climates it helps in keeping the head warm and, conversely, in very hot places it helps to ward off the direct rays of the sun. But while there is no doubt truth in this, the role of hair as insulation doesn't seem to provide a full explanation. Why, for example, was hair retained (or at least not noticeably reduced in quantity) in geographically temperate areas where neither extreme cold nor extreme sun posed a threat?

Desmond Morris has suggested that head hair developed primarily as a marker of species - our ancestors' naked bodies topped by flowing manes of hair immediately setting them apart from other species. This makes sense but I doubt that it is the whole story. What strikes me is the extraordinary extent to which human hair can be customized by cutting to varying lengths, braiding, knotting into ornamental shapes, razing off, dyeing, coating with mud, wax, animal fats, etc., colouring with powders or dyes, tying with cords or ribbons, curling, frizzing, backcombing or straightening, extending with animal or human hair, adorning with anything from feathers to flowers,

beads to bones. More so even than skin, our hair seems to have been designed specifically as a medium of expression. There's simply so much you can do with it.

Put crudely, I'm suggesting that we have hair so that we can have hairdressers. If this seems a frivolous explanation this is only because we so persistently underrate the practical, even crucial, significance of body decoration. Like all species, our ancestors needed visual differentiation from other animals but, uniquely, as a tribally organized species our ancestors needed the means of differentiating themselves according to which tribe they belonged to. We have already seen how modifications of the skin (for example, by means of body painting, tattooing, scarification and piercing) can serve this purpose but positioned so prominently at the top of the body, so perfectly suited to customizing and so minimally 'functional' in other senses of the term, head hair seems to be that part of the body most purpose-built as a medium of expression .

While Desmond Morris's explanation hinges simply on the assumption that early humans had hair on their heads, my explanation derives from the view that our ancestors - like present day traditional peoples - customized their hair in tribally distinctive ways. Unlike Morris, who visualizes the original **Homo sapiens** with 'unadorned and unstyled' hair, I see head hair as developing in tandem with - stimulated by - early experiments in its adornment and styling.

Of course, as with skin, the hair of our more distant ancestors has long since disappeared. Yet the fact that no human society has ever been discovered in which hair is left to simply grow naturally points towards the view that the practice of customizing hair is of great antiquity. Contemporary barbering equipment, permanent wave machines, dyeing techniques and so forth may make 'hair art'

easier, but evidence from surviving tribal societies makes it clear that extraordinary results can be achieved by technologically simple means - techniques which could well have been developed and exploited long, long ago.

Consider, for example, the amazing hairstyles sported by the males of the Nuba tribes of the Sudan:

"To the closely cropped hair (hair is never allowed to exceed about 1/2 to 1/3 of an inch in length) is added beeswax. This results in a type of cake, as the beeswax is not rubbed in but simply stuck on. The wax cake is stippled with a comb or small stick, and then coated by shaking on the appropriate colour. Young men may attach feathers along the sagittal crest - perhaps reversing the direction of the feathers on either side of the rum. Sometimes a series of thorns or seedpods will be used . . . The entire hair fashion may also be sprinkled with herbs (tao) for protection or with bits of blueing or ground mica for decorative flair."
[James C. Faris, **Nuba Personal Art,** p.65]

Or, those worn by young Masai warriors:

"The typical Masai warrior, known as a **moran,** grew his hair very long and had it styled by a fellow **moran**. This arduous task sometimes took 15 or 20 hours to perform. First, the hair was parted from ear to ear, smeared with fat, red ochre and clay and twisted into as many as 400 individual strands. The strands at the back of the head were then grouped into 3 pigtails around long, pliant sticks, and the hair ends were bound to the sticks neatly with sheep skin, so that they tapered to a point. The strands of hair at the front of the head were arranged to fall forward over the face."
[Esi Sagay, **African Hairstyles,** pp.30-31]

Not only do such distinctive hairstyles promi-

nently proclaim tribal identity, they also vividly mark personal differences of status within each tribe. While it is only recently in the West that hairstyles have served to signal 'tribal' membership (for example, the Teddy Boy's quiff, the Skinhead's crop, the Punk's mohican or the Rapper's razored designs) hair and status have long been linked in Western history. Typically, the more 'impractical' a hairstyle the more it demonstrated wealth and aristocratic standing. This reached amazing extremes in Europe in the 17th and 18th centuries when the hair of high-status women reached for the skies with the aid of complex hidden structures and was adorned with everything from birdcages filled with live butterflies to spinning, clockwork windmills.

Alternatively, enormous wigs were worn - by European men as well as women. This was not, however, a new or even uniquely Western invention. The aristocracy of ancient Egypt, for example, had worn dazzling wigs in colours like indigo blue or copper red. The wigs worn by certain 'Big Men' in the highlands of Papua New Guinea make even those of 17th-century Europeans seem discreet in comparison:

"The wig was built on a frame of pliant cane strips, bound with lianas. To this the manufacturers fastened lengths of hair, sewing them with a flying-fox bone needle and bark thread. They placed the completed wig on a stand underneath a banana stem which was slung horizontally across supports. Lumps of melted resin from the kilt tree . . . were placed on the banana stem and allowed to drip on to the wig in order to set the hair hard. The makers next smoothed the surface down with a rolling-pin, and rubbed pig or pandanus grease over it. Inside the frame they placed a bark-cloth lining. Finally they painted the wig in bright colours with chevrons, streaks, triangles . . . On the day of dancing its wearer and his helpers would further fringe the wig with

scarab beetles enclosed in bands of yellow orchid vine, light-coloured furs, and the leaves of a plant which is used in moka ritual to attract valuables. The topknot was left unpainted, but round it twined another bright fur, while from it sprang a medley of feathers set in a circlet." [Andrew and Marilyn Strathern, **Self-Decoration in Mount Hagen,** pp.87-88]

'Bigwigs' in every sense, such headpieces are seen as a source of great power (especially in attracting women) and for this reason their manufacture is ritually protected - the process taking place in great secrecy, the wig-maker prohibited from having sex until the wig's completion. Of course, the equation of hair (even in the form of a wig) and power is hardly unique to New Guinea - as is well illustrated by the biblical story of Samson. On the one hand, the extraordinary power of hair clearly derives from and reflects its almost limitless capacities as a medium of expression. On the other hand, its power seems to derive from its strange nature - a part of us (what could be more personal?) which is actually dead and alien to us.

This is the point of overlap between hair and nails. Both, of course, can be decorated (in the case of nails, a body art which, especially in America and amongst black communities in Britain, has reached great sophistication in recent years) but just as importantly, both share a unique, intermediary status between the living and the (un)dead. In many traditional societies this indeterminate status causes great concern over hair and nail clippings - obliging people to bury them secretly to keep enemies from casting dangerous spells over them.

We in the contemporary West are more nonchalant about such things - our locks mingling with others on the floor of the hairdresser's, our nail clippings flicked casually on the bathroom floor. But can we really and truly be

nonchalant about that which - only a moment before - was an intrinsic part of ourselves? The Victorians at least seem to have been aware of the unique power of such 'waste products' - the lock of hair secreted in a gold case like a religious relic or fetishistically braided into a watch chain as a constant reminder of one's beloved and a symbol of intimacy.

What we do not explicitly acknowledge in our day to day practices nevertheless seems to surface powerfully in our erotic imaginations. The Vamp's sexy long nails only one step removed from the Vampire's talons, the 'chest wig' of the Disco dandy only one step removed from the werewolf's fur. That which is halfway between me/not me, the living and the dead, is also halfway between the human and the animal.

"Both hair and nails remind us of what we once were. Yet at the same time in their decoration, their customizing, they clearly set us apart from all other creatures. This is especially true of hair which, while reminiscent of fur, is a uniquely human feature - not only in its intrinsic characteristics but more significantly, in its capacity for modification.

For the Nuba, the significance of proper hair grooming extends all the way to the definition of the human species. Hair grooming, the ability to remove hair, and smooth bodies are all characteristics of humans - characteristics not all shared by animals not language (which monkeys, in Southeastern Nuba myths, once shared with man), but shaving - the choice to have or not to have hair - that distinguishes humans from other 'moving species'."
[James C. Faris, **Nuba Personal Art,** pp.55-56]

Surely the Nuba are right. For only human beings - The Customized Ape - would transform fur into a 'crowning glory' and claws into 'nail art'.

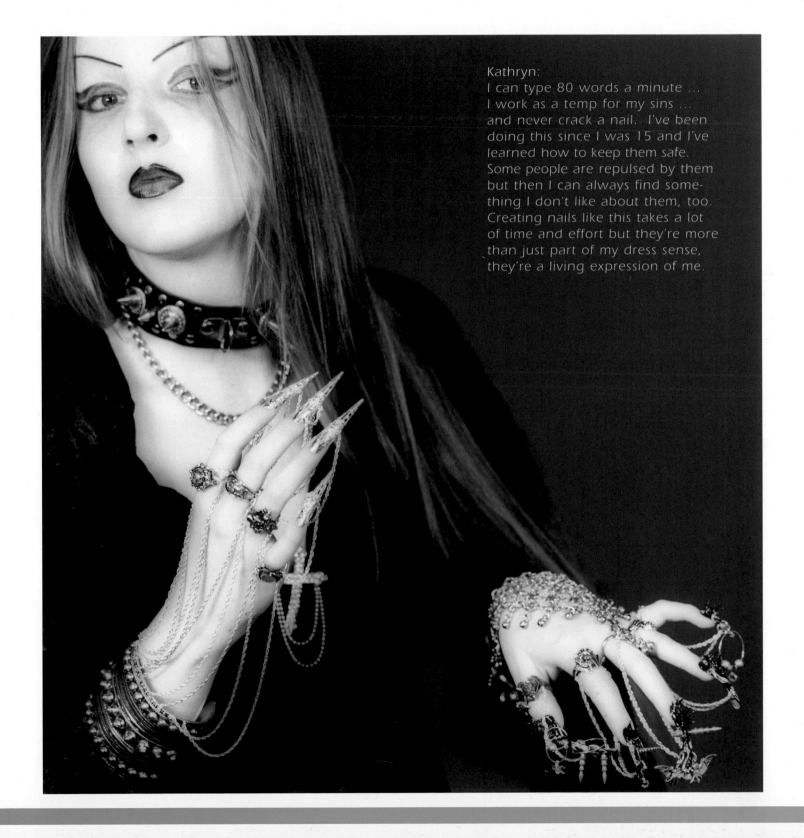

Kathryn:
I can type 80 words a minute ...
I work as a temp for my sins ...
and never crack a nail. I've been
doing this since I was 15 and I've
learned how to keep them safe.
Some people are repulsed by them
but then I can always find some-
thing I don't like about them, too.
Creating nails like this takes a lot
of time and effort but they're more
than just part of my dress sense,
they're a living expression of me.

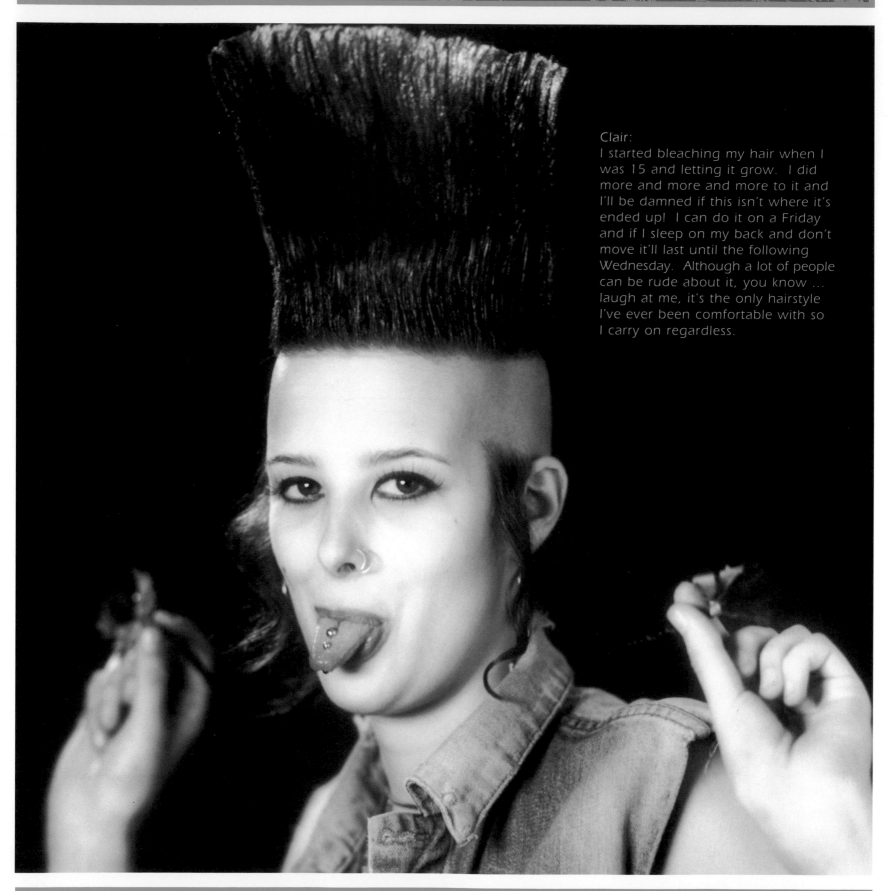

Clair:
I started bleaching my hair when I was 15 and letting it grow. I did more and more and more to it and I'll be damned if this isn't where it's ended up! I can do it on a Friday and if I sleep on my back and don't move it'll last until the following Wednesday. Although a lot of people can be rude about it, you know … laugh at me, it's the only hairstyle I've ever been comfortable with so I carry on regardless.

Arthur:
I'm always playing with my hair …
shaving it, bleaching it, growing it …
if I don't like what I've done or I get
bored it doesn't take long before I
can start again.

Alison:
I've dyed my hair black since you
took these photos, I doubt anyone
would recognize me at first glance.
It depends on my mood, you know,
how I present myself.

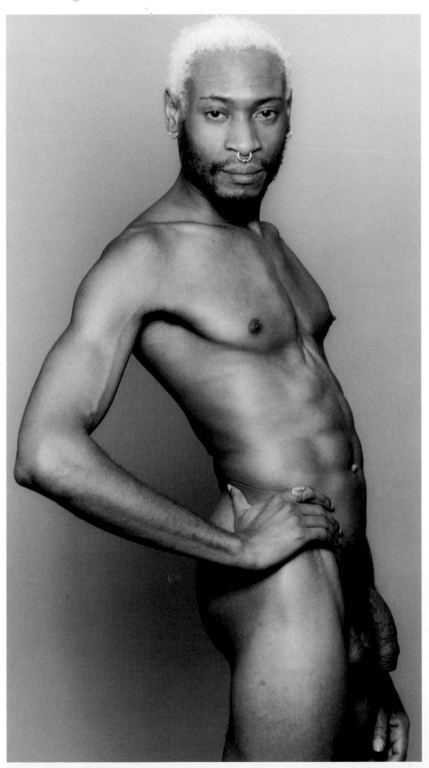

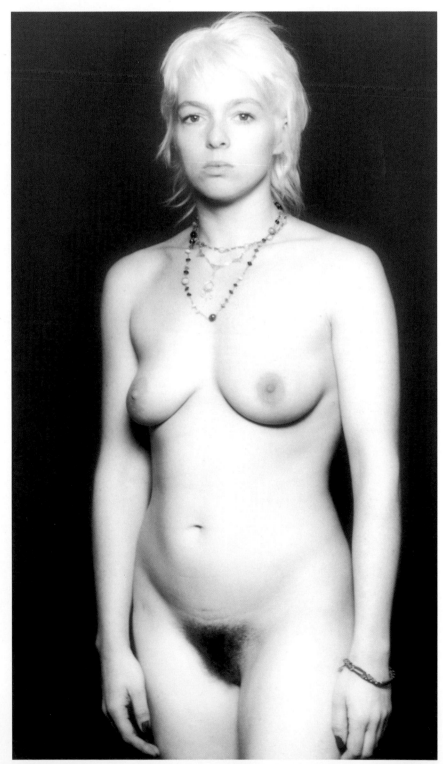

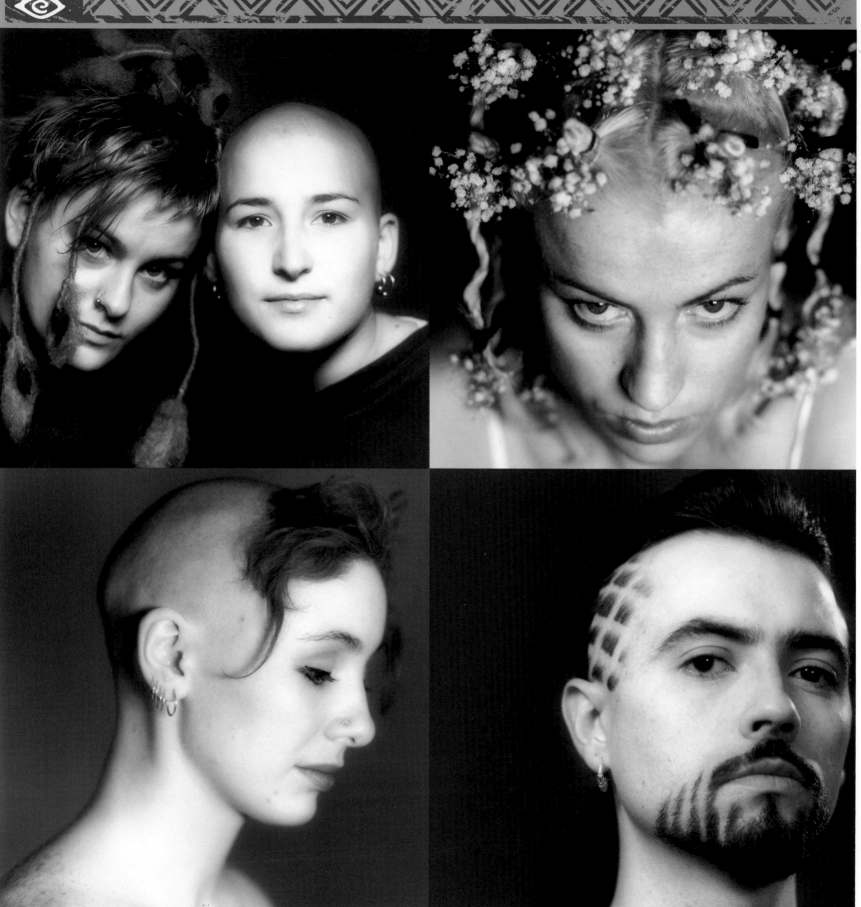

OPPOSITE PAGE: CLOCKWISE

Valentina:
The story of my hairstyle is not so dramatic.
I'm a photographer too and aware of visual
impact so I had a friend who is a hairdresser
do something fun before I came here.
Lucrecia:
When I was 16 I wanted to shave my head.
It was because I was very sad inside and I
wanted to show this ... but I didn't, then.
Later, I finally did shave it ... and for similar
reasons. Now, I love it so much I can't
imagine ever growing it back.

Jo:
I guess I'm a bit uncontrollable, not house-
broken, so yeah ... I've always looked a bit
unusual ... made my own clothes, that sort
of thing.

Alex:
I feel like a cruel Caliph from ancient
Babylonia with my beard. I've been shaving
it like this for many years and it's hard to
imagine myself without it.

Lucy:
I cut my hair like this accidentally and I
thought it was funny so I kept it. Now it's
been a while since we did these photographs
and I've shaved them into little devils horns
... or insect antennae, take your pick ... and
they're even more humorous. I find it hard
to take myself too seriously.

THIS PAGE:

Sonny:
I wanted to be an actress, a famous actress,
when I was growing up. I was made to
feel nothing as a child so I have this strong
desire to be seen and accepted. I know we
haven't talked about our hair but that's not
so important.
Sophie:
I also wanted to be an actress but only in
the movies, I prefer them to the stage. Like
Sonny, I felt small and neglected as a child
... my older sister got all the attention.

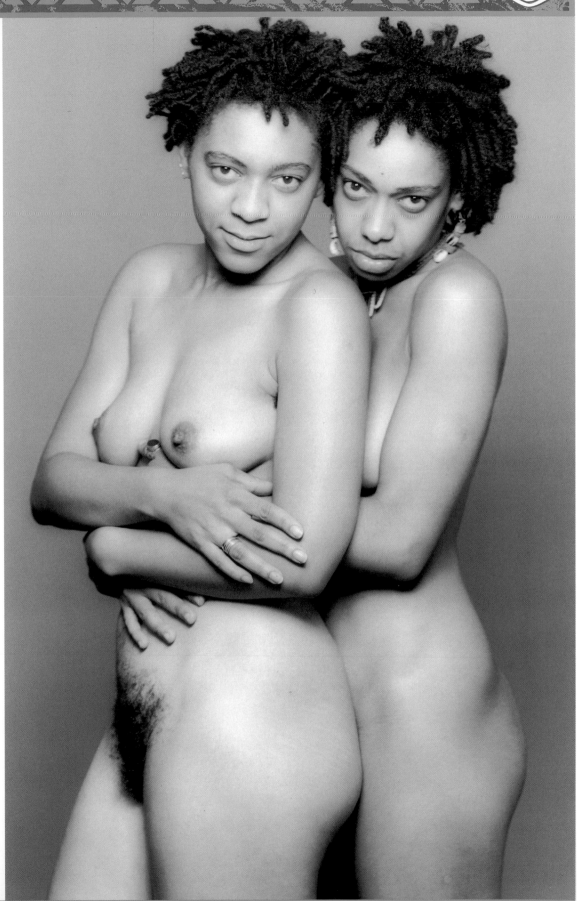

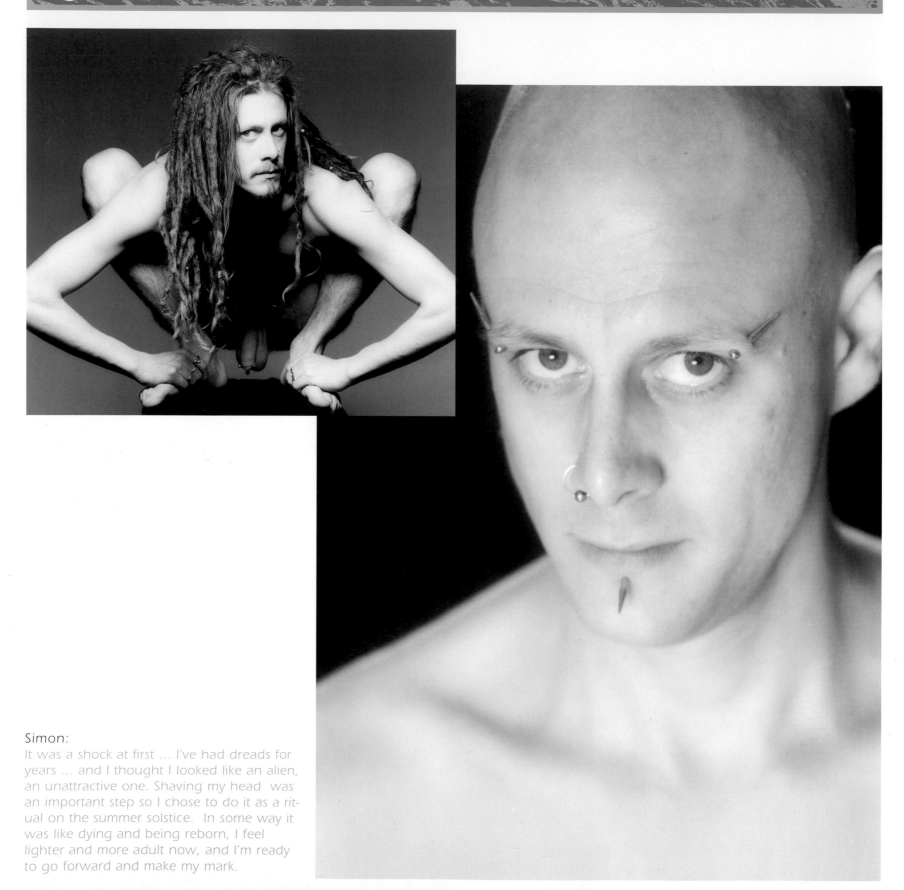

Simon:

It was a shock at first ... I've had dreads for years ... and I thought I looked like an alien, an unattractive one. Shaving my head was an important step so I chose to do it as a ritual on the summer solstice. In some way it was like dying and being reborn, I feel lighter and more adult now, and I'm ready to go forward and make my mark.

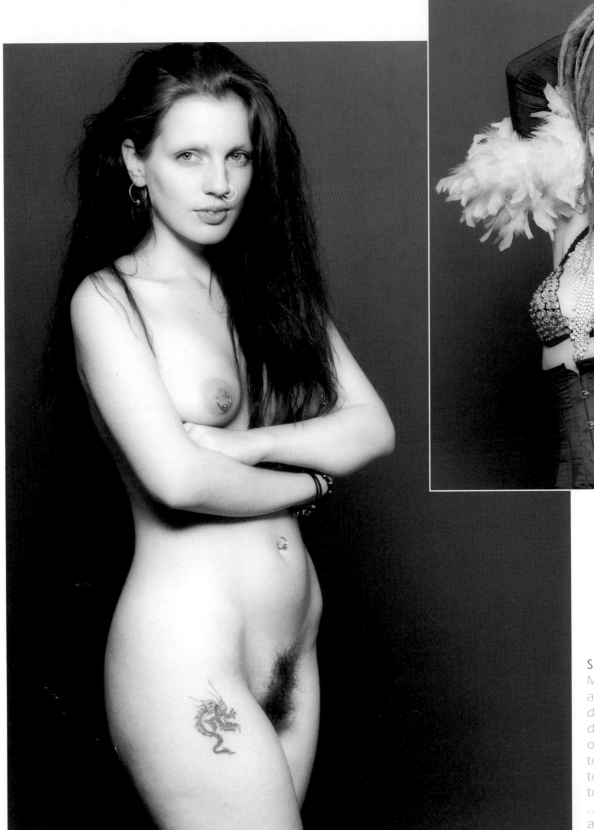

Suzy:
My sister's gone respectable, got a farm and everything, but I can't help it ... I just do enjoy shocking people, I can be so disgraceful. I must admit I try to outdress others whenever I get a chance, anything to get noticed. You see, in my job I have to look quite drab so I find it's great fun to re-create myself ... wigs, nails, make-up ... the lot. I'm a bit like a magpie, I love anything that glitters.

Fizzy:
I must say I find these ballerina shoes REALLY uncomfortable, I would love to wear them out but there's no way. It's a shame, they give you such long legs.

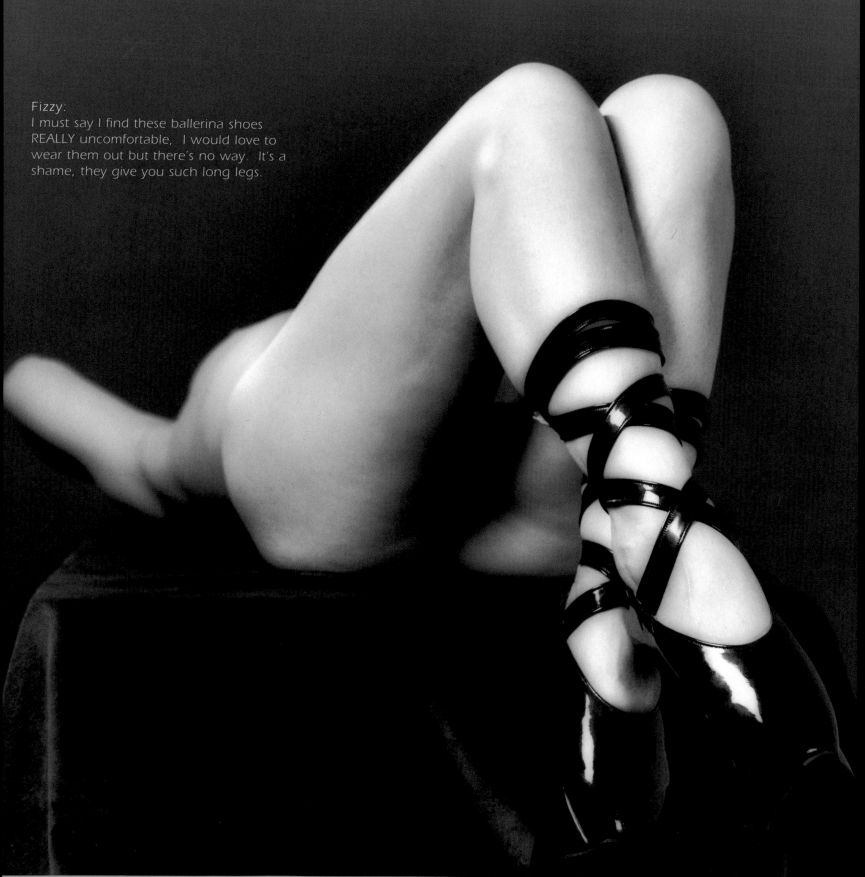

THE FOOT & THE SHOE

A 'masterpiece of engineering and a work of art'. The face? The hands? No, this is Leonardo da Vinci's assessment of the human foot. And without doubt he was justified in his praise, not only because of the extraordinary complexity of the foot's 26 bones, 114 ligaments and 20 muscles, but also because it was this typically un-praised and often joked about part of the body which set the course for all of human development.

By facilitating bipedal rather than quadrupedal locomotion, the human foot released the hands to pursue their own development of the unique, opposable human thumb. (That is, a thumb which can move independently and in opposition to the other fingers so as to make grasping objects easier.) This, in turn, facilitated complex tool use and making - the shaping of spears, flint or shell blades and, in time, even the computer on which I am writing this on. But such technological expertise is only part of the story. Tool use and making demanded more social co-operation and this created the foundations of tribal life, complex cultural systems and language. All the time, our ancestors' brain size expanded while, at the other end of the body, the feet went on adroitly making it all possible.

In short, we as human beings stand apart from other primates because we stand on two feet. Naturally, however, this hasn't kept us from 'improving' on this masterpiece of art and engineering in our species' drive to customize the human body. As with other parts of the body, the feet may be tattooed or painted (the semi-permanent body art of intricate designs applied to the foot with henna dye being especially highly developed amongst women in parts of Northern Africa and India) and, as with fingernails, the toenails may be painted. The ankle, as previously mentioned in our discussion of jewellery, is a valuable site for attaching bracelets and other ornaments - and in India, for example, rings may be worn on the toes just as they are on the fingers.

More dramatically, if initiated at an early age, the entire shape of the foot may be altered. Infamously, this body art was highly developed in Imperial China. Girls between the age of 5 and 7 whose feet were tightly bound to force the toes back towards the heel over many years were, in later life, highly desired as courtesans or wives by wealthy, powerful men. Ideally resulting in a tiny foot measuring only 3 or 4 inches from heel to toe, effective locomotion was sacrificed in pursuit of an aesthetic ideal. The 'Lotus Foot', as it was known, had strong, arguably obsessive, erotic connotations in Imperial China: the exaggerated cleft of the foot being seen (even apparently sometimes used) as an imitation vagina.

More typically, throughout human history the foot has been customized by being placed within the outer covering of a sandal, shoe or boot. Originally worn for protection (from sharp stones, thorns, poisonous animals or plants, extremes of temperature, etc.) a good example of such footwear is provided by that of the 'Iceman' who had oval pieces of leather under the soles of his feet which were turned up at the sides and held in place by an intricate web of grass cord straps which surrounded each foot and under which was stuffed a tight layer of grass to provide warmth.

It is a mistake, however, to assume a fixed correlation between footwear and practical protection. Firstly, many if not most tribal people get by perfectly well (and often have healthier feet in the process) without any means of protecting their feet except the thick calluses which nature and exposure provide. On the other hand, a great deal of footwear (especially but not exclusively that found throughout Western history) has been specifically designed to make locomotion more rather than less difficult. To view such shoes and boots as 'impractical' is, however, to miss the point. As with any other adornments or garments, the practical functions of footwear may have little to do with the physiological functions of the body - serving a wide range of cultural and erotic functions instead.

For example, as in ancient Egypt, Greece and Rome, a key practical purpose of footwear may be to serve as a sign of wealth or status. To these ends, the more 'impractical' the shoes or boots the better - a clear indication that one can afford to get from A to B by more extravagant means than simply walking on one's own two feet. In extreme form (for example, the tall, precarious pedestals which the women of Renaissance Venice or the Japanese geishas strapped to their feet) such inhibition of efficient movement appears to be designed to mark subservience of women to men) as well as to signal wealth.

Time and time again (despite our typical assumptions and jokes about their ugliness or odour) the feet - and therefore shoes and boots - are highly charged with erotic possibility. Beyond the real and symbolic implications of footwear which impedes movement and escape, thereby suggesting dependence, submission, vulnerability, the shape of the foot has often been seen as indicative of the genitals. We've already mentioned the Chinese view of the 'Lotus Foot' as a vagina. In Europe in the Middle Ages, on the other hand, men's shoes known as the **poulaine** sported absurdly long points way beyond the actual then

a symbolic representation of an enormous penis. (So blatant was this symbolism that both the Church and various governments tried to legally restrict the size of such pointed shoes but, as is usual with such 'sumptuary laws', with little actual success.) While less extreme, the 'Winkle-picker' and other sharply pointed shoe and boot designs of more recent times must surely owe much of their popularity to this, even if subconscious, symbolic equation of the foot and the penis.

Another important erotic motivation in footwear design concerns the high heel which is often a feature of women's shoes and boots. The raising of the heel has the effect of altering posture such that the backside is thrust further back and the breasts further forward. In this way the high heel (interestingly, like Chinese footbinding) emphasises both of the primary female sexual triggers.

Additionally, of course, the precariousness of extremely high heels also has the effect of underlining vulnerability and dependence. Yet, at the same time, if the heel is sharpened into the stiletto style (perfected by Italian designers in the mid 1950s) completely contrary erotic connotations are also present: the feminine shoe as a weapon and a means of keep-

ing men 'under the heel' of dominant, even dangerous women.

The erotic implications of such designs make the shoes and boots which feature them an obvious candidate for fetishistic

itself be the object of sexual desire - even serving for some 'true' fetishists an essential, even exclusive component of sexual experience.

While any part of the body (and any of its adornments and items of clothing) can become the focus of fetishistic obsession it is statistically remarkable how often it is the foot and footwear which acquires this adored status. But perhaps, moving beyond the popular comic degradation of the foot (humour always being a clue to more serious preoccupations), all this completely unremarkable when we return with clearer insight to da Vinci's 'masterpiece of engineering and a work of art'. If we're obsessed by the foot and its attire this is perhaps simply a manifestation some subconscious awareness that it is this part of the body which, more than any other, makes us what we are.

Arthur:
My god, I mean these are heels … it's still hard to get them in men's sizes. They're probably the most impractical design ever but they give me that extra few inches of height which I feel nature robbed me of and this

obsession. Yet writing about and by shoe fetishists makes it clear that even quite plain and seemingly unerotic designs can hold powerful fascination. Beyond which, of course, the naked, unadorned foot can

gives me more confidence.
There's such a big taboo against men wearing women's shoes … not the other way around … I think we should all be able to wear what we like.

BJ:
What can I say? Under the heel of a
beautiful woman ... it doesn't get
much better.

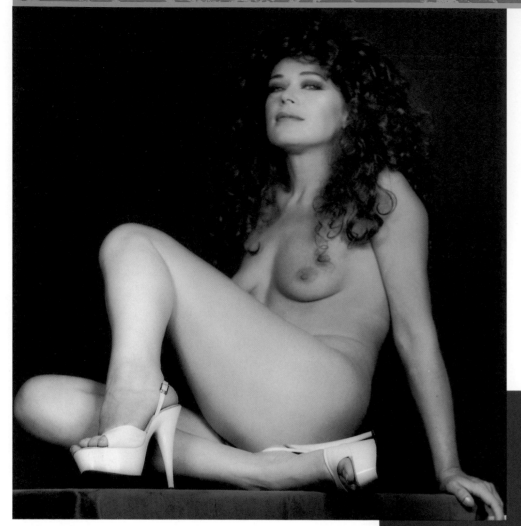

Fizzy:
I've been wearing stilettos since I was 13 so I'm really comfortable in them, they make me feel proud and dignified and I know I walk taller.

Giles:
What's nice about these boots is that both men and women can wear them, I like that.

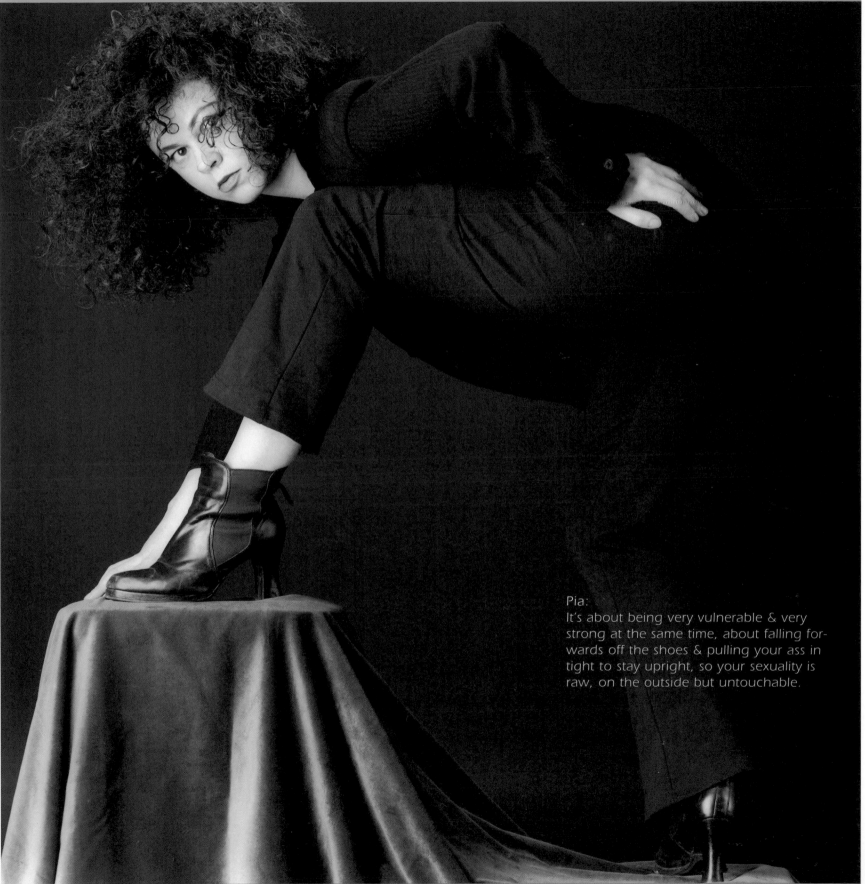

Pia:
It's about being very vulnerable & very strong at the same time, about falling forwards off the shoes & pulling your ass in tight to stay upright, so your sexuality is raw, on the outside but untouchable.

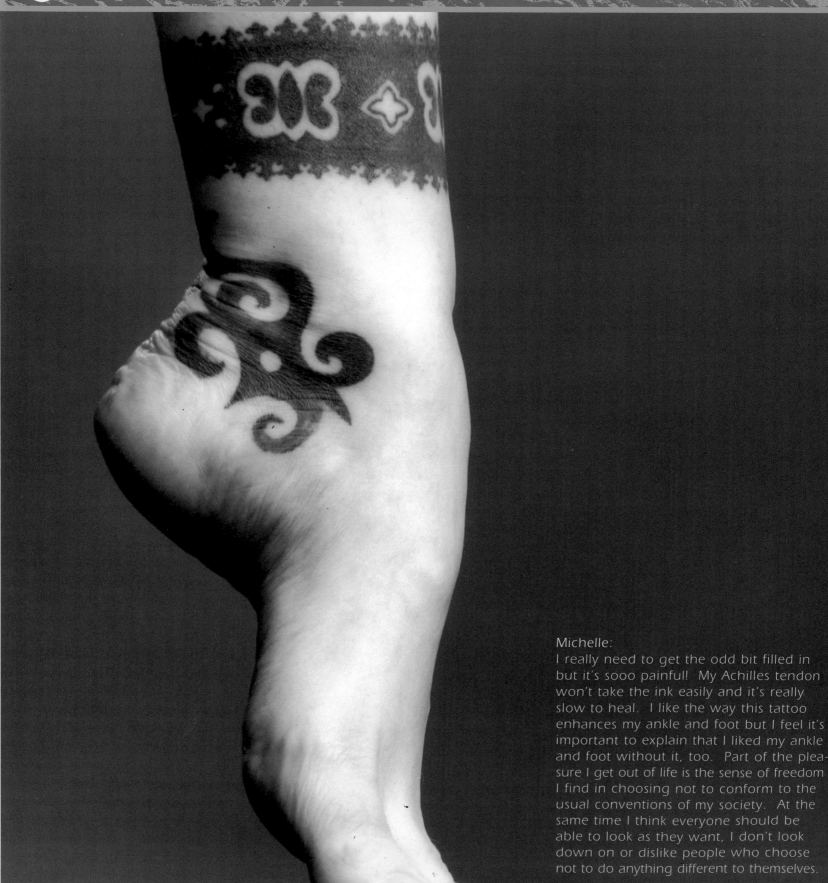

Michelle:
I really need to get the odd bit filled in but it's sooo painful! My Achilles tendon won't take the ink easily and it's really slow to heal. I like the way this tattoo enhances my ankle and foot but I feel it's important to explain that I liked my ankle and foot without it, too. Part of the pleasure I get out of life is the sense of freedom I find in choosing not to conform to the usual conventions of my society. At the same time I think everyone should be able to look as they want, I don't look down on or dislike people who choose not to do anything different to themselves.

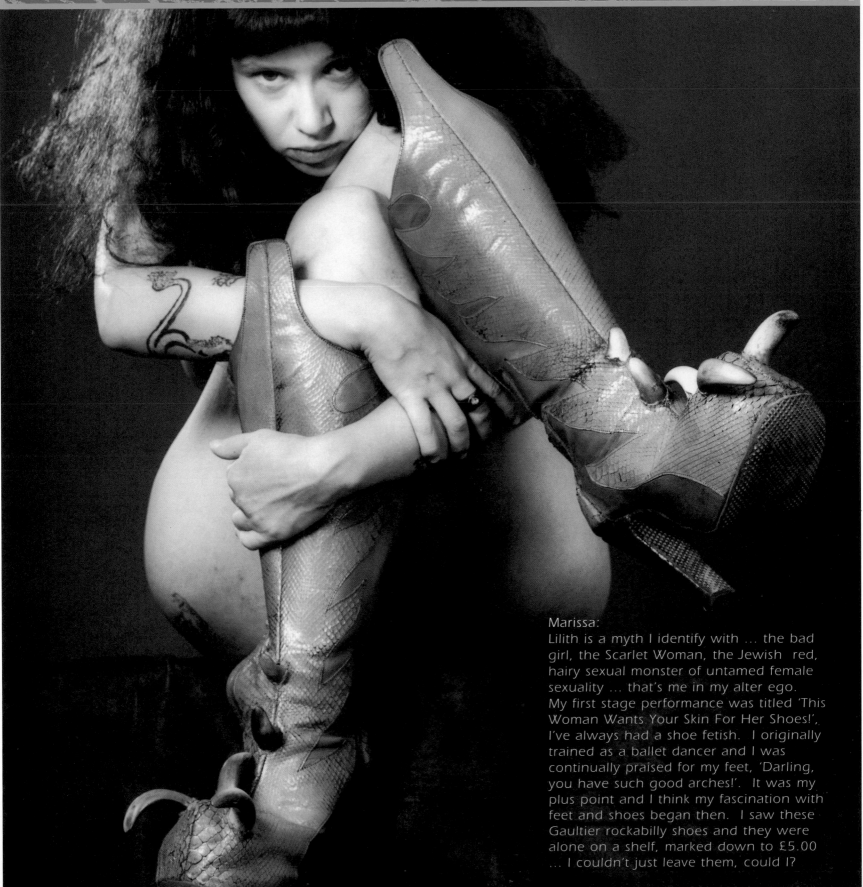

Marissa:
Lilith is a myth I identify with … the bad girl, the Scarlet Woman, the Jewish red, hairy sexual monster of untamed female sexuality … that's me in my alter ego. My first stage performance was titled 'This Woman Wants Your Skin For Her Shoes!', I've always had a shoe fetish. I originally trained as a ballet dancer and I was continually praised for my feet, 'Darling, you have such good arches!'. It was my plus point and I think my fascination with feet and shoes began then. I saw these Gaultier rockabilly shoes and they were alone on a shelf, marked down to £5.00 … I couldn't just leave them, could I?

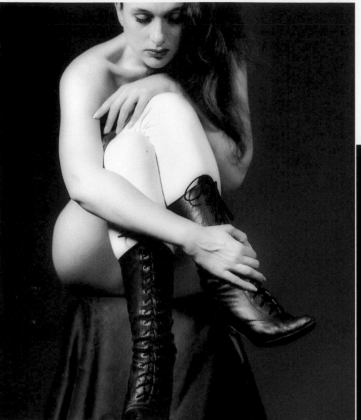

Ria:
These boots have seen a lot of action and
they take forever to put on and take off
... but they're worth it!

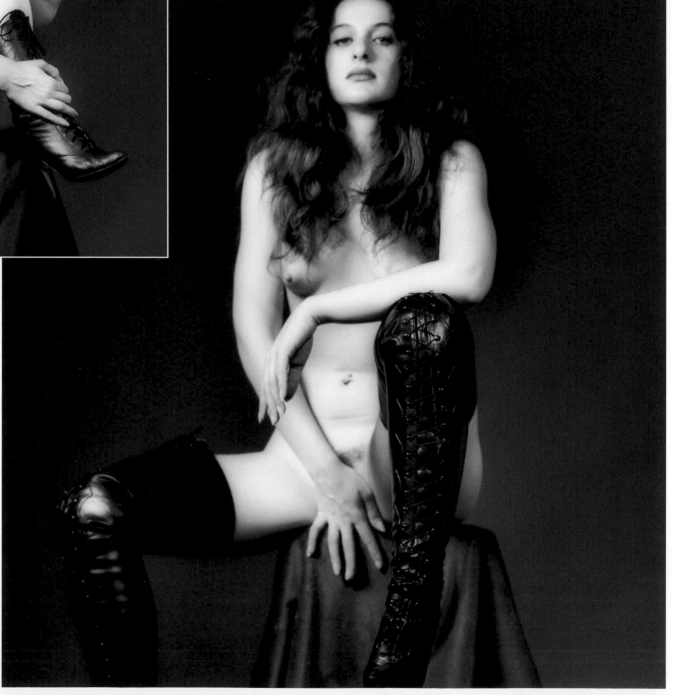

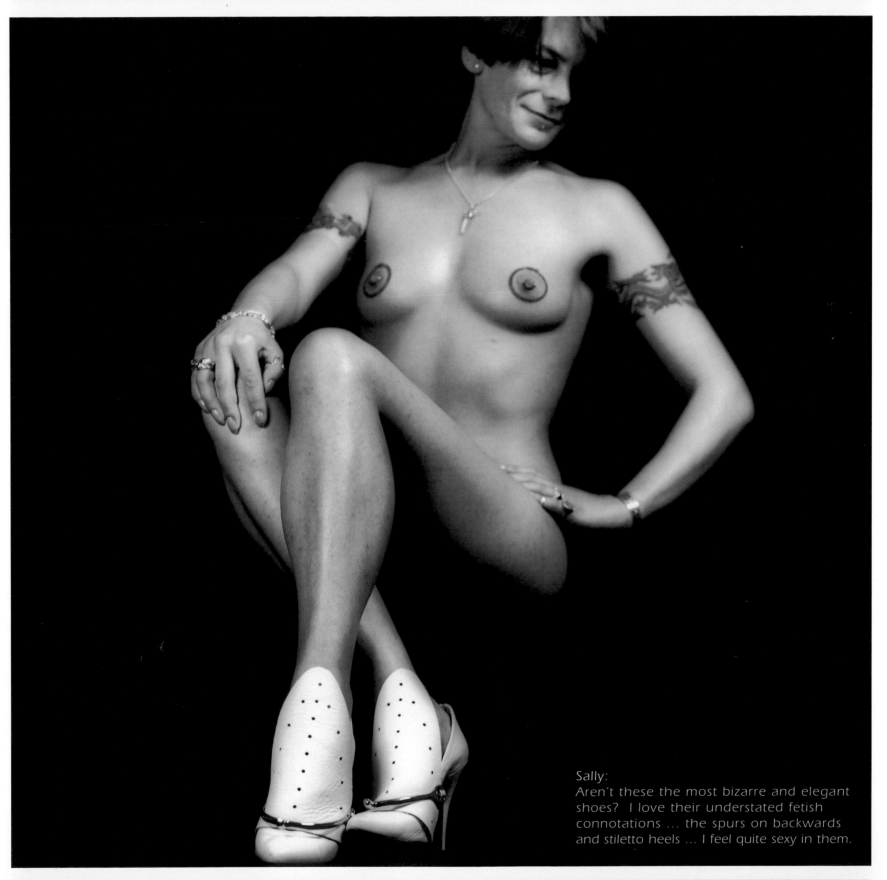

Sally:
Aren't these the most bizarre and elegant shoes? I love their understated fetish connotations ... the spurs on backwards and stiletto heels ... I feel quite sexy in them.

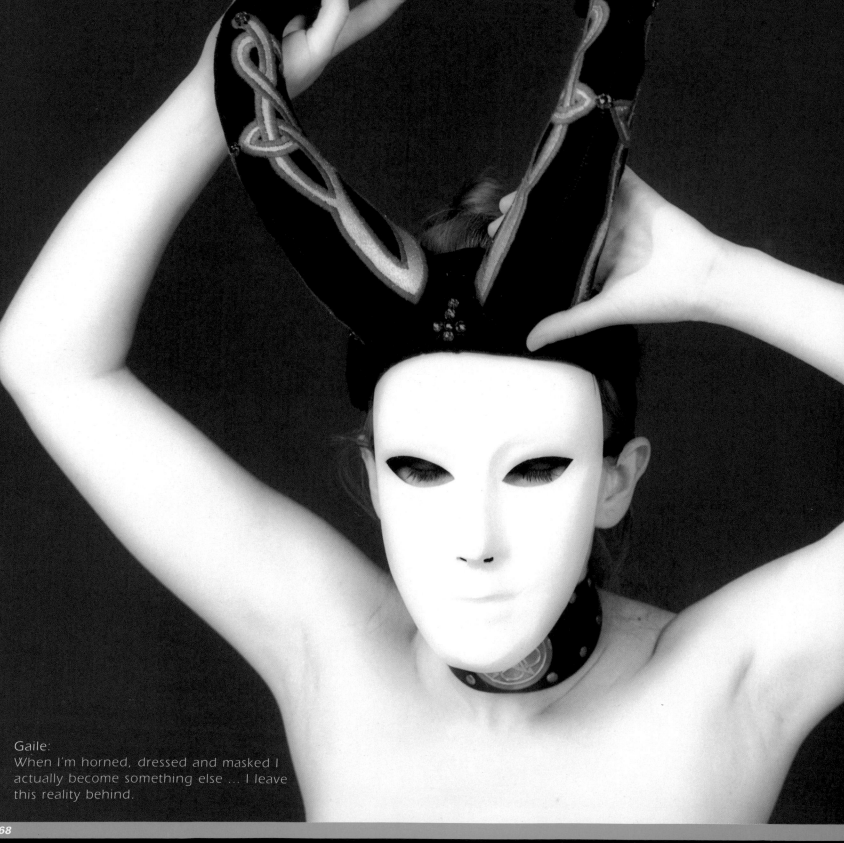

Gaile:
When I'm horned, dressed and masked I actually become something else ... I leave this reality behind.

MASKS

A covering of the face designed to disguise or transform identity, masks date back at least to the Stone Age. Found on all continents and in an astonishingly wide range of cultures - from the 'secret societies' of tribal Africa to the Incas of Peru and Aztecs of the Americas, from the ancient Greeks to the Rio Carnival - the pervasiveness of masks causes us to consider just why it should be that human beings are so desirous of concealing or altering their identity.

While our own recent and contemporary use of masks seems predominantly designed to conceal who you are (for example, at a masked ball or fancy dress party) the much more ancient - and no doubt original - function of masks was to transform what you are. A magical, extraordinary invention (in its own way, at least as imaginative as, say, the creation of flint cutting implements or the harnessing of fire), the mask made it possible for its wearer not only to escape his or her personal identity but the bounds of human existence as well.

Thus the Stone Age hunter in a mask representing a particular animal had the capacity to become, understand, capture and then subdue the spirit of the hunted animal. Or a shaman donning a mask which represents the spirit of, for example, the clouds or rain, immediately embodies this natural force (as amongst the Hopi and Zuni Indians of the American Southwest) and thereby, it is hoped, ensures the fertility of the harvest.

Alternatively, the obliteration of personal identity which masks confer can serve to render the wearer a more effective representative of social forces. The practical advantages of this are particularly clear when it comes to meting out punishment - in New Britain, for example, a secret society known as the Dukduk, its members all wearing huge five-foot-high masks, judges and exe-

cutes wrong-doers. Their onerous task completed anonymously, they can then return as individuals to live without prejudice in their community. On the other hand, the same anonymity afforded by a mask can be used in other societies in initiation rites. This can take the form of a tribe's elders donning traditional masks in order to step out of the role of a particular individual known to the initiate and to step into the role of mythic ancestor. Or, as in Zaire in Africa, initiates may emerge from their rite of passage ritual wearing masks in order to symbolize the moment when they leave their youthful identities behind and are transformed into adult members of the tribe.

Additionally, masks can be made as horrific as possible to frighten off disease, evil spirits or, on the battlefield, a human enemy. And they can serve as story-telling devices - visual reminders of mythic and real characters from a culture's history. This is obviously of particular importance in cultures which have no written history or literature, but the playwrights of ancient Greece also recognized the role of masks in theatrical performance and this tradition was continued throughout Europe in Medieval times in the form of the mystery plays which enacted the stories of the Bible. (A particularly highly developed form of this theatrical use of masks is found in the Nō drama of Japan which gives names to some 125 different types of masks.)

Although masks figured prominently in the Commedia dell'arte theatrical innovations of Renaissance Italy their importance in Western theatre diminished (and almost disappeared) in the 18th, 19th and 20th centuries.

Nevertheless, another important role of masks - that of marking special festive occasions - has survived and even thrived. In particular, the popularity of the Venice Carnival gave a new lease of life to all the masks/char-

acters which first appeared in the Commedia dell'arte - most famously, the white Harlequin. Separate, but equally vibrant mask traditions have developed around all the great carnivals of the modern world: Rio, Bahia, Trinidad, Mardi Gras in New Orleans and, in Britain, the Notting Hill Carnival which celebrates the cultural heritage of West Indians. (Even when not actually worn, the mask defines the processional - disguised - activity of masquerading.)

As well as serving to underline the importance of certain festive occasions, masks also contribute to the ribaldry and fun of such events by obscuring personal identity. Able to step out of everyday roles and given the licence which anonymity affords, masked revellers can party in an uninhibited fashion. This, of course, is also the special advantage of a masked ball or fancy dress party: the possibility of conducting ourselves in a way which is free of our normal social constraints. (The downside and also the essential inherent danger of such occasions seen in Edgar Allan Poe's chilling short story 'The Mask of the Red Death'.)

Such anonymity no doubt also accounts for much of the popularity of masks within the contemporary 'Fetish Scene' - making it possible to dress, undress or behave in ways which are defined by the mainstream as deviant, immodest or perverse while safely protected from personal identification and censure.

However, it seems to me that the rubber and leather masks which have gained great popularity with 'Fetish Fashion' and often in more extreme and deliberately sinister forms within the 'S/M Scene', also draw upon many of the more ancient functions of masks found amongst traditional peoples. Thus the masked dominatrix embodies magical, even spiritual forces in a way which is not unlike that of the 'primitive' shaman

the actual individual becoming a symbolic representation (in this case, of demonic, Sadeian forces). And the masked submissive, on the other hand, becoming depersonalized in a way which is reminiscent of the tribal initiate - the individual ego being supplanted by a generalized identity of role within the context of a ritual in such a way that an erotic act becomes simultaneously a mythological event.

Our Halloween tradition also revives functions of masks which go beyond that of simply concealing identity. Whether in the form of ancient witches, demons, ghosts and monsters or modern-day superheroes, the masks and costumes worn for Halloween transform mere humans into larger-than-life mythic characters who, if only for one night, are afforded their rightful place in our world. While we typically treat Halloween as an occasion for playful fun and feasting, the masks we wear link us to pre-Christian, Pagan spirits of great antiquity.

Far from being just a bit of fun (and they certainly are that) masks play a vital part in human existence - transporting us beyond our mundane roles and identities to commune with the gods and to break free of those everyday inhibitions which, if always constantly adhered to, would drive us all insane. Reviving our flagging spirits and affording us much-needed escape from the rigorous conventions of modern life, masks are at least as important now as they were in the Stone Age.

Betti:
I sometimes feel like an insect or a creature from fantasy, this I really love! If I want I can almost become my image ... like a shape shifter ... very exciting.

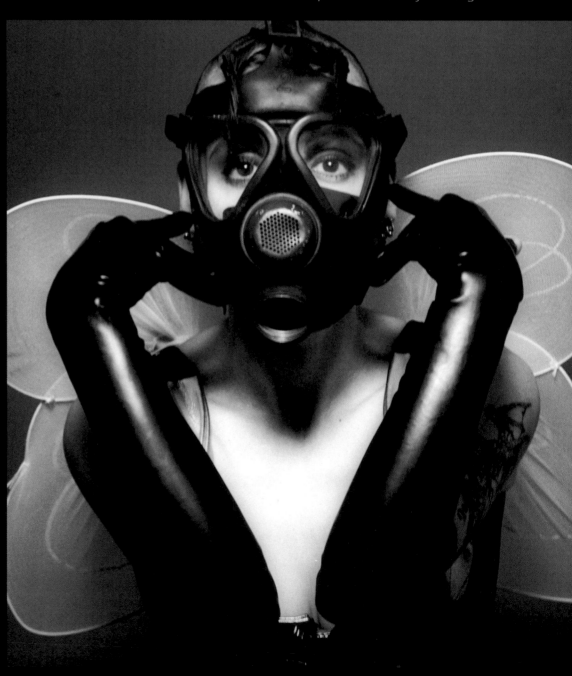

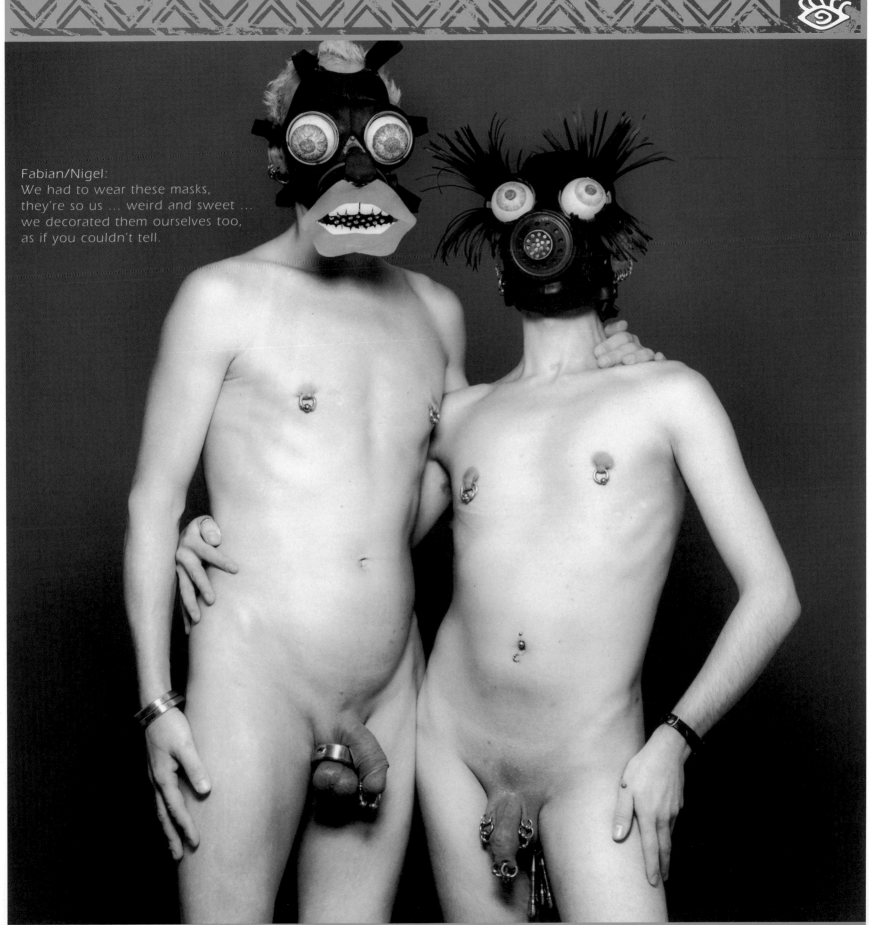

Fabian/Nigel:
We had to wear these masks,
they're so us ... weird and sweet ...
we decorated them ourselves too,
as if you couldn't tell.

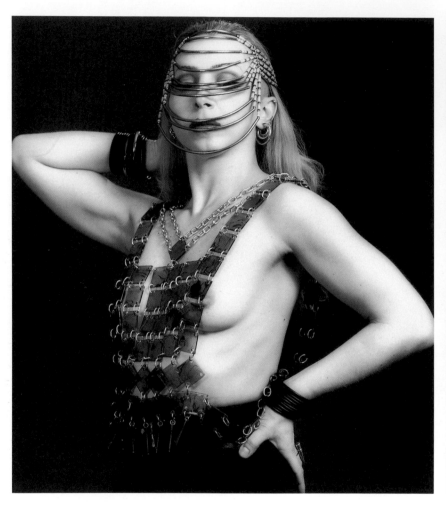

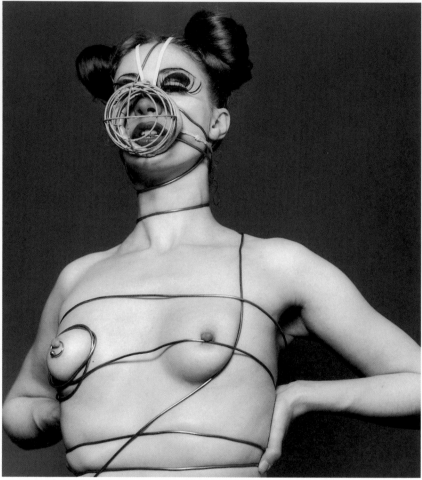

Isa:
I feel very Middle Eastern, like a harem girl, in this mask. It's actually one of my necklaces but it looks so good on the face. The only problem is keeping it in place, the bottom pieces keep falling down and they can end up in my mouth.

Nicola:
Don't ask me why because I haven't figured it out but I like making myself look grotesque. I'll just wrap bits of wire, cling-film or whatever around me and distort my shape. It's probably an extension of my stage persona ... or vice-versa.

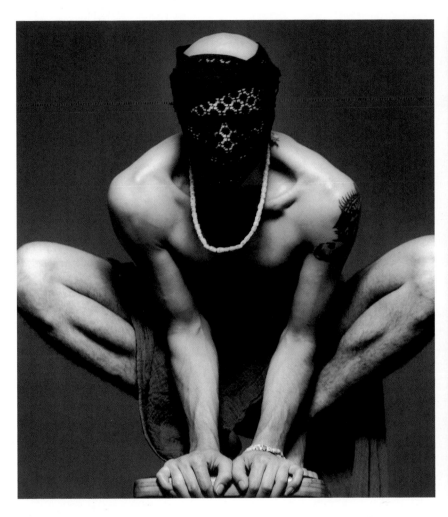

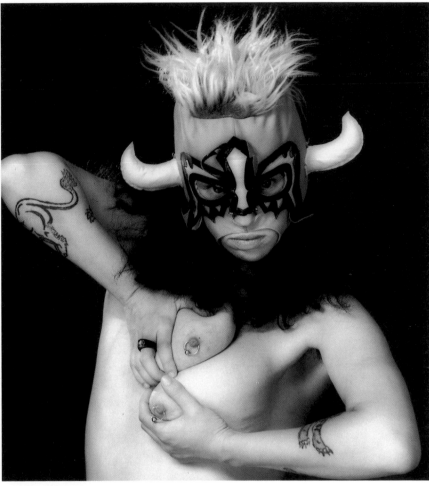

Martin:
I was raised in South Africa and I love the tribal way of presenting yourself. I've always taken bits of cloth and wrapped them about myself … I'm experimenting all the time.

Marissa:
This is a Mexican wrestling mask I'm wearing and it ties into the comic book iconography I've always loved. It's part of my super-hero outfit which I wear to clubs and use in my performances.

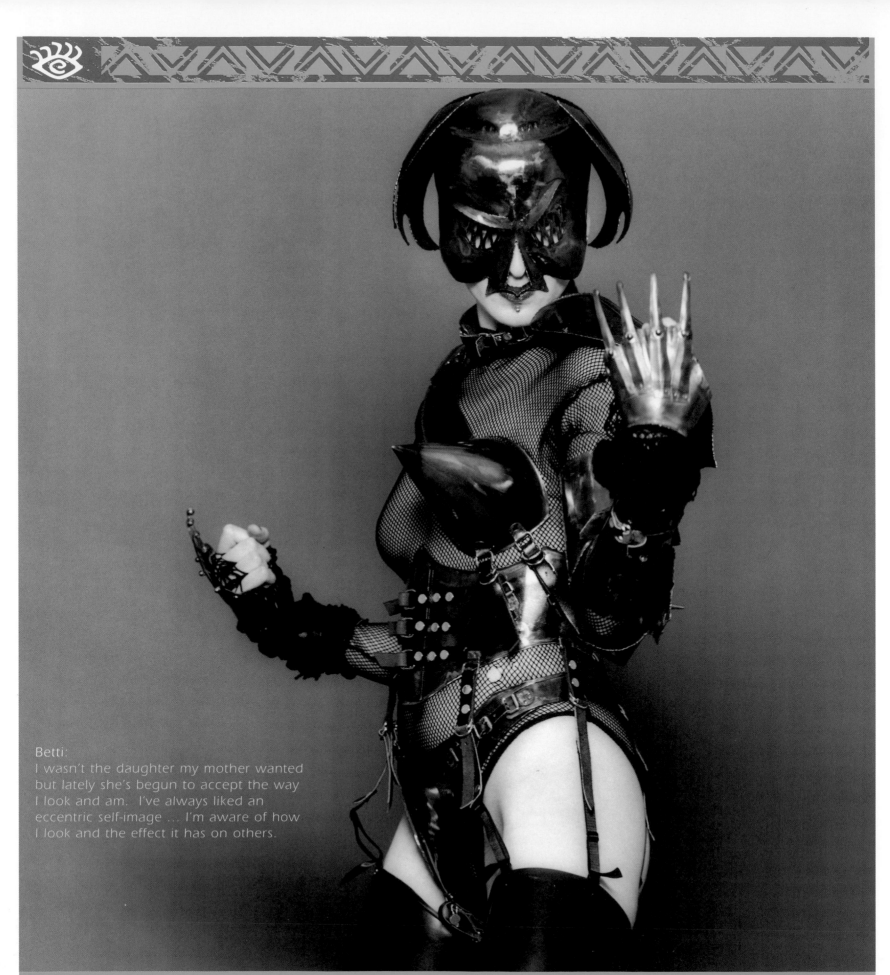

Betti:
I wasn't the daughter my mother wanted but lately she's begun to accept the way I look and am. I've always liked an eccentric self-image … I'm aware of how I look and the effect it has on others.

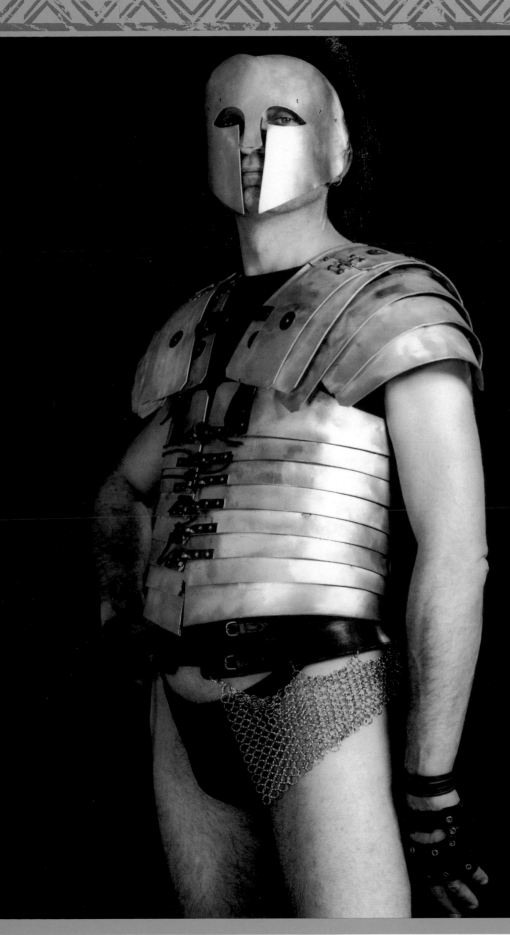

Nick:
I was influenced by H R Giger and his
insect-like designs ... combinations of
organic and inorganic as a living duality.
I wanted to wear an armour, or carapace,
as flexible as possible which is what led me
to the Roman style. My mask is Greek, as
enthusiasts always point out, but I never
intended to make an exact copy, this outfit
will continue to mutate. Once I'm enclosed
in this metal casing I feel powerful.
People don't fuck with you when you wear
a visual statement like this!

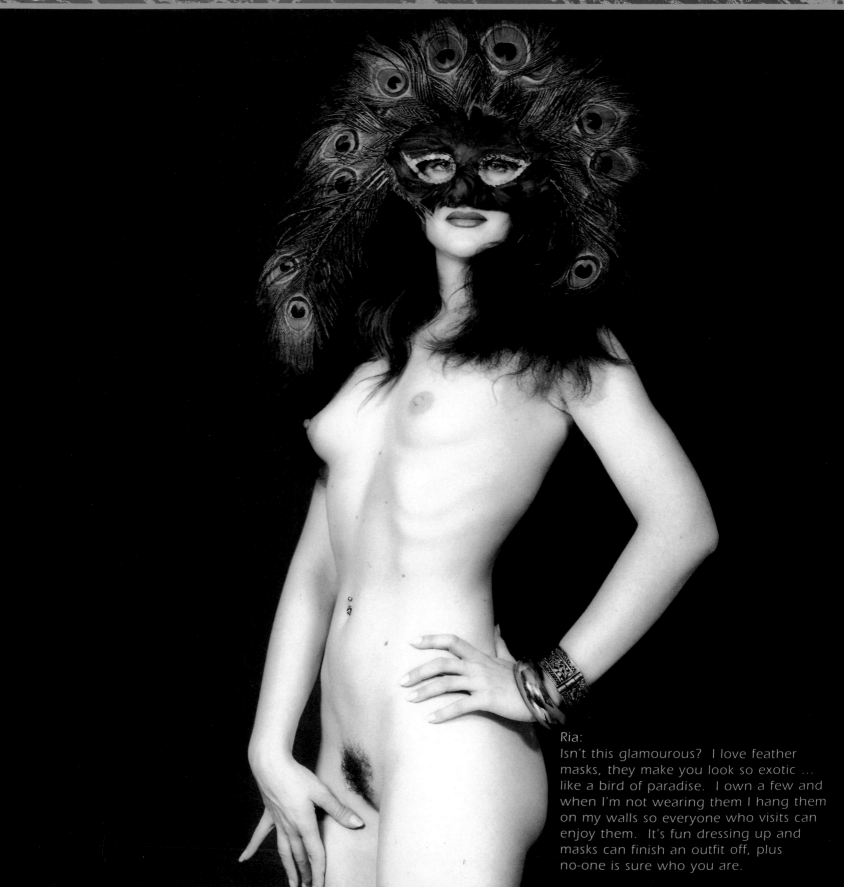

Ria:
Isn't this glamourous? I love feather masks, they make you look so exotic … like a bird of paradise. I own a few and when I'm not wearing them I hang them on my walls so everyone who visits can enjoy them. It's fun dressing up and masks can finish an outfit off, plus no-one is sure who you are.

Giles:

This is my alien surgeon's mask … it really makes me look quite evil. Most of the tubes are just for show, it's more theatrical than functional.

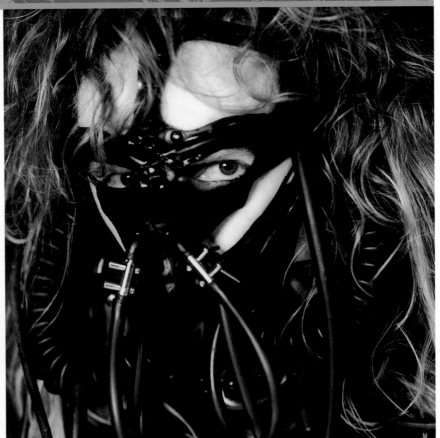

Xandra:

The stranger the better! I love the smell of rubber and I can almost go into a trance when I'm all zipped up and enclosed. I find it a real turn-on. I'm both powerful and captive.

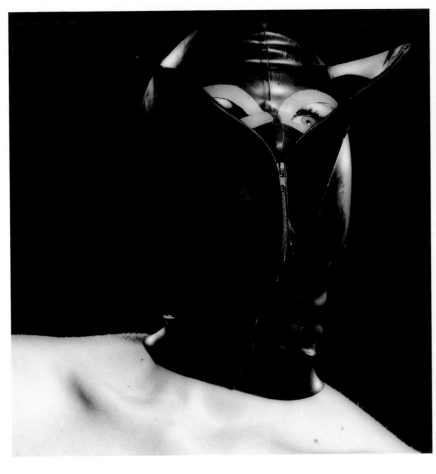

Gaile:

Through the garments and horns I make I can bring the creatures of my imagination to life. Celtic satyrs and fairies. I often wonder if I was a part of this mythical world in another life.

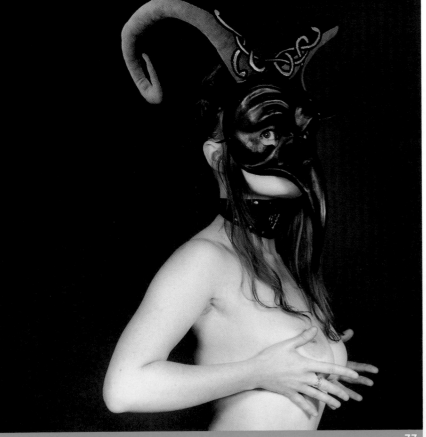

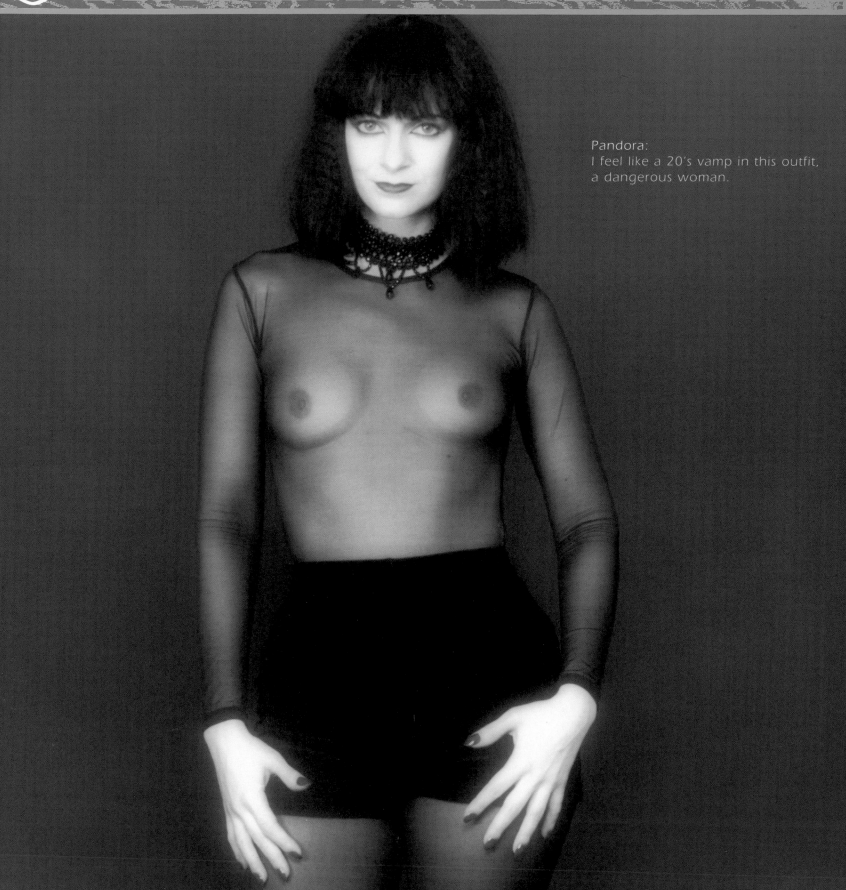

Pandora:
I feel like a 20's vamp in this outfit,
a dangerous woman.

SECOND SKINS

Fur, scales, bark, cellulose, skin . . . all organisms must have some sort of outer covering to serve as a barrier between themselves and the environment; a division between inside and outside. Only we human beings, however, have been able to devise additional membranes - second skins - of our own choosing.

Of course not all humans wear such additional outer coverings. At least until waves of missionaries convinced them otherwise, a great many of the world's tribal peoples (perhaps a majority in the warmer regions of the planet) saw no need to cover those parts of their bodies which Western culture requires to be hidden. This is not, however, to suggest that such peoples possess no sense of modesty.

The definition of modesty varies from culture to culture and fluctuates markedly from one historical period to the next. When worlds collide - that is to say, when markedly different cultures come into contact and conflict - a focal point of this collision is inevitably differing definitions of modest concealment. Inevitably too, it is the victor's definition which prevails. This is, of course, what happened in the great 'Age of Discovery' when Europeans first came into contact with vast numbers of previously unknown 'naked savages'. We won - and century by century, year in year out, it is our Judeo-Christian-European definition of modesty which has prevailed - with once proudly adorned, tattooed, scarified peoples now almost universally hiding their bodies behind hand-me-down, tattered T-shirts and shorts.

Aesthetic considerations aside, there are two distinct reasons why the current near-ubiquity of Western dress is pro-foundly disturbing. Firstly, the missionaries' disdain for the native body arts (all those techniques of customizing the body celebrated elsewhere in this book) has deprived traditional peoples of crucial symbols of their ancient heritage through which their way of life took sustenance. Secondly, despite our own ancestors' unquestioned assumptions, these were never 'naked savages' in the first place.

While the definition of modesty is part of one's culture, a sense of modesty - of shame and, alternatively, of propriety - is an inherent part of human nature. For example, in societies where lip plugs are traditionally worn, to be without one's lip plugs can be a source of embarrassment precisely equivalent to our own sense of shame should we discover that our fly is undone or our skirt has ridden up beyond what we intended. The same is true of the other adornments worn in traditional societies - even a thin coating of animal fat (barely perceptible to our eyes) may be the difference between proper and improper attire. We in the West have never had a monopoly on modesty. (And by the way, what might be termed 'the politics of modesty' has also been subject to dispute within the West: the kilt traditionally and proudly worn by Scottish men was labelled as scandalously immodest by the English who, after their conquest, tried to ban it but succeeded only in making it a symbolic focus of Scottish identity.)

While our clothing has inevitably developed an association with modesty its original function no doubt derived from the more immediately practical need of keeping warm. Indeed, it was the technical advances of clothing which allowed our ancestors to inhabit practi-cally all geographic regions and, crucially, to withstand the rigours of the Ice Age.

In this regard it is interesting to consider the garments of the recently discovered 'Iceman'. Especially so, as this individual's outfit constitutes the earliest surviving example of a 'second skin'. This 5000-year-old Neolithic man's dress consisted of (1) a pair of fur stockings, (2) a leather 'suspender belt' (so to speak) which went around his waist and, as well as serving to hold various objects, held up his fur stockings by means of thin 'suspenders', (3) a leather loin cloth which wrapped under and flared over his belt, (4) a sleeveless fur cape or cloak (its fur sewn in decorative horizontal stripes), (5) an outer cloak made of plaited grass which was also textured in horizontal stripes, (6) a fur cap and (7) leather sandals which were stuffed with grass for added warmth.

A more recent use of the phrase 'second skin' derives from the 'fetish fashions' which have become so popular in recent years. Here the association is with materials like rubber, PVC, Lycra or leather designed to cling tightly to the body and thereby expose its every curve and crevice. The clubs where such garments are worn in their most exotic forms always have strict dress codes to keep out those in casual (non-fetishistic) clothing. The Iceman would have little problem getting in: his fur and leather garments a 'second skin' in both senses of the term.

While clothing has become the cornerstone of modest concealment it has also, in the same process, become a key component of fetishistic allure. That which covers the 'naughty bits' inevitably

acquires the erotic power of that which it conceals. The power isn't eradicated, simply transferred and externalized. Furthermore, our own history would seem to suggest that the more rigorously and extensively the body is concealed, the greater the extent of fetishistic obsession. (Consider, for example, the Victorian era in Britain or the **fin de siè-cle** era of Freud's Vienna which were characterized by both a hyper concern for modesty and, at the same time, endemic fetishistic fixation.)

A fetish is an object which possesses an unexpected, intangible power which is beyond rational explanation. In the West we usually define this in erotic terms. While certain garments (high heeled shoes, corsets, stockings and suspenders) or materials (leather, PVC, rubber or silk) are popularly categorized as 'fetishistic' in actual fact any object can acquire such erotic power for a particular individual. It is simply a matter of personal associations - in particular, the specific circumstances of our early sexual experiences seem to be important.

We are all fetishists - it is simply that some of us are more finely or, conversely, broadly focused than others. In the former case - where one fetishistic association predominates above all others to an exclusive degree - sexual arousal may become totally dependent upon the presence of the fetish object. Most of us, on the other hand, are more polymorphous - finding a wide range of objects and materials sexually exciting (or not) depending upon our own personal backgrounds.

Our culture as a whole goes in and out of periods of fetishistic preoccupation. In the early '60s, for example, the 'kinky'

imagery of **The Avengers,** 'Swinging London', the Psychedelics and sci-fi visions of a sexy future focused erotic attention on certain garments (boots, catsuits, tight mini skirts) and materials (plastics, leather) to the point where these almost eclipsed the erotic power of the naked body itself. By the late '60s, however, the Hippies' pursuit of 'The Natural' brought attention back to the 'liberated' naked body. The '80s and '90s, with their renewed emphasis on 'fetish fashion', have seen another swing of the pendulum.

Conceivably the advent of the next millennium will see the erotic appeal of the naked body once again triumph over that of its 'second skins'. But despite what the Hippies (or their predecessor Rousseau) may have thought, there is actually no such thing as a purely 'natural' human body. Whether it be with garments or with tattoos, piercings, make-up or hair styling, the human body is always a product of culture and personality as much as a product of biology and it is the former rather than the latter which, ultimately, sparks our desires.

Even if it were possible to completely de-customize our bodies to revert to a truly 'natural' state, we would be left with a physicality which was as unenticing as it was meaningless. While the male baboon may be excited by a female baboon's pink, fleshy bottom - a trigger which is purely biological in origin - our sexual arousal is stimulated by a vision of the human form which is defined by our particular cultural and historical circumstances. Our eroticism, inevitably, focused on that supremely unnatural object, the customized body.

Fizzy:
'Why do people wear rubber?' I always
used to wonder about this until I tried
on my first rubber catsuit and realised
how it pulls the right places in ... and
pushes the right places out. It can also
make you feel hugged, held tightly.
I believe in fairies - in this outfit I can
suspend belief and become one myself.
I even wear the wings for sex.

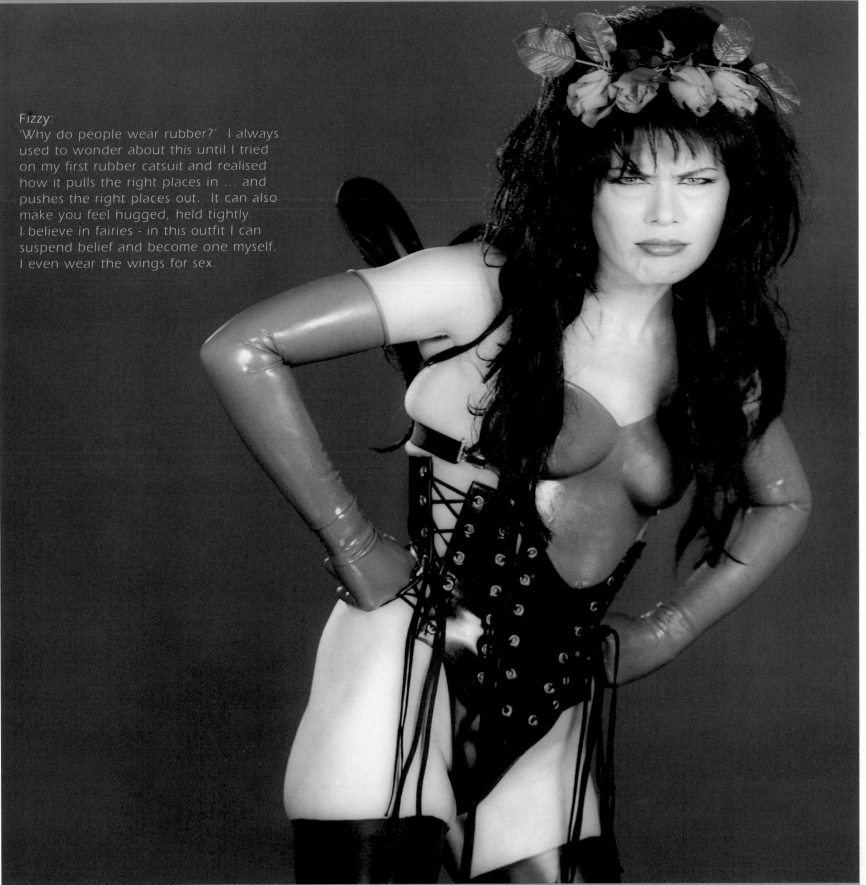

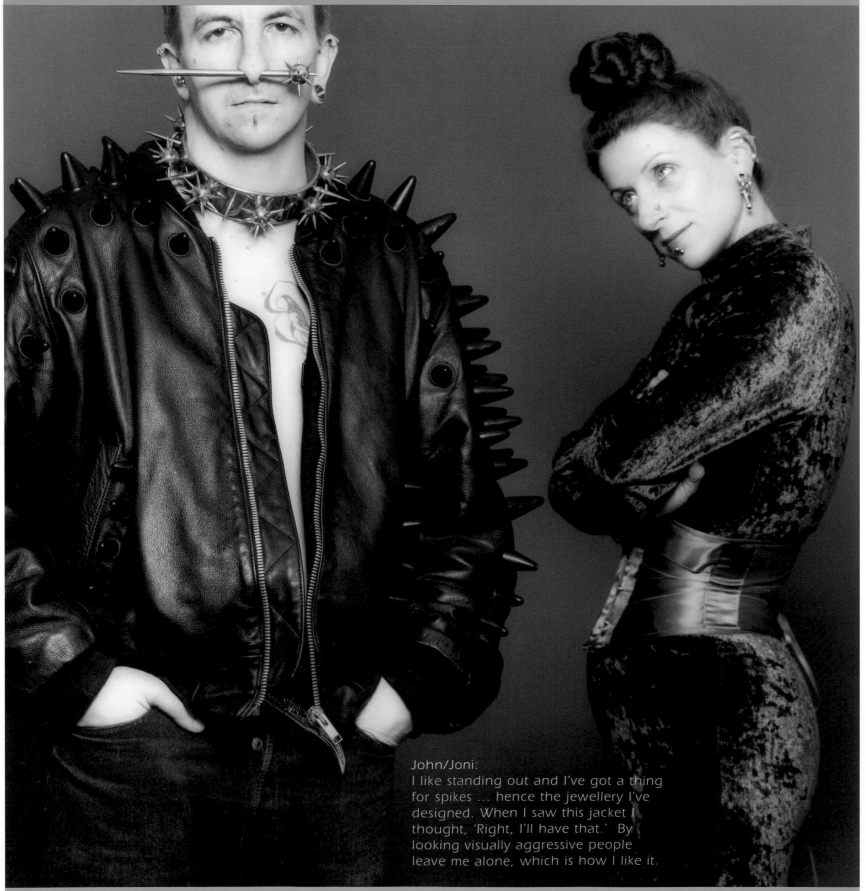

John/Joni:
I like standing out and I've got a thing for spikes … hence the jewellery I've designed. When I saw this jacket I thought, 'Right, I'll have that.' By looking visually aggressive people leave me alone, which is how I like it.

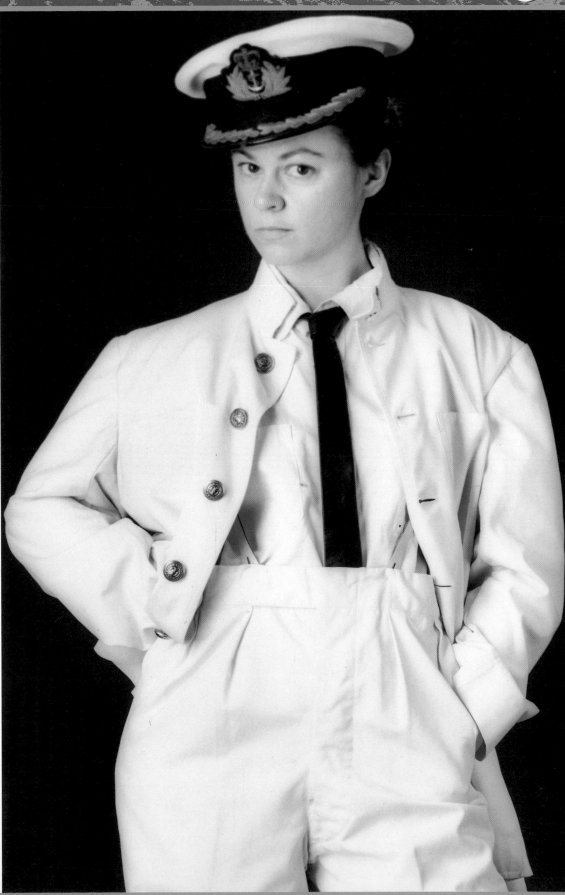

Pia:
It's about which of the infinite number of possible sexual identities you reveal from under the surface, about the power of keeping it a secret under a second skin until you choose to take it off.

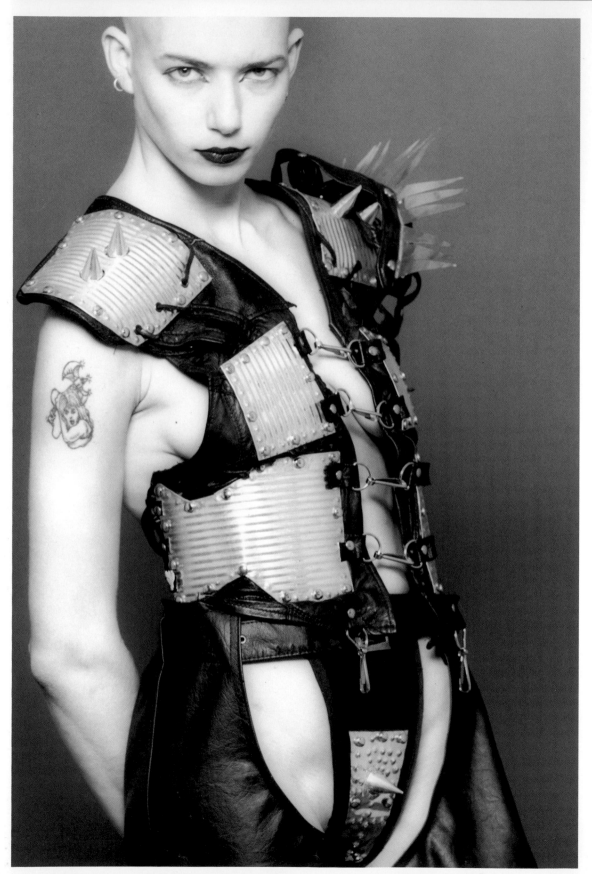

Jed:
My parents saw me as the bright one and so they pushed me to get degrees but it wasn't for me. I wanted to know I could take care of myself, express the real me. This led me to being a survivalist for a while, living in derelict squats and washing in water I had to boil in the backyard over a fire. This armour was made by a friend of mine and I love it. I was the family rebel.

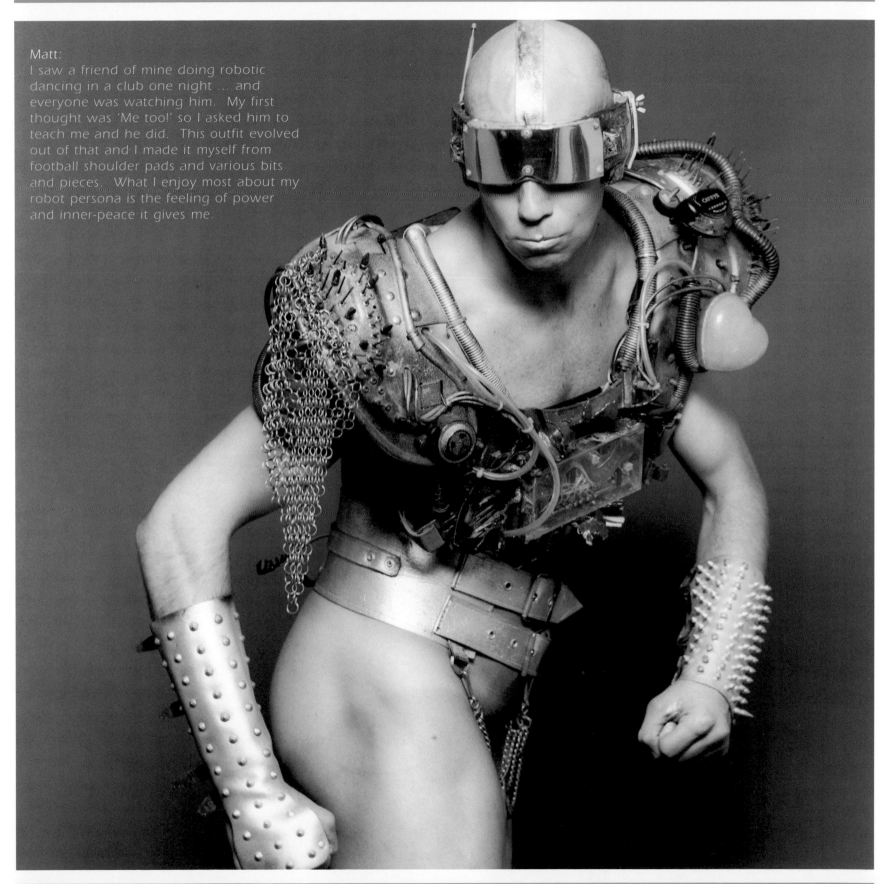

Matt:
I saw a friend of mine doing robotic dancing in a club one night ... and everyone was watching him. My first thought was 'Me too!' so I asked him to teach me and he did. This outfit evolved out of that and I made it myself from football shoulder pads and various bits and pieces. What I enjoy most about my robot persona is the feeling of power and inner-peace it gives me.

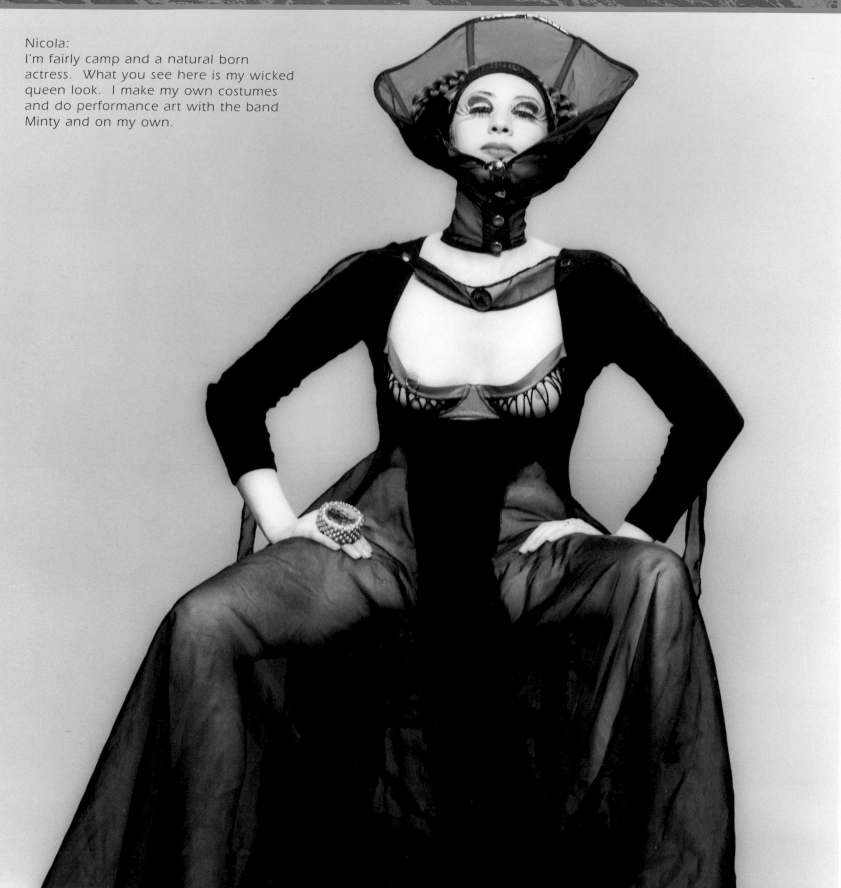

Nicola:
I'm fairly camp and a natural born actress. What you see here is my wicked queen look. I make my own costumes and do performance art with the band Minty and on my own.

Lisa:
If I'm dressing for sex it's important to wear clothes that help bring out that part of me I'm trying to express. When I wear rubber I enjoy the fact that it's vacuum packed on - it makes me feel all sinewy and sensuous. Leather gives me strength ... and I love the smell!

Johnny:
Johnny Chrome and Silver, he's a cyber-punk, super-hero from the future ... that's who you're looking at right now. Don't stare too hard!

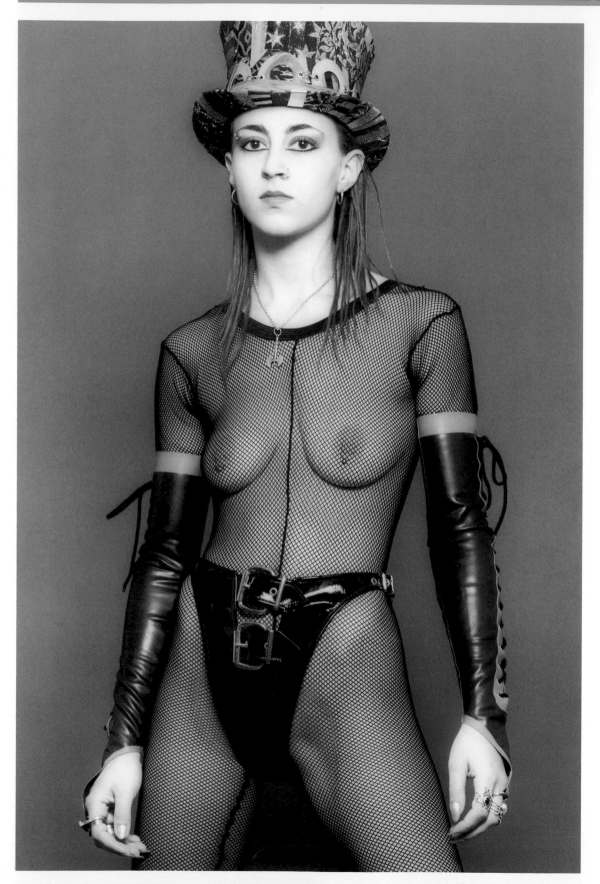

Tracey:
I hate to admit it but appearance is primary for me, just as important as personality. I like guys who really dress up … wear make-up … who really take the time to look special. I do.

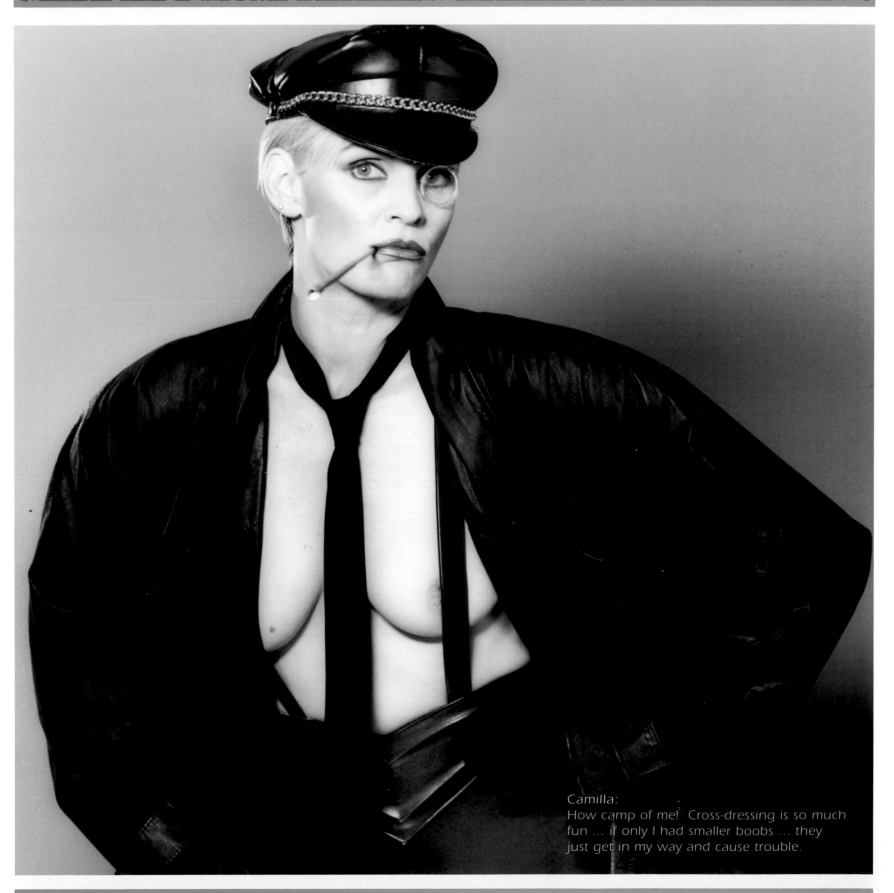

Camilla:
How camp of me! Cross-dressing is so much
fun ... if only I had smaller boobs ... they
just get in my way and cause trouble.

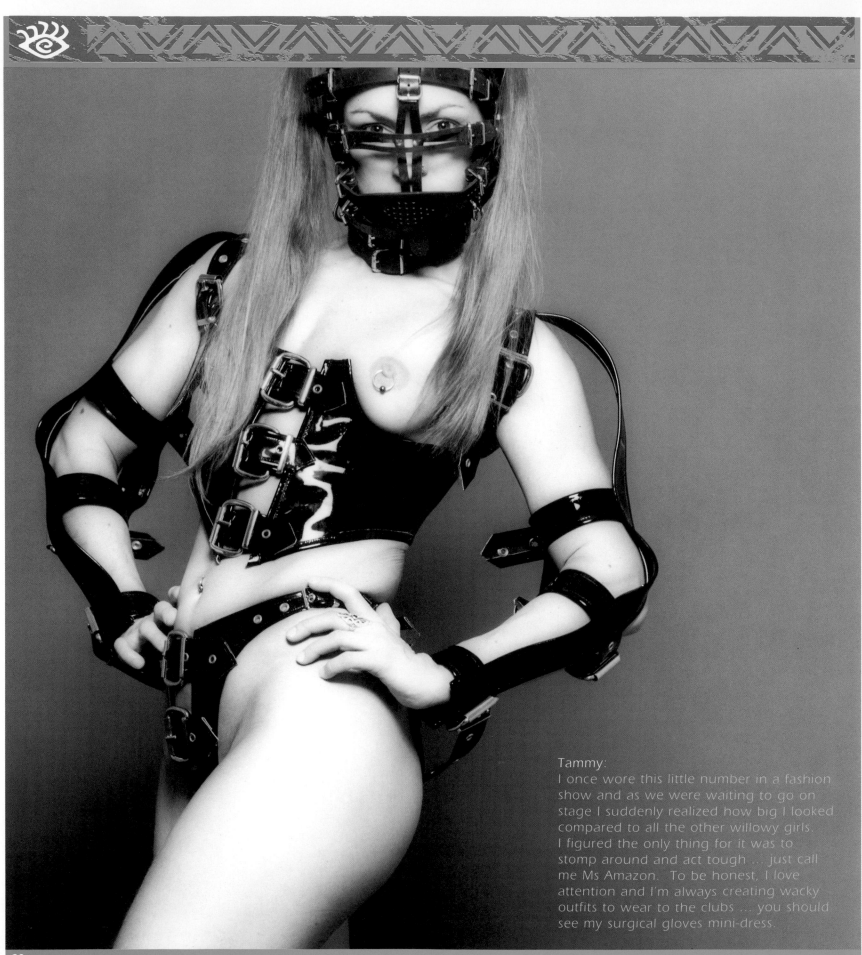

Tammy:
I once wore this little number in a fashion show and as we were waiting to go on stage I suddenly realized how big I looked compared to all the other willowy girls. I figured the only thing for it was to stomp around and act tough ... just call me Ms Amazon. To be honest, I love attention and I'm always creating wacky outfits to wear to the clubs ... you should see my surgical gloves mini-dress.

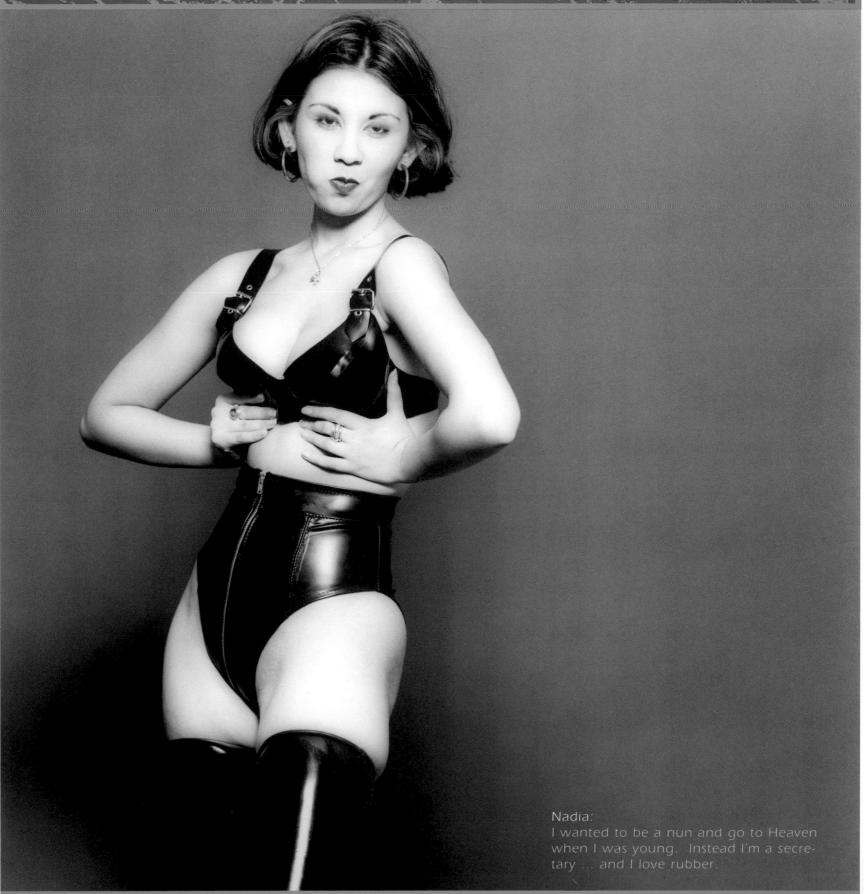

Nadia:
I wanted to be a nun and go to Heaven when I was young. Instead I'm a secretary ... and I love rubber.

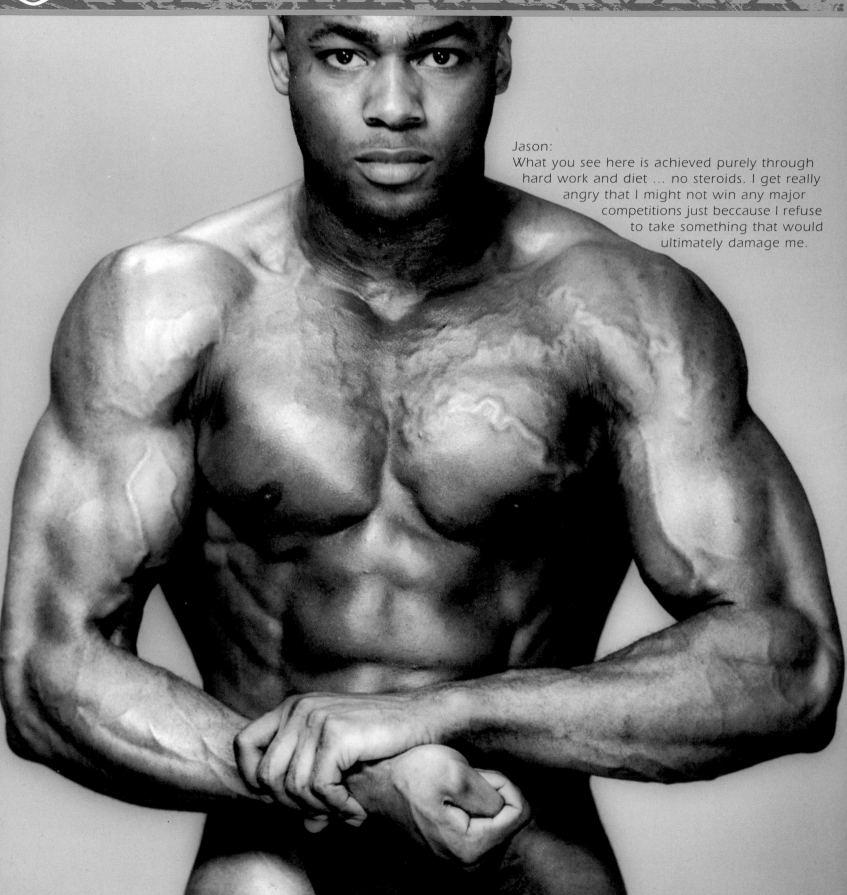

Jason:
What you see here is achieved purely through hard work and diet … no steroids. I get really angry that I might not win any major competitions just beccause I refuse to take something that would ultimately damage me.

BODY SCULPTING

Up to this point we have considered various means of customising the surface of the human body. There are so many of these techniques (painting, scarification, tattooing, piercing, covering) that one would have thought human beings would be satisfied with the seemingly endless possibilities of such superficial alteration. Not only Human history has seen an extraordinary - truly mind-boggling - range of techniques for altering the body's shape as well as its surface.

Perhaps most famously, women of the Padaung tribe of Burma (until quite recent times) had their necks stretched by means of the gradual addition of brass rings, one on top of the other. The process was begun in childhood and once the neck was fully stretched, it is said that the rings could never be removed as, unaided, the neck wouldn't be capable of supporting the head. According to some sources - perhaps this is myth, perhaps not - a Padaung woman caught in an act of adultery would have her neck rings removed and be obliged by the frailty of her neck to spend the rest of her life in a horizontal position.)

Although generally less well known, a more widespread - and equally amazing - technique of modifying the body is cranial shaping. Practised by a wide range of peoples including the Mangbetu tribes of Central Africa, the Chinook peoples of the northwest coast of North America and the ancient Egyptians, this can only be done to newborn infants (whose skull is still comparatively elastic). Cranial shaping is accomplished either by wrapping the skull tightly with fabric to force it to grow in a more conical shape or by means of securing cradle boards to the baby's head front or back to produce a flattening effect. A less extreme form of cranial shaping (partial wrapping with a linen 'bandeau') was practised in rural France until the 18th century.

Although today's 'Modern Primitives' seem determined to revive and develop most traditional methods of customizing the body, 'cranial deformation' (as it used to be termed in the West) is surely one technique which will resist re-discovery. The reason, of course, being that such parental control of appearance runs precisely counter to our contemporary inclination to view customizing the body as an expression of individuality and non-conformity.

The traditional peoples who practised cranial shaping saw things very differently, however. Often permitted only for those born of the upper strata of society, such flattened or pointed heads were the mark of high status and privilege. (The Chinook, for example, had slaves who were immediately identifiable by their naturally rounded - 'ugly' - heads.) Because pointed or flattened heads were seen as both aesthetically and socially desirable cranial shaping was viewed as a parental responsibility rather than an imposition.

Other techniques of body shaping practised in non-Western societies include the use of tight bands to restrict either the biceps or the calf muscles in order to produce a pronounced bulge above and below the constriction, the stretching of the penis with weights (until it becomes dysfunctional) among certain Saddhu religious sects in India and, of course, the well-known footbinding of the ancient Chinese (discussed at length in chapter 5).

While, to my knowledge, foot-binding, cranial alteration, neck-stretching, etc. have not been practised in our own society (but see **Modern Primitives** for descriptions of Fakir Musafar's experiments in California with muscle restriction and penis stretching)

this is not to say that we reject all methods of customizing the shape of our bodies. Far from it. In particular, 'foundation garments - corsets, bustles and, more recently girdles and bras - have served to transform women's bodies into a closer approximation of fashionable ideals throughout much of Western history.

Currently enjoying something of a revival the corset in other centuries (in particular the 17th, 18th and 19th) was seen as a necessary part of a respectable woman's attire. (The phrase 'a loose woman' originally referred to an uncorseted woman. Conversely, a 'staid woman' - meaning steadfast and proper - derives from an earlier word for corset, stays.) Corseting garments have had a fascinating history: swinging back and forth between accepted fashion and conversely, fetishistic innuendo. In Britain during much of the Victorian era it managed to be both - 'strait-laced' on the one hand but when carried to extremes of tight-lacing tipping over into provocative and controversial eroticism. Nevertheless (or perhaps because of these associations) the corset remained very popular even **de rigueur** in certain circles - becoming much longer in the 1890's when it served to thrust the chest forward and the rear backward to produce a distinctive 'S' shape when viewed from the side.

By the 1920's, however, when the ideal woman's body was suddenly boyish, the corset gave way to elasticized girdles and breast 'flatteners' designed to minimize feminine curves. Then, immediately after the 2nd World War, a yearning for a return to a more traditional definition of femininity brought Dior's popular 'New Look' with its pinched-in waist and voluptuous curvaceousness. To achieve this a form of small corset known as a 'waspie' was often necessary. Yet by the 1960s things changed yet again - in part propelled on by the 'Youth

Revolution" - and a straight up and down girlish figure undermined the desirability of any curve-accentuating garments.

Throwing off their foundation garments (the burning of bras, even if mythical, perfectly capturing the spirit of the times), the search for girlish natural slimness focused interest on an entirely different method of altering body shape: dieting. While dieting has also been practised in non-Western, traditional societies, the desired result was typically the precise opposite of ours. For example, in parts of West Africa girls whose families could afford it were sent to a 'fattening house' where, after months of eating weight-inducing foods and taking as little exercise as possible, they emerged to face inspection by potential husbands.

Strange to our eyes, the equation of plumpness and beauty is perfectly logical in societies when food is scarce and fat is, therefore, a status symbol. Judging from the extremely rotund 'Venus' figurines which have survived from the Upper Palaeolithic period (some of the oldest examples of sculptural art) it is clear that the notion that 'Big Is Beautiful' represents the original human beauty ideal. (While our current 'Less Is More' ideal may prove to be simply a short-ived, curious historical blip.)

At the same time, however, it would be a mistake to assume that plumpness is seen as desirable everywhere outside the West. To achieve a trim, slender waist corsets have long been used by some tribal peoples from as far afield as New Guinea and Africa. Interestingly, in all the cases of which I am aware it is men rather than women who wear such constricting garments. For example, amongst the Dinka peoples of Sudan the men day in and day out wear beautiful, long corsets which are made of thousands of colour beads, which flare up dramatically

in the back to a point above the shoulders and are actually sewn onto the men's bodies - to be removed only when replaced by one of a different colour to indicate a change of age status.

Are there techniques of body-shaping found only in the West? Perhaps body building and plastic surgery can qualify in this regard. Deprived of exercise - obviously a necessity in traditional societies - many Westerners are drawn to a physical ideal which harks back to earlier, more physical ways of life and, to compensate, have developed extraordinary technology and exercise/dieting regimes specifically designed to 'pump up' muscle tissue. In the process, champion body builders (now female as well as male) have created forms of physical development which have never actually existed previously.

In the area of plastic surgery, while our technical accomplishments are without equal, our motivation falls outside the usual sphere of customizing the body in one important regard. As with most of our mainstream make-up, the objective of the plastic surgeon is always to remain invisible - to artificially enhance the 'natural body' without being seen to do so. This is very different from all those traditional body arts which proudly proclaim their artifice and which, amongst other things, serve to set human beings apart from 'nature'. Of course, in the process we delude ourselves. The ideals of 'natural beauty' which the surgeon so skilfully seeks to create are actually only our own inventions - a product of culture rather than biology - and, as such, they are subject to the caprices of fashion. This is not to argue one way or the other on the desirability of plastic surgery, only to
question if it deserves to be classified as a 'body art' in the same sense as tattooing, scarification, piercing, cranial shaping, neck-stretching. In my view, an art must proclaim

itself as such rather than hide behind a façade of 'natural beauty'.

There is one fascinating exception. The French artist Orlan has, for several years now, undergone a series of plastic surgery operations which explicitly defy the normal expectations and motivations of such procedures. Orlan's objective isn't to make herself more beautiful - indeed, her latest operations shift her appearance precisely in the opposite direction. 'An art form for the 21st century', The Reincarnation of Saint Orlan project began when Orlan combined elements from great female icons (Mona Lisa's forehead, the chin from Botticelli's Venus and eyes from Gérôme's Psyche, etc.) in a computer generated self-portrait. Then, in a series of cosmetic surgery operations which were videoed and beamed by satellite to art galleries around the world, Orlan's face was actually altered to fit this digital image.

The next stages of the project depended on Orlan finding plastic surgeons (in New York and Japan) prepared to work towards a result which would be deliberately in contradiction to our accepted definition of beauty. In 1993, in New York, she had a series of implants normally used for accentuating the cheek bone, inserted above her eyebrows to create 'horns'. The next stage, in Japan, will involve the conversion of her small, pert 'attractive' nose into an enormous, bulbous one. What she really wants is a nose like a rhinoceros' but surgeons tell her that this may 'only be possible in 50 years' time'.

A true 'Modern Primitive' Orlan is blending Western science and ancient body art objectives - freeing the body from its biological inheritance and making it an expression of the human imagination.

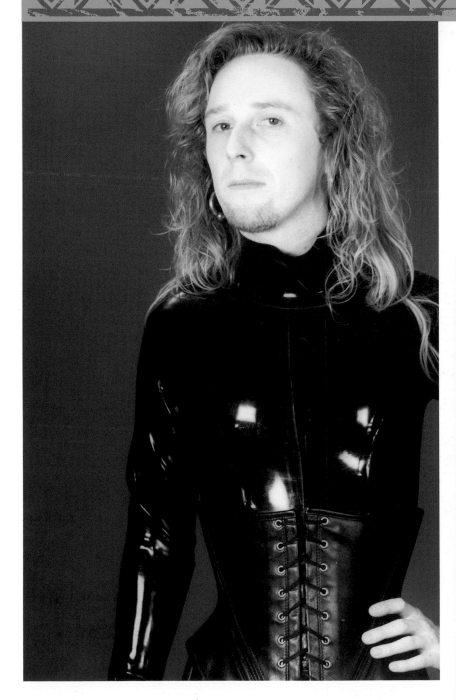

Giles:
I've always constricted my waist with belts. When they're pulled tightly around my waist I feel stronger, more supported. I don't like wearing loose things. I don't really wear corsets very often but when I do I become quite intense and disciplined, this gives me great pleasure. One of the reasons it took so long for me to come to be photographed is that I gain weight easily. I'm not always pleased with my shape but I'm slim enough now.

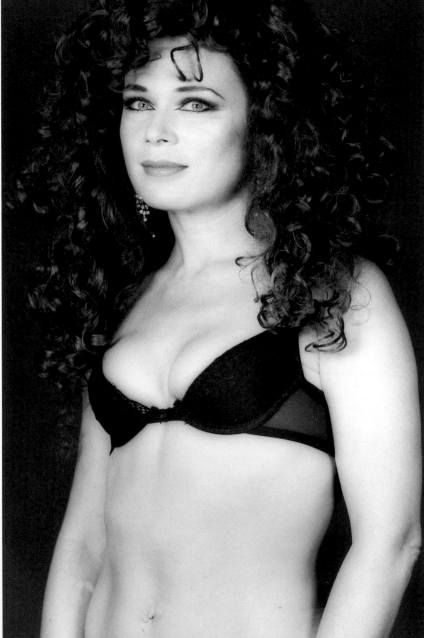

Fizzy:
I've always wanted a cleavage and never had one, so when my boyfriend gave me my first Wonderbra I was over the moon! To be honest it's a little bit like wearing a cage ... it's very tight ... but it's worth it.

Shelly:

I have large breasts, womanly hips and a small waist ...I'm not always comfortable with my body. When I wear a corset and accentuate and control my shape, it creates an image I can accept more easily.

Ria:

These old-style girdles are great, stretchy yet still firm enough to keep that tummy in. I feel like my mom when I wear this one but I'm a lot naughtier … I think.

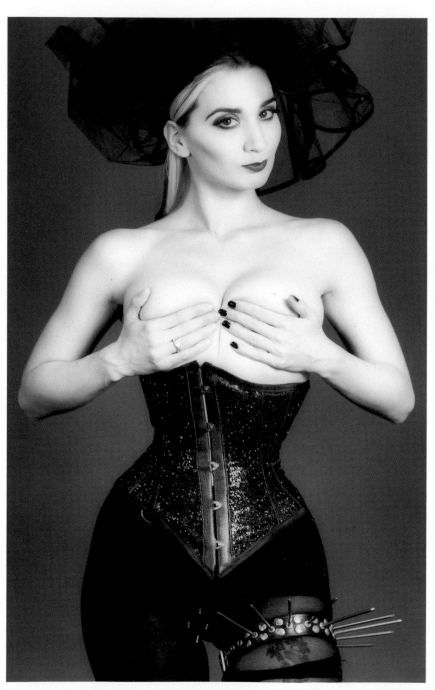

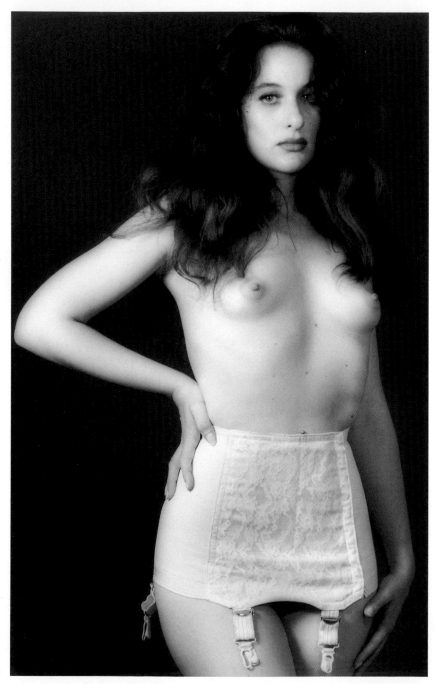

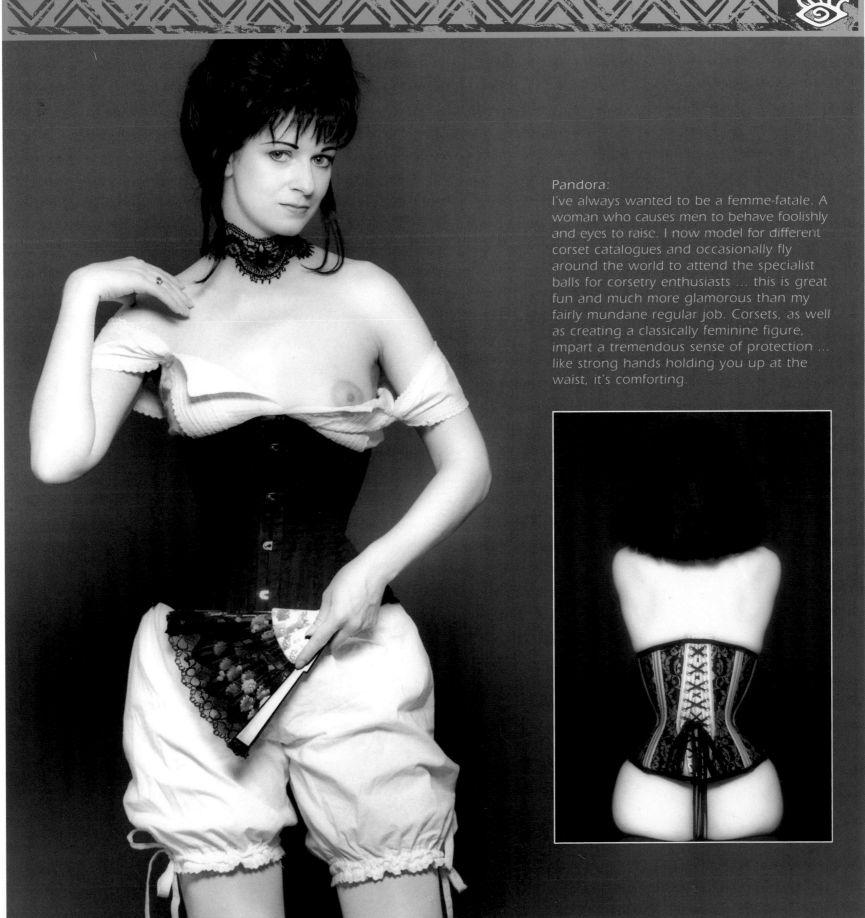

Pandora:

I've always wanted to be a femme-fatale. A woman who causes men to behave foolishly and eyes to raise. I now model for different corset catalogues and occasionally fly around the world to attend the specialist balls for corsetry enthusiasts ... this is great fun and much more glamorous than my fairly mundane regular job. Corsets, as well as creating a classically feminine figure, impart a tremendous sense of protection ... like strong hands holding you up at the waist, it's comforting.

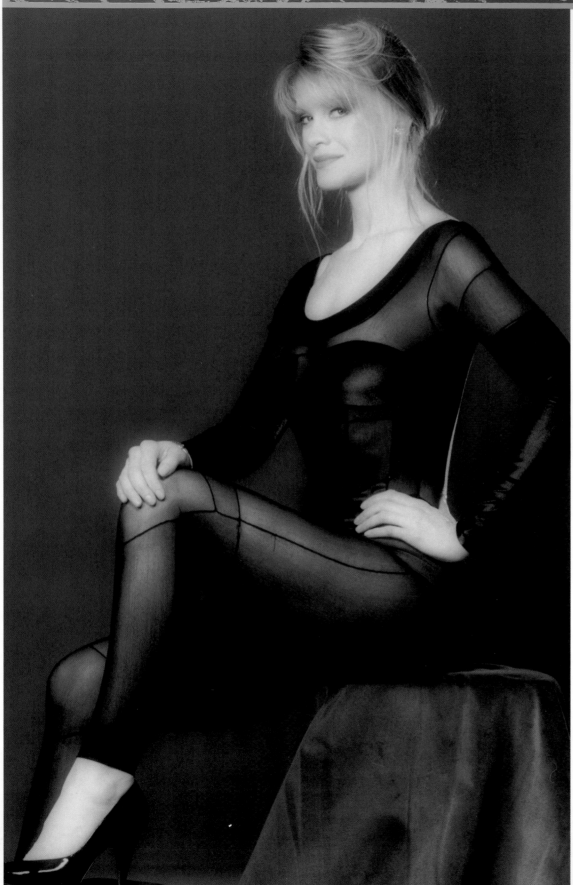

Cindy:

I was an ugly duckling before transforming myself through plastic surgery. No one of any importance used to look twice at me and yet now, I'm fêted and talked about ... interviewed on prime time T.V. For those of you who would dismiss me as a bimbo for modelling myself after Barbie Doll, I happen to be a member of Mensa. If you think about it for a moment it makes sense ... Barbie Doll is the most famous and loved creation there is in terms of femininity ... I want some of that. I've had over 30 operations, some of them fairly experimental. I'm having a major one soon after this particular photo shoot, a chin reduction ...pretty drastic but it must be done! The problem is that as I attain my goals I have to then go back and get earlier work redone to match the latest ... it's never ending.

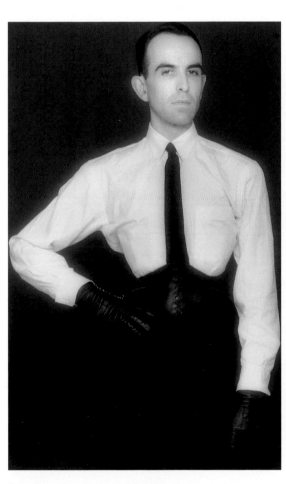

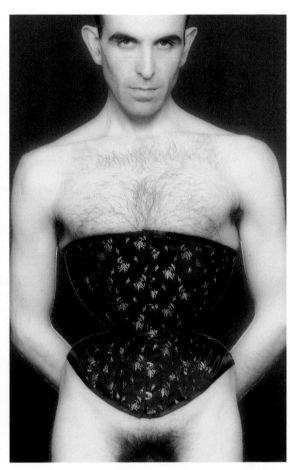

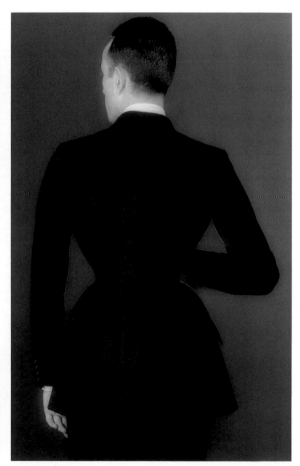

Pearl:

As a child my brother and I helped lace our grandmother into her corsets and afterwards I used to enjoy dressing up in her clothes … that's the only explanation I have, tenuous as it is, for my obsession. It was on a visit to the States that I saw my first truly tight corsetry and knew what my destiny was. It takes tremendous will and determination to live like this and it's given me a focus that was previo

usly absent. My waist has been reduced from 30" to 17" during the four years I've been training it but there are sacrifices. Because I can now only use the top half of my lungs I tend to only speak just above a whisper and my food intake needs to be little and often. 'I must also have plenty of spare time, both in getting somewhere and returning, for if I was to be late and become anxious the stress

could possibly kill me … I might suffocate. It's all worth it. You see, I spent many years drifting and almost penniless whereas now, I'm doing beading on the clothes of many top haute couture houses and making corsets myself. This was unthinkable before. Sex is good too, the pressure creates an intensity that can make you swoon … would you consider wearing such a thing?

Isabella:
Tiny shoulders and a big bum, that was me before ... I wasn't too happy with my body. Luckily I respond quickly to weight training and I've managed to achieve what you see in just 10 months. Being an attention-lover, the thought of winning competitions and being noticed and admired really appeals to me.
I don't want to become massive though, just defined and shapely. To tell the truth I like to attract men and most of them don't find Olympic size women very sexy.

Brian:
I use steroids intermittently but I still need to keep a close eye on my intake. I'm gay and basically want to attract a certain kind of man … I'm not interested in competition, just masculinity and sex. Although I've never thought of myself as effeminate, subconsciously I'm probably still proving something. This is where the danger lies. With steroids you get such a dramatic size increase to begin with everyone suddenly wants you. Then they get used to your new size and you don't get noticed so much. If you're not careful, that's when you start overusing them … to get that attention again.

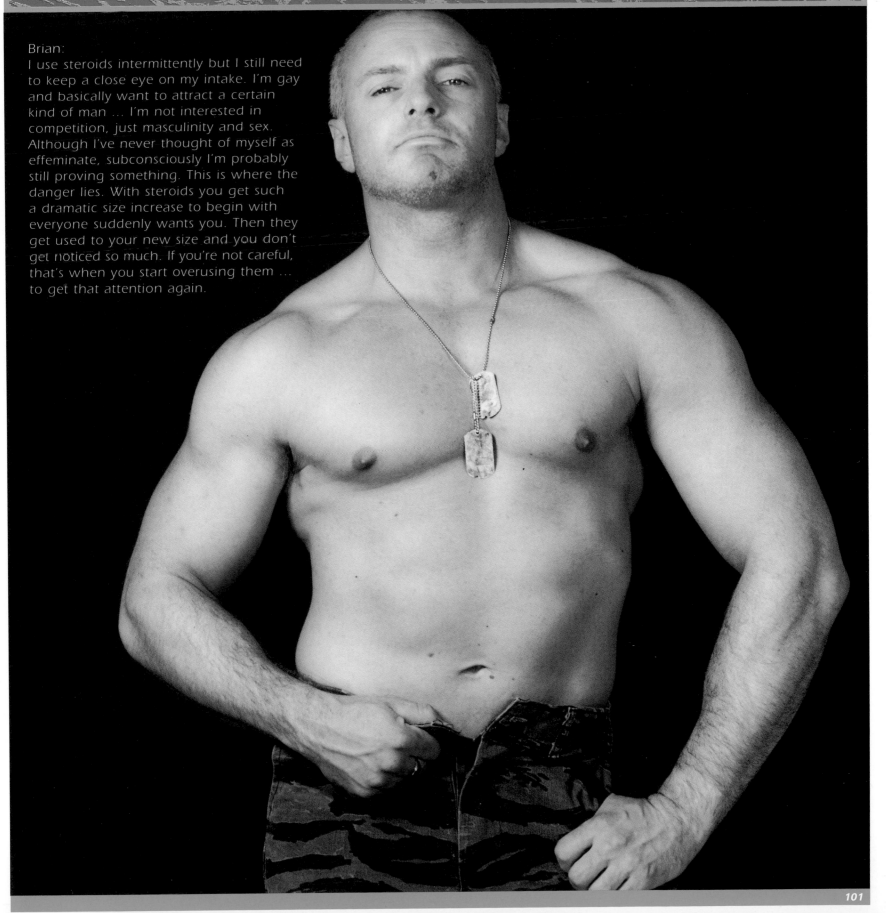

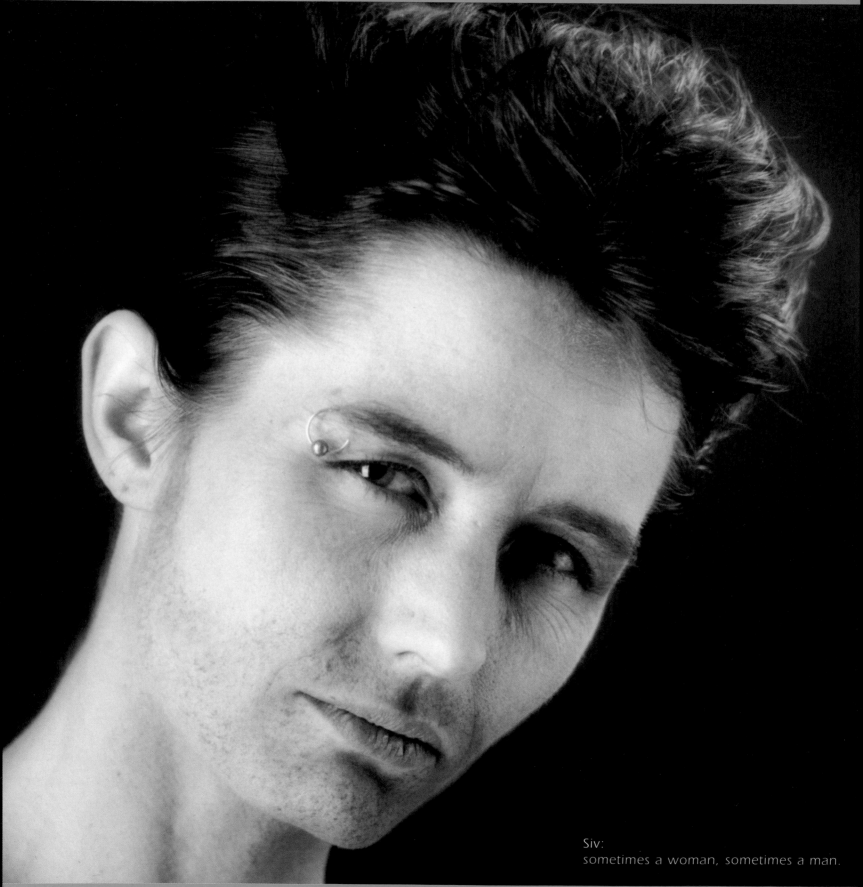

Siv:
sometimes a woman, sometimes a man.

The human body has traditionally been available in two basic models: male and female.

That it is now possible to transform a male body into a female body (and, less easily, the reverse) would surely amaze tribal and peasant peoples - even those who have perfected and take for granted those, often astounding bodily transformations previously discussed in this book. But however technically advanced, these operations should be seen as a different kind of customizing of the body than previously considered body arts like tattooing, scarification, piercing or adventurous hairstyling.

To stretch the neck beyond its natural length, to shape the skull into a point or even to simply paint the skin blue with pink spots is to boldly go where human biology never foresaw nor intended. To re-shape a male penis into a female vagina is, on the other hand, to remain completely within the definition of the natural body. One biologically defined body is simply being substituted for another. As with almost all of Western plastic surgery, physical 'gender reassignment', while an extremely artful technique, isn't a body art which incorporates a creative, imaginative leap beyond genetically determined physical reality. As with a 'nose job' or a 'tummy tuck', the objective, the ideal, is that the transformation of the body involved should be invisible and undetectable. While the individual transsexual is transformed, no new - artificial and hence artistic' - model of human appearance results.

This distinction has important - practical - ramifications. Focusing on gender as a physiological phenomenon (a matter of genitalia, breasts and buttocks), gender reassignment neglects the enormous extent to which gender is a cultural phenomenon. To be a man or a women in, say, New Guinea, Bali or the Amazon is a very different matter from being a man or a woman in our own society. And, indeed, the same is true of Western society in previous centuries. By focusing on gender as a purely physical matter - and by proposing a purely physical 'solution' - we side-step a crucial question: isn't it possible that it is our culture's definitions of 'masculinity' and 'femininity' which are urgently in need of reassignment?

Human beings have always constructed separate, distinctive 'male' and 'female' identities. Differing from one society to the next, one era to the next, such identities are learned rather than genetically inherited. Is there a physiological bottom line of gender, a universal territory of maleness and femaleness which is found in all societies? Perhaps, but what is undeniable is that most of what we label as 'typically male' or 'typically female' derives from the specific social and cultural world which an individual happens to be born into.

Speech, gait, posture, gesture and so forth all play an important part in any society's construction of 'male' and 'female' identity. But it is different rules and possibilities for customizing the appearance of the body which most immediately and vividly sets the sexes apart - thereby introducing yet another important function of body decoration and adornment.

For example, amongst the Nuba it is males and only males who spend long hours painting intricate designs on their bodies while it is females and only females who have detailed patterns of scarification etched into their skin as they progress through life. In societies where clothing is worn differences of dress (for example,

trousers for men, dresses for women) also serve to visually differentiate the sexes. Whatever the medium used - paint, scarification, hairstyles, piercings, neck stretching, attire, etc. - there is always some distinctive feature of how the body is customized which signals that someone is a 'real man' or a 'real woman'.

The purpose of such visual differentiation, however, extends far beyond that of simply distinguishing one sex from another. Indeed, in societies where clothing is minimal, tightly fitting or non-existent, there is no need for such visual coding - nature's own gender indicators performing this task perfectly well. Rather than just signalling 'This is a man/woman' the real function of gender-specific adornment or dress is to give some symbolic clue to how a particular society defines masculinity and femininity in a broader sense. That is, in any society the differences between 'proper male attire' and 'proper female attire' underline and define key assumptions concerning 'proper male behaviour' and 'proper female behaviour'. Compare the two styles and what results is an instant visual guide to 'proper' relations between the sexes as defined by that culture.

For example, it is apparent from the differences of male and female body decoration amongst the Nuba that they view males as more creative and individualized than females (who must conform to and accept decorations which are as uniform and traditionally determined as they are permanent and painful). Likewise, in our own society, the (now rather old-fashioned) view that women should wear draped dresses or skirts while men alone can wear bifurcated trousers implies - and, indeed, imposes in a very practical sense - limitations on what sort of activities are and are not suited to women. At the same time

our society's traditional view that women and not men can be highly adorned and decorated (a subject we will return to in a moment) underlines an assumption that men are more 'practical' and 'serious', women more 'frivolous' and 'superficial'.

In this way gender-specific differences in the customized body function as indicators not only of what sex a person is but also as a symbolic expression of the culture's definition of 'masculinity' and 'femininity'. In short, differences in how the body is transformed according to gender serve to define - to express, visualize, represent and explore - gender itself.

For this reason, whenever someone challenges and refuses to comply with their society's rules of what a male or female should look like they are challenging far more than simple aesthetic principles. As in the recent Western instances of female 'Bobby-soxers' in jeans, male Hippies with long hair or male Glam Rockers or Goths in make-up, it is the very definitions of 'male' and 'female' which are being questioned - as is, ultimately, the significance of gender.

Many traditional societies, rather than belligerently resisting such 'gender bending', found ways of accommodating and even institutionalizing it. Most famously, in a wide band of North American Indian tribes stretching across most of the Plains and the Prairies, those who wore clothing or adornment deemed appropriate for the opposite sex were simply reclassified in a sort of 'Third Sex' category known as the **berdache**. Included here were males who dressed in female attire, females who dressed in male attire and members of either sex who chose some blend of the two styles. Instead of being ostracized, **berdaches** were generally afforded a higher status - being typically seen as spir-

itually powerful individuals. Likewise in many parts of India, the **hijra** (transvestite or eunuch males) are traditionally given special spiritual duties which are believed to confer good fortune on a newly born male child and its family.

The point is that those who defy the rules of a culture's definition of appropriate male or female customized appearance can either be classified as a positive or a negative anomaly. In the West it is, of course, usually the negative reaction which is most typical. At least in recent times, this has been especially true when men have adopted those forms of adornment and dress traditionally associated with women. While once even female athletes were ostracized if they dared to wear trousers or, heaven forbid, shorts, this battle has now been largely won and a woman in leggings or jeans is seen as completely normal on all but the most formal social occasions.

A man in a dress, stilettos and make-up, on the other hand, is still likely to be harshly ridiculed. Unless, of course, 'she' is a model or an entertainer. In which case the negative flips into the positive to confer a special status which isn't that far removed from that of the Native American **berdache** or the Indian **hijra** - conferring in some instances (e.g. Quentin Crisp, Bowie, RuPaul, Winston, George O'Dowd) not only fame and fortune but even a certain aura of spiritual or magical power.

For the ordinary man in the street, however, skirting with feminine attire and adornment remains a risky business. While the same might well be said of men in most traditional societies (a Nuba male who wanted to indulge in scarification rather than body painting would no doubt have a very hard time of it) we Western males face a particularly acute problem because our

society's views on appropriate male appearance are so unusually restrictive.

It was not always so. Up to the time of the French Revolution the Western definition of masculinity gave plenty of scope for painting and preening and generally exploring in a creative way the expressive possibilities of the customized body. After the French Revolution (in part because the bourgeoisie wanted to distance itself from the excesses of the aristocracy by emphasizing boring, bland respectability) Western men suffered what the social psychologist J. C. Fluge has termed 'The Great Masculine Renunciation' - that is, a renunciation of what was once called 'finery' and which included everything from the use of bright colours in dress to exotic hairstyles, the use of make-up to the wearing of sexy shoes. The result was what might be termed The Invisible Man - a creature strangely cut off from that long and wonderful history of the human body as a medium of creative expression and artistic experimentation.

As we have seen time and time again throughout this book it is more often than not the male of our species who has delighted in the status of 'peacock'. 'The Great Masculine Renunciation' of the West has effectively excluded men (and with ever increasing Westernization, now includes practically all male **Homo sapiens**) from that arena of bodily expression which - as this book has tried to show - constitutes a primary, fundamental and necessary component of human behaviour.

While the great majority of men have simply accepted this state of affairs (probably not even realizing their loss) a minority have fought back. Dandies, Hipsters, Bikers, Mods, Hippies, Psychedelics, Glam Rockers, Punks, New Romantics, Rappers, Ravers, Modern Primitives and others have all

pushed against the restrictions on male adornment which Western society has decreed be 'normal'. Battles have been won but the war is far from over. Despite enormous media excitement about 'unisex' and 'gender bending' it is still the case that a man on the street wearing, say, a bit of eye shadow or lipstick (our society's last preserve of the ancient art of body painting) risks verbal harassment at the very least.

Faced with this situation many Western males have simply opted to switch their gender identity - either temporarily in the form of the transvestite or permanently in the case of the transsexual. While the latter option - that of actually, physiologically switching one's gender - has only been available in recent times (the first successful male to female 'sex change' was performed in the 1920s) the former option, a substitution of the adornments, attire and mannerisms associated with one gender for that of the other has probably existed throughout human history. There have always been and presumably will always be a small percentage of people (both males and females) who grow up feeling that their true self is 'trapped' in the body of the opposite sex. What is, however, noteworthy about transvestism in our contemporary world is its dramatic and ever-increasing impact on mainstream society.

In the cinema, the theatre, popular music, club culture and the phenomenal success of events like New York's 'Wigstock' festival, we see evidence of a pervasive preoccupation with transvestism - with the 'drag queen' a (perhaps **the**) key iconic image of our age. To some extent, this simply - but significantly - reflects our culture's growing confusion and concern about gender identity itself. As the consensus which existed only 20 or 30 years ago about what is 'typically male' or 'typically female' has been

questioned and challenged, our culture (and, ultimately, we as individuals) enter a period of 'gender crisis'.

While spotlighting the transvestite as a popular icon, this contemporary 'gender crisis' has also prompted another response - one that is less imitative and straight-forward, more complex and potently creative. Increasingly, literal cross-dressing has given way to a freer, less stereotypical, approach which simply ignores categories of 'male' and 'female' style altogether. Both within and without the 'Drag Scene' (for example, amongst 'Modern Primitives' and the 'Fetish Scene' as well as amongst so many of those flocking to New York's 'Wigstock' or clubs like London's 'Kinky Gerlinky') one today finds more and more men who are experimenting with ways of adorning, decorating, dressing and customizing themselves which, while defying traditional Western notions of masculine appearance, are also largely outside our traditional notions of femininity. Instead of simply switching male for female attire, these 'Angels' (for like the biblical creatures they are not men and not women) are creating a 'Third Sex' - one which embraces all and every possibility of the customized body.

As with all stylistic revolutions, this reflects an important ideological shift: the growing view that personality and potential are not - or need not be - defined or limited by one's sex. Weaving together arguments put forth by feminists, Gays and Lesbians, those within the ever growing ranks of 'The Third Sex' are vividly translating new ideas about gender into visual reality.

This marks an entirely new development in the history of the customized body. While in all previous societies and eras your biological gender defined and restricted what

you could and could not do to transform your body, a new age is slowly but steadily dawning in which your genitals may play no part in determining your appearance. And just as some men are kicking back the boundaries of 'The Great Masculine Renunciation' - embracing peacock-like colour and 'frivolous' adornment - some women are increasingly experimenting with body arts like tattooing which were once seen in the West as a purely masculine preserve. The phenomenal rise in body piercing combines both tendencies: males embracing a delight in jewellery which was previously seen as 'unmanly', women going far beyond previous (Western) definitions of what constitutes 'feminine' adornment.

Incorporating so many ancient, pre-Western techniques of customizing the body - irrespective of whether our culture defines them as 'masculine' or 'feminine' - these modern-day 'Angels' mark a return to those 'primitive' visions of the body which have for so long been ignored or even denigrated in our culture. But, at the same time, such 'Modern Primitives' are in the forefront of a radically new approach to body decoration. Tribal societies - indeed, all previous societies - were founded on the principle of conformity. As well as gender, age, social role, family background, class, caste and so forth all limited appearance. Our present and future approach to the transformation of the body, on the other hand, is based on individual choice - the customized body as an expression of unique identity.

In the past, what you were determined what you looked like. Today what you choose to look like expresses who - or indeed what - you would like to be.

The choice is yours.

Arthur:

I design and make clothes, as well as wear them. What I don't agree with are the rigid definitions of what a particular sex can or can not wear. Why can't a man wear cloth cut in a shape we label feminine? Clothes are clothes ... they have no gender. I would love to own a shop that sold garments meant for either sex. I don't just mean unisex but 'dresses', 'skirts', 'blouses', etc. to be worn by whoever felt good in them.

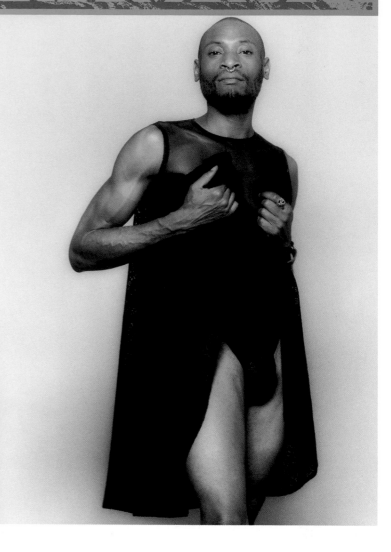

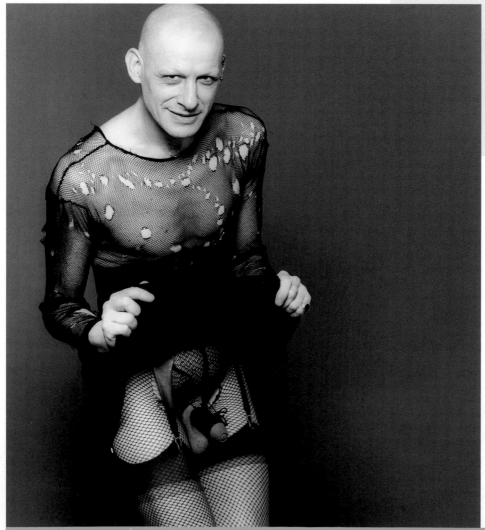

Jon:

As an art student in the 60's I had long hair and looked the part and even recently my mother told me, "John, you're so zany!" and my fathers' comment on my piercings was, 'You're really with it, kid!" Bless 'em. I guess my look is an extension of my Goth leanings. My girlfriend doesn't understand but I just keep doing my own odd things. Who knows where all this is going but I just keep on. My eldest son isn't into this at all, he's very conservative but he accepts me.

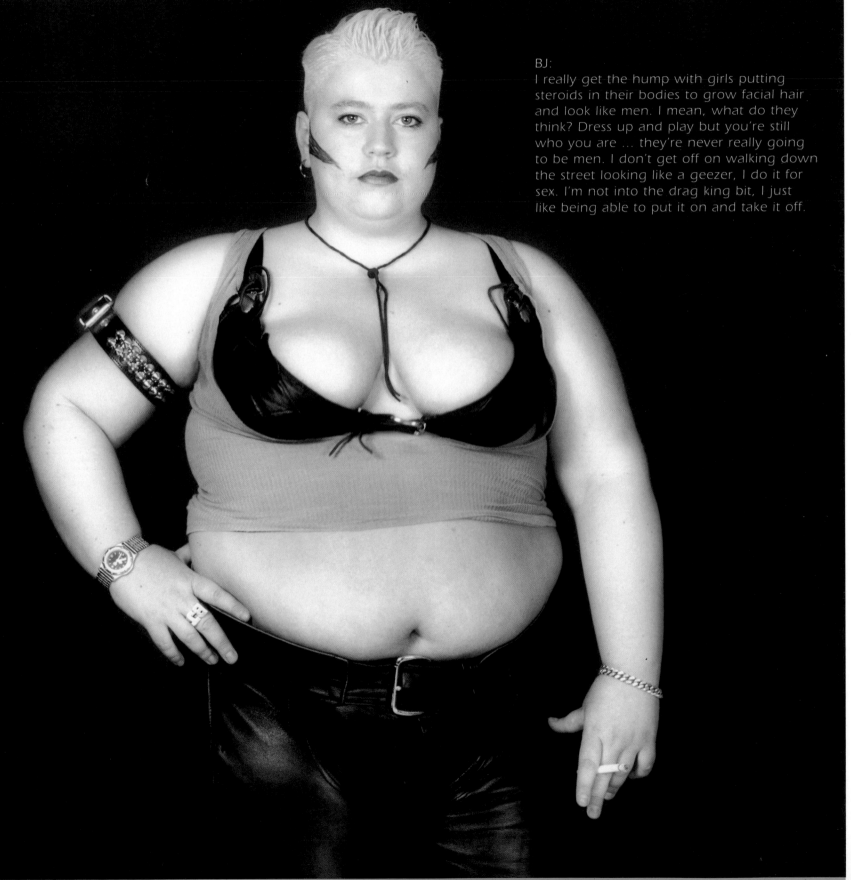

BJ:
I really get the hump with girls putting steroids in their bodies to grow facial hair and look like men. I mean, what do they think? Dress up and play but you're still who you are ... they're never really going to be men. I don't get off on walking down the street looking like a geezer, I do it for sex. I'm not into the drag king bit, I just like being able to put it on and take it off.

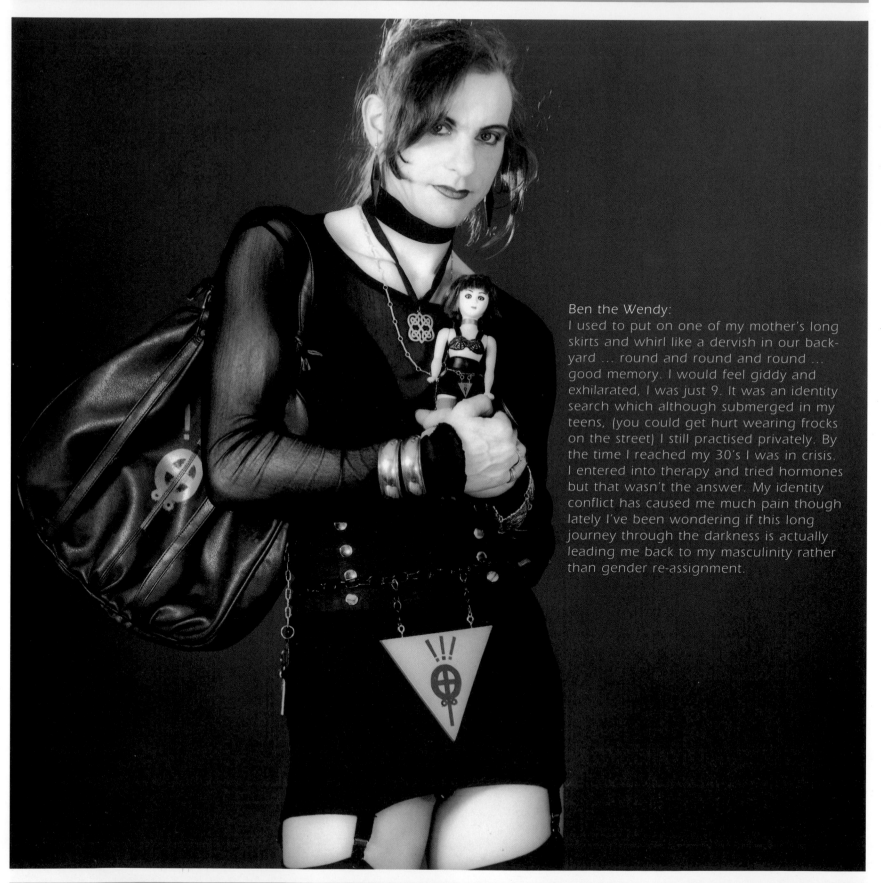

Ben the Wendy:
I used to put on one of my mother's long skirts and whirl like a dervish in our back-yard … round and round and round … good memory. I would feel giddy and exhilarated, I was just 9. It was an identity search which although submerged in my teens, (you could get hurt wearing frocks on the street) I still practised privately. By the time I reached my 30's I was in crisis. I entered into therapy and tried hormones but that wasn't the answer. My identity conflict has caused me much pain though lately I've been wondering if this long journey through the darkness is actually leading me back to my masculinity rather than gender re-assignment.

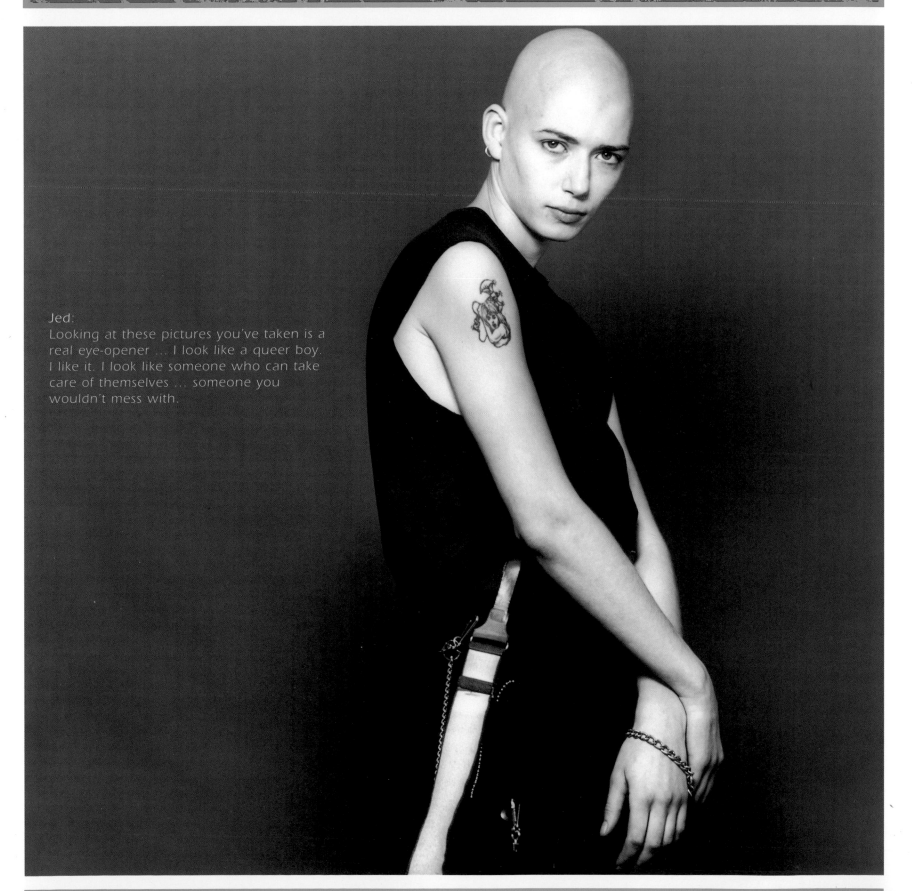

Jed:
Looking at these pictures you've taken is a real eye-opener ... I look like a queer boy. I like it. I look like someone who can take care of themselves ... someone you wouldn't mess with.

Christie:
We met at a fetish club, it's quite an unusual story actually. I was lesbian while I lived as a woman … even ran a lesbian club. I never felt comfortable though, I felt like a fraud and it wasn't until I finally saved the money to have my breasts removed, they were quite large and cumbersome, and a hysterectomy that things began to fall into place. With my new body and state of androgyny I became heterosexual, more or less, although I didn't know this until I met and fell in love with David. We were friends for a long time before he asked me to be in a relationship with him and now we've been together for more than three years.

David:
I was attracted to Christie because she's androgynous, I'm in love with her.

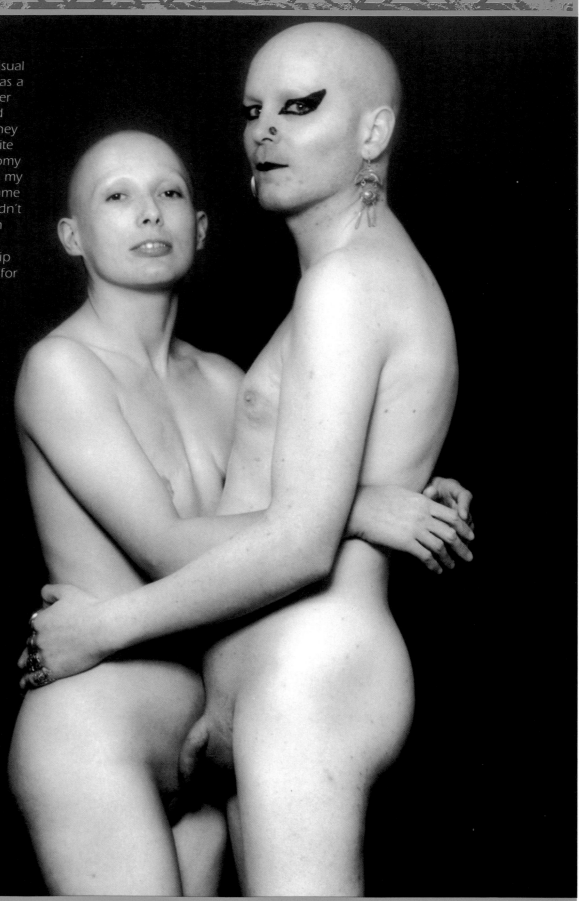

Danielle:
I'm still planning further changes, still redesigning my body. I'd prefer larger breasts and a smaller nose but that depends on me saving enough money which isn't easy. On the other hand I'm very pleased with my vagina, it can pass for the real thing. The question of my gender was tremendously stressful and pushed me into an aggressive state which has eased considerably since the change, I'm multi-sexual ... I like men, women and different stages of gender change but I prefer not to tell others I was once a man. As far as I'm concerned I'm a woman and always was.

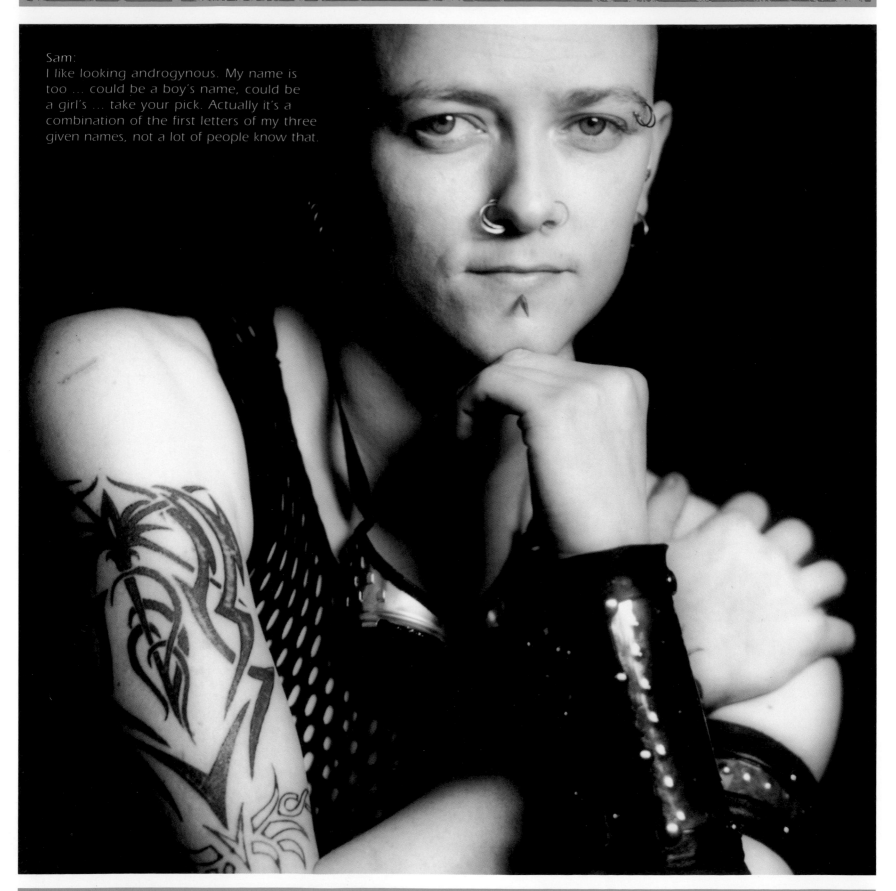

Sam:
I like looking androgynous. My name is too ... could be a boy's name, could be a girl's ... take your pick. Actually it's a combination of the first letters of my three given names, not a lot of people know that.

Mahn:
I used to get tattoos on my arms to look like one of the lads, camouflage, but I regret it now … they're not very nice.
I feel more comfortable in drag.
I'm more glamourous and attractive as a woman but I don't know if I'm ready to have a sex-change.

Fran:
I hate it when people address me incorrectly, it can ruin my mood for the rest of the day. When someone opens a door for me or tells me I'm looking pretty, it makes such a difference.

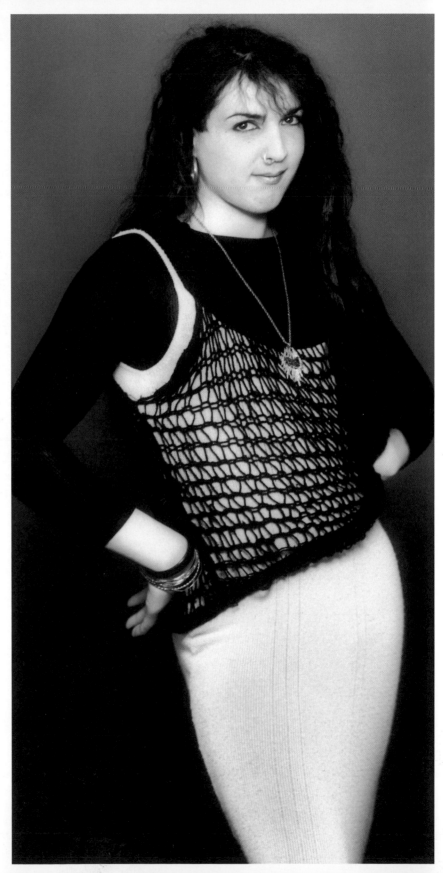

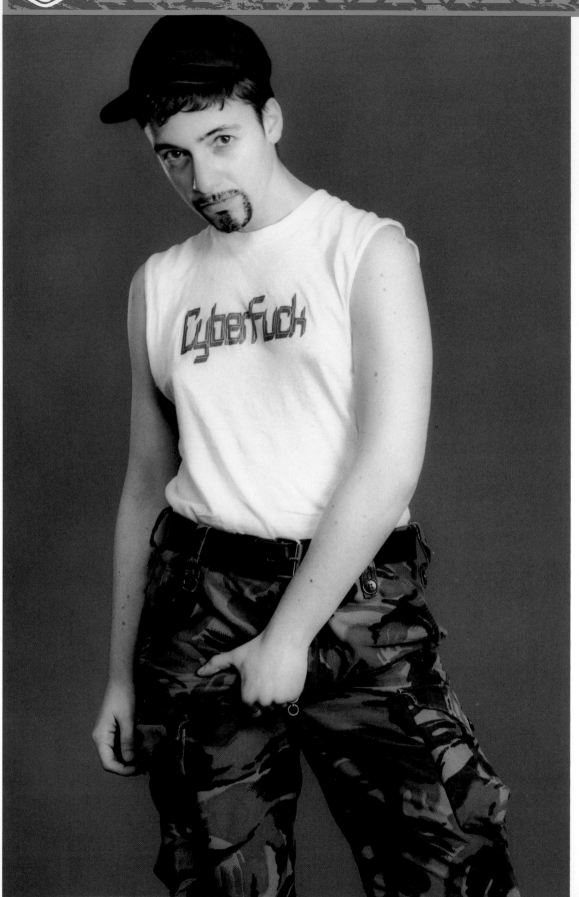

Tina:

I grew up in Greece and because of my build was perceived as masculine. I used to be uncomfortable with this and tried to conceal it with padded bras and long hair, etc. I felt like a fake. It wasn't until I left my country that I felt confident enough to present myself as more male. Now that I dress like this I've become more sexually responsive, I feel very much at home. My main problem is that looking like this on the street can be dangerous. I try to play with the shame of possibly being discovered, pointed out, and turn it into something positive. Recently, I've discovered a very disturbing element to my cross-dressing: A young woman saw me looking at her and became uneasy which, I realized, made me excited. It was the sense of power it gave me ... not very PC ... but true.

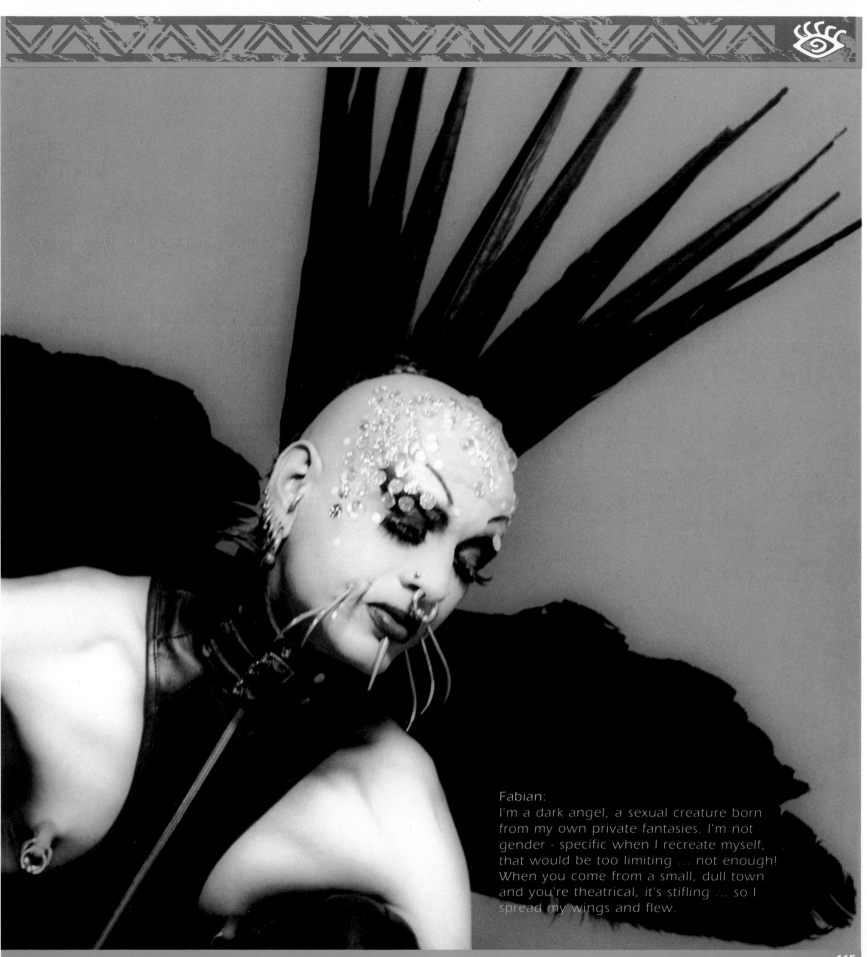

Fabian:
I'm a dark angel, a sexual creature born from my own private fantasies. I'm not gender - specific when I recreate myself, that would be too limiting ... not enough! When you come from a small, dull town and you're theatrical, it's stifling ... so I spread my wings and flew.

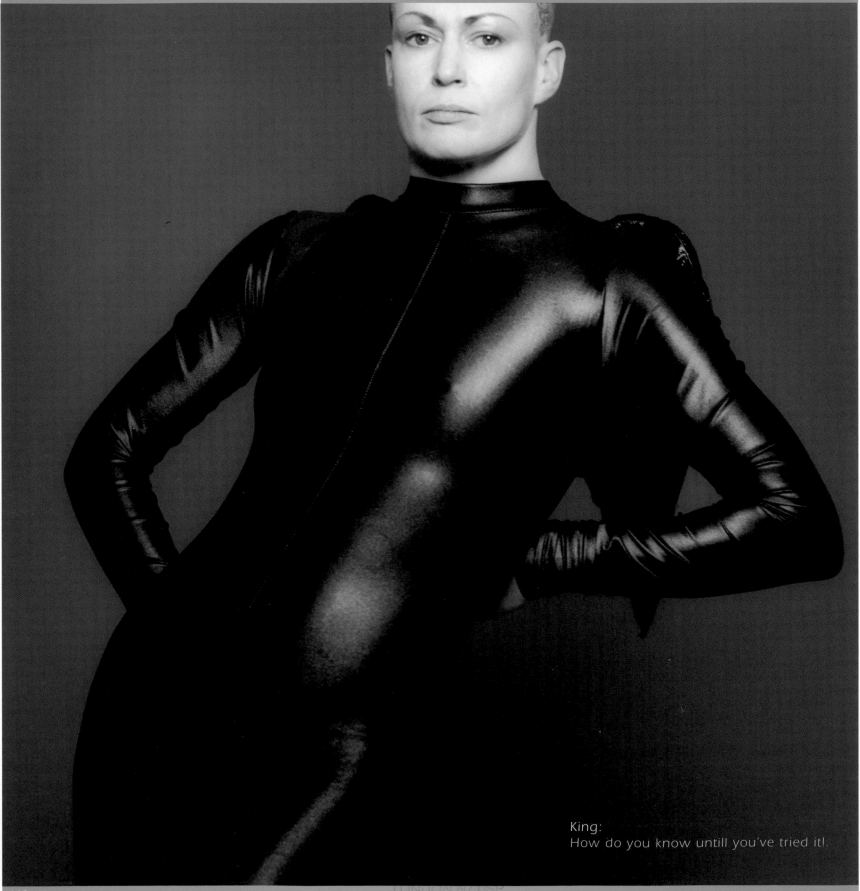

King:
How do you know untill you've tried it!.

LONDON N7 USP
TEL: 020 7700 8642

BIBLIOGRAPHY

APTER, EMILY, FEMINIZING THE FETISH: PSYCHOANALYSIS AND NARRATIVE OBSESSION IN TURN-OF-THE-CENTURY FRANCE, CORNELL UNIVERSITY PRESS, ITHACA, NEW YORK AND LONDON, 1991.

ARMSTRONG, RACHEL,'POST-HUMAN EVOLUTION', ARTIFICE, ISSUE 2, 1995.

BANKES, GEORGE, AFRICAN CARVINGS, THE AMENITIES COMMITTEE OF THE BOROUGH OF BRIGHTON, UK, 1975.

BECKWITH, CAROL AND ANGELA FISHER, AFRICAN ARK: PEOPLES OF THE HORN, COLLINS HARVILL, LONDON, 1990.

BINDER, PEARL, THE PEACOCK'S TAIL, GEORGE G. HARRAP & CO., LONDON, 1958.

BOUCHER, FRANÇOIS, A HISTORY OF COSTUME IN THE WEST, THAMES & HUDSON, LONDON, 1987.

BRAIN, ROBERT, THE DECORATED BODY, HUTCHINSON, LONDON, 1979.9

BRAND, CLAVEL, FETISH, LUXOR PRESS, LONDON, 1970.

BRAUN & SCHNEIDER, HISTORIC COSTUME IN PICTURES, DOVER PUBLICATIONS, NEW YORK, 1975.

CALLENDER, CHARLES & LEE M. KOCHEMS, 'THE NORTH AMERICAN BERDACHE', CURRENT ANTHROPOLOGY, VOL. 24, NO. 4, 1983, PP.443-470.

CARTER, ALISON, UNDERWEAR: THE FASHION HISTORY, B.T. BATSFORD, LONDON, 1992.

CHENOUNE, FARID, A HISTORY OF MEN'S FASHION, FLAMMARION, PARIS, 1993.

CHERMAYEFF, CATHERINE, ET AL., DRAG DIARIES, CHRONICLE BOOKS, SAN FRANCISCO, 1995.

CLAPHAM, ADAM & ROBIN CONSTABLE, AS NATURE INTENDED: A PICTORIAL HISTORY OF THE NUDISTS, ELYSIUM GROWTH PRESS, LOS ANGELES, 1986.

CLARKE, BOB CARLOS, THE DARK SUMMER, QUARTET BOOKS, LONDON, NEW YORK, 1985.

CLARKE, PAULINE, THE EYE OF THE NEEDLE, PUBLISHED BY PAULINE CLARKE, NUNEATON, WARKS, UK, 1994.

CORSON, RICHARD, FASHIONS IN HAIR, PETER OWEN, LONDON, 1965.

DELIO, MICHELLE, TATTOO: THE EXOTIC ART OF SKIN DECORATION, ST. MARTIN'S PRESS, NEW YORK, 1994.

DOUGLAS, MARY, NATURAL SYMBOLS: EXPLORATIONS IN COSMOLOGY, PENGUIN BOOKS, LONDON, 1973.

DWYER, JANE POWELL (EDITOR), THE CASHINAHUA OF EASTERN PERU, THE HAFFENREFFER MUSEUM OF ANTHROPOLOGY, RHODE ISLAND, USA,1975.

EBIN, VICTORIA, THE BODY DECORATED, THAMES & HUDSON, LONDON, 1979.

FARIS, JAMES C., NUBA PERSONAL ART, GERALD DUCKWORTH & CO., LONDON, 1972.

FEHER, MICHEL ET. AL [EDITORS], FRAGMENTS FOR A HISTORY OF THE HUMAN BODY, PARTS ONE-TWO-THREE, ZONE, NEW YORK, 1989.

FISHER, ANGELA, AFRICA ADORNED, COLLINS HARVILL, LONDON, 1987.

FLUGEL, J.C., THE PSYCHOLOGY OF CLOTHES, THE HOGARTH PRESS, LONDON, 1971.

GAMMAN, LORRAINE & MERJA MAKINEN, FEMALE FETISHISM: A NEW LOOK, LAWRENCE & WISHART, LONDON, 1994.

GARBER, MARJORIE, VESTED INTERESTS: CROSS-DRESSING AND CULTURAL ANXIETY, PENGUIN BOOKS, LONDON, NEW YORK, 1992.

GLYNN, PRUDENCE, SKIN TO SKIN: EROTICISM IN DRESS, GEORGE ALLEN & UNWIN, LONDON, 1982.

GOFFMAN, ERVING, THE PRESENTATION OF SELF IN EVERYDAY LIFE, PENGUIN BOOKS, LONDON,1975.

GOING, CHRIS, 'SCYTHIAN MAN', BODY ART, ISSUE 1, UK, 1987.

GOODE, KENNETH, INTO THE HEART: ONE MAN'S PURSUIT OF LOVE AND KNOWLEDGE AMONG THE YANOMAMA, SIMON & SCHUSTER, NEW YORK, 1991.

GOTTWALD, LAURA & JANUSZ, FREDERICK'S OF HOLLYWOOD 1947-1973: 26 YEARS OF MAIL ORDER SEDUCTION, STRAWBERRY HILL, NEW YORK, 1973.

HALLPIKE, C.R., 'SOCIAL HAIR' IN TED POLHEMUS (EDITOR) SOCIAL ASPECTS OF THE HUMAN BODY, PENGUIN BOOKS, LONDON, 1978.

HOEBEL, E. ADAMSON, ANTHROPOLOGY: THE STUDY OF MAN, McGRAW-HILL, NEW YORK, LONDON, 1966.

JAGUER, JEFF, THE TATTOO: A PICTORIAL HISTORY, MILESTONE PUBLICATIONS, HANTS, UK, 1990.

JOHN, ERROL ET. AL, MASQUERADING: THE ART OF THE NOTTING HILL CARNIVAL, THE ARTS COUNCIL OF GREAT BRITAIN, UK, 1986.

JONES, DYLAN, HAIRCULTS: FIFTY YEARS OF STYLES AND CUTS, THAMES & HUDSON, LONDON, 1990.

KENSINGER, KENNETH M., HOW REAL PEOPLE OUGHT TO LIVE: THE CASHINAHUA OF EASTERN PERU, WAVELAND PRESS, ILLINOIS, USA, 1995.

KENSINGER, KENNETH M. ET. AL, THE CASHINAHUA OF EASTERN PERU, STUDIES IN ANTHROPOLOGY AND MATERIAL CULTURE, VOLUME 1, THE HAFFENREFFER MUSEUM OF ANTHROPOLOGY, RHODE ISLAND, USA, 1975.

KIDWELL, CLAUDIA BRUSH & VALERIE STEELE, MEN AND WOMEN: DRESSING THE PART, SMITHSONIAN INSTITUTION PRESS, WASHINGTON, 1989.

KIRK, KRIS & ED HEATH, MEN IN FROCKS, GMP PUBLISHING, LONDON, 1984.

KUNZLE, DAVID, FASHION AND FETISHISM: A SOCIAL HISTORY OF THE CORSET, TIGHT LACING AND OTHER FORMS OF BODY-SCULPTURE IN THE WEST, ROWMAN & LITTLEFIELD, TOTOWA, NEW JERSEY, USA, 1982.

LAUTMAN, VICTORIA, THE NEW TATTOO, ABBEVILLE PRESS, NEW YORK, LONDON, PARIS, 1994.

LEACH, EDMUND, 'MAGICAL HAIR', JOURNAL OF THE ROYAL ANTHROPOLOGICAL INSTITUTE, VOL.88, PART 2, PP.146-164, 1958.

LEUZINGER, ELSY, THE ART OF BLACK AFRICA, EDICIONES POLIGRAFICA, BARCELONA, SPAIN, 1985.

LÉVI-STRAUSS, CLAUDE, STRUCTURAL ANTHROPOLOGY, ALLEN LANE THE PENGUIN PRESS, LONDON, 1969.

Lêvi-Strauss, Claude, The Way of the Masks, Jonathan Cape, London, 1983.

Lurie, Alison, The Language of Clothes, Hamlyn Paperbacks, Feltham, UK, 1982.

Mack, John, Masks and the Art of Expression, Harry N. Abrams, New York, 1994.

McClellan, Jim, 'Orlan', Observer, Life, pp.38 - 42, April 17, 1994.

McDowell, Colin, Dress To Kill: sex, power & clothes, Hutchinson, London, 1992.

Mertens, Alice & Joan Broster, African Elegance, Macdonald, London, 1974.

Morris, Desmond, Bodywatching: a field guide to the human species, Grafton Books, London, 1987.

Morris, Desmond, Manwatching: a field guide to human behaviour, Jonathan Cape, London, 1977.

Morris, Desmond and Peter Marsh, Tribes, Pyramid Books, London, 1988.

Mulvagh, Jane, Vogue History of 20th Century Fashion, Viking, London, 1988.

Musafar, Fakir (editor), BodyPlay: The Book, Volume 1, Insight Books, Menlo Park, California, 1995.

Nanda, Serena, 'The Hijaras of India', Journal of Homosexuality, Vol. 11, Nos. 2/4, pp.35-54, 1986.

Nicholson, Geoff, Footsucker, Victor Gollancz, London, 1995.

Perutz, Kathrin, Beyond the Looking Glass: life in the beauty culture, Penguin Books, London, 1972.

Polhemus, Ted, Body Styles, Lennard Publishing, Luton, UK, 1988.

Polhemus, Ted, Streetstyle: from sidewalk to catwalk, Thames & Hudson, London, 1994.

Polhemus, Ted, Style Surfing: What to wear in the third millennium, Thames & Hudson, London, 1996.

Polhemus, Ted (editor), Social Aspects of the Human Body, Penguin Books, London, 1978.

Polhemus, Ted & Jonathan Benthall (editors), The Body as a Medium of Expression, Allen Lane Penguin Books, London 1975.

Polhemus, Ted & Lynn Procter, Fashion & Anti-Fashion: an anthropology of clothing and adornment, Thames & Hudson, London, 1978.

Polhemus, Ted & Lynn Procter, Popstyles, Vermilion, London,1984.

Polhemus, Ted & Housk Randall, Rituals of Love: sexual experiments, erotic possibilities, Picador, London, 1994.

Price, Anna, 'Orlan', Artifice, Issue 2, 1995.

Randall, Housk, 'Erotic body manipulation' in Tony Mitchell (editor) Café Sex, Fourth Estate, London 1996.

Randall, Housk, Revelations: chronicles and visions from the sexual underworld, Skin Two, Tim Woodward Publishing, London, 1993.

Ribeiro, Aileen, Dress and Morality, B.T. Batsford, London, 1986.

Richie, Donald & Ian Buruma, The Japanese Tattoo, Weatherhill, New York, Tokio, 1980.

Richter, Stefan, Tattoo, Quartet Books, London, 1985.

Riefenstahl, Leni, The Last of the Nuba, Collins Harvill, London, 1986.

Roach, Mary Ellen & Joanne Boblz Eicher, Dress, Adornment & the Social Order, John Wiley & Sons, New York, 1965.

Rossi, William A., The Sex Life of the Foot and Shoe, Routledge & Kegan Paul, London, 1977.

Rubin, Arnold (editor), Marks of Civilization: artistic transformations of the human body, Museum of Cultural History, University of California, Los Angeles, 1988.

Rudofsky, Bernard, The Unfashionable Human Body, Rupert Hart - Davis, London, 1972.

RuPaul, Letting It All Hang Out: an autobiography, Warner Books, London, 1995.

Sacher-Masoch, Leopold von, Venus In Furs, Blast Books, New York, 1989.

Sagay, Esi, African Hairstyles: styles of yesterday and today, Heinemann, New Hampshire, USA, 1983.

Saint-Laurent, Cecil, A History of Women's Underwear, Academy Editions, London, 1986.

Sayer, Chloé, Mexican Costume, Colonnade Books, London, 1985.

Schevill, Margot Blum, Costume as Communication: ethnographic costumes and textiles from middle America and the central Andes of South America, Haffenreffer Museum of Anthropology, Rhode Island, USA, 1986.

Scutt, Ronald & Christopher Gotch, Skin Deep: The Mystery of Tattooing, Peter Davies, London, 1974.

Spindler, Konrad, The Man in the Ice, Weidenfeld & Nicolson, London, 1994.

Strathern, Andrew & Marilyn, Self-Decoration in Mount Hagen, Gerald Duckworth and Co., London, 1971.

Steele, Valerie, Fashion & Eroticism: ideals of feminine beauty from the victorian era to the jazz age, Oxford University Press, New York, 1985.

Steele, Valerie, Fetish: Fashion, Sex and Power, Oxford University Press, New York, 1996.

Tait, Hugh, Seven Thousand Years of Jewellery, British Museum Press, London, 1995.

Thevoz, Michel, The Painted Body, Skira/Rizzoli, New york, 1984.

Thomas, Nicholas, Oceanic Art, Thames & Hudson, London, 1995.

Thompson, Mark (editor), Leatherfolk: radical sex, people, politics & practice, Alyson Publications, Boston, 1991.

Trasko, Mary, Daring Do's: a history of extraordinary hair, Flammarion, Paris, New York, 1994.

Trasko, Mary, Heavenly Soles: extraordinary twentieth-century shoes, Abbeville Press, Paris, New York, 1989.

Turner, Terence S., 'Tchikrin: a central brazilian tribe and its symbolic language of bodily adornment' Natural History Magazine, October, 1969.

Ucko, Peter, 'Penis Sheaths: a comparative study' Proceedings of the Royal Anthropological Institute of Great Britain and Ireland, pp.27-67, 1969.

Vale, V & Andrea Juno (editors), Modern Primitives: an investigation of contemporary adornment & ritual, Re/Search Publications, San Francisco, 1989.

Villeneuve, Roland, Fétichisme et Amour, Editions Azur, Claude Offenstadt, Paris, 1968.

Virel, André, Decorated Man: the human body as art, Harry N. Abrams, New York, 1980.

Williams, Walter L., 'Persistence and change in the berdache tradition among contemporary lakota indians', Journal of Homosexuality, Vol. 11, Nos. 3/4, pp. 191-199, 1986.

Wilson, Elizabeth, Adorned in Dreams: fashion & modernity, Virago Press, London, 1985.

Woodforde, The Strange Story of False Hair, Routledge & Kegan Paul, London, 1971.

Wroblewski, Christopher, Skin Show: the art & craft of tattoo, Dragon's Dream, WHS Distributors, Leicester, UK,1981.

MAGAZINES

Body Art
Publications Ltd., P.O.Box 32, Great Yarmouth, Norfolk, NR29 5RD, UK.

Body Play: & modern primitives quarterly
Insight Books, P.O. Box 2575, Menlo Park, CA94026-2575, USA.

<<O>>: the art of fetish fashion and fantasy
<<O>> Publishing House, Hong Kong, P.O. Box 1426, Shepton Mallet, Somerset BA4 6HH, UK.

Piercing World
P.A.U.K., 153 Tomkinson Road, Nuneaton, Warks, CV10 8DP, UK.

Ritual Magazine
14, Emerald St., London WC1 3QA

Secret Magazine
Glitter Sprl., P.O.Box 1400, 1000 Brussels 1, Belgium.

Shiny magazines
G & M Fashions, Ltd., P.O. Box 42, Romford, Essex RM4 1QT, UK.

Skin Two
Tim Woodward Publishing Ltd., BCM Box 2071, London, WC1N 3XX, UK.

Tattoo Ink
Harris Publications, 115 Broadway, New York 10010, USA.

Tattoo Revue
Flamingo S.r.l., V. Pe Abruzzi,87, 20131 Milano, Italy.

Tattoo Savage: a walk on the wild side
Paisano Publications, 28210 Dorothy Dr, Agoura Hills, CA 91301,USA.

Tattootime
Tattootime Publications, P.O. Box 90520, Honolulu, Hawai 96835, USA.

VIDEOS

'Mistress of the Rings' a film by Steen Schapiro available from Danish Film Institute Workshop, Vesterbrøgade 24, DK 1620 København V Denmark.

'Discipline Gym: body discipline' a film by Azzlo-Rwp. P.O.Box 1956 Freepost ND6272 London N19 4BR.

'Penetration' Vols.1, 2 and 3.
'Devotion'
'Heavenly Bodies'
'The Living Canvas'
The Wildcat Collection, 16 Preston Street, Brighton, East Sussex, BN1 2HN, UK.

'Pierce with a Pro',
educational film produced by Gauntlet, distributed by The Wildcat Collection. 16 Preston Street, Brighton, East Sussex, BN1 2HN, UK.

'The Rubber Ball' and 'Designer Sex'
films by Salvatore Mulligan
available from Skin Two, 23 Grand Union Centre, Kensal Rd, London W10 5AX.

TED POLHEMUS

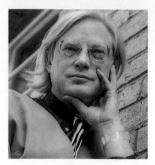

How people choose to present themselves has always had a profound fascination for me. It's much more than simply a question of aesthetics. I yearn to know what is being 'said' why this particular person walking towards me on a city street or in front of me at the supermarket check-out has chosen to 'package' themselves in this particular way. It has always seemed to me that a person's chosen image is a more effective résumé of their inner self than anything they might put into words.

I find conventional, 'natural' beauty extremely boring. In that I'm more enticed by the packaging than the raw, untouched body which lies beneath it you could say I'm fetishistic. At the same time, however, it isn't strictly true that I am stimulated by the trappings of appearance in and of themselves - it is people and their patterns of relationships which ultimately interest me. The packaging is just a way of seeing what lies beneath; a means to an end but, in my view, one of the most important.

As I look at the wonderful photographs which Housk Randall has taken for this book I find myself entranced by these dazzling individuals. (Just as I remain captivated by those - sadly so rapidly disappearing - tribal peoples who first demonstrated the extraordinary extent to which the human body can be transformed into an artistic medium.) By comparison my own appearance styles are hardly noteworthy but I do strive to include myself within the ranks of the customized ape as much as possible. This takes two forms. On the one hand I attempt to do my bit to stand up to that epidemic of casualness which seems to threaten our age - more often than not finding myself the only person wearing a suit and a tie in business meetings or social gatherings. Alternatively, for example at a fetish club, I might be found in a rubber corset proudly showing off my nipple piercings. A large, post-modern tattoo incorporating a wide range of styles has been planned and re-planned for ages. Friends increasingly doubt that this will ever be accomplished but I like to image that one day I too will be a suitable subject for Housk Randall's camera.

Ted Polhemus studied anthropology at Temple University in Philadelphia and at University College, London - specializing in the expressive possibilities and meaning of the human body.

His books include: The Body as a Medium of Expression (co-editor), Social Aspects of the Human Body (editor), Fashion & Anti-fashion (with Lynn Procter), Body Styles, Rituals of Love (with Housk Randall), Streetstyle and - most recently - Style Surfing: What to Wear in the Third Millennium.

He is also a photographer, an exhibition organizer, a lecturer and a frequent guest on radio and TV.

'We would like to thank Maria de Marias for her meticulous assistance in the preparation of this manuscript, Adrian Gray for his sensitive and careful design of this book, Jo Brocklehurst for her drawings, our families for their support and encouragement, Sara Lloyd for her continuing help, Ilford Aniitec Ltd for their photographic materials, Simon Rogers for his magnificent body painting, Alex Binney and Into you for so many of the exceptional tattoos represented within and especially all those body artists who have allowed themselves to be photographed for this book.

Ted Polhemus ▪ Housk Randall

HOUSK RANDALL

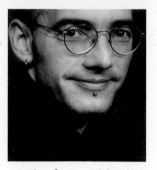

Wouldn't it be easy, or possibly more comfortable, to dismiss the preoccupation of many of the people included in The Customized Body as unimportant, ridiculous or even mad? It might be, but that would be to only focus on the form rather than delve into the impulses which lie behind it. My experiences - both as photographer and psychotherapist - have led me to the view that there is a common sub-text behind the myriad expressions of adornment and body modification which I have documented: although often unacknowledged, most people's actions are propelled by a search for identity and/or desirability. We need some proof of existence during (and perhaps after) this brief dream and in customizing our bodies in distinctive ways we accomplish this. To tattoo my skin, to pierce my flesh, to shave my hair ... all these things give both a feeling of control over one's life and mark against the obliteration of that life.

So why now? Why are these particular avenues - of customizing the body and of self-realization through that process - being explored to such a great extent in the 1990s? My personal opinion is that as Western society becomes increasingly computerized and technological the importance of individual experience and input seems diminished, possibly lost. Ancient rituals and 'primitive' practices offer an increasing number of people a focus, a vision of where we've been, something to hold onto as we rush towards the millennium and an uncertain future.

Housk Randall is a psychotherapist and one of the leading observers in the new field of erotic anthropology. Through the medium of photography, he presents the extraordinary individuals who populate the visually distinctive subcultures of our time. Housk joins and becomes an integral part of the worlds he researches and then, from an informed and compassionate perspective, documents their fantasies, attitudes and lifestyles.

Housk Randall is the author of Revelations and co-author (with Ted Polhemus) of Rituals of Love. The powerful imagery he creates is regularly exhibited in galleries around the world.